Story of photography

From its beginnings to the present day

Second edition

Michael Langford FBIPP, Hon FRPS

Photography Course Director, Royal College of Art, London

Focal Press
Focal Press
An imprint of Butterworth-Heinemann
Linacre House, Jordan Hill, Oxford OX2 8DP
A division of Reed Educational and Professional Publishing Ltd

OXFORD BOSTON JOHANNESBURG
MELBOURNE NEW DELHI SINGAPORE

First published 1980 Reprinted 1992, 1995, 1996

Second edition 1997

© Michael Langford 1997

All rights reserved. No part of this publication may be reproduced in any material form (including photocopying or storing in any medium by electronic means and whether or not transiently or incidentally to some other use of this publication) without the written permission of the copyright holder except in accordance with the provisions of the Copyright, Designs and Patents Act 1988 or under the terms of a licence issued by the Copyright Licensing Agency Ltd, 90 Tottenham Court Road, London, England W1P 9HE. Applications for the copyright holder's written permission to reproduce any part of this publication should be addressed to the publishers

British Library Cataloguing in Publication DataA CIP record for this book is available from the British Library

ISBN 0240 51483 1

Library of Congress Cataloguing in Publication Data A catalogue record for this book is available on request

Printed and bound in Great Britain

Story of photography

11

MERTHYR TYDFIL COLLEGE LIBRARY

470° Acc. 8997

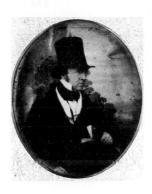

Contents

Introduction vii

Part 1 - Technical evolution

Pre-history and discovery

Light-sensitive materials used in the camera obscura make photography possible. Daguerreotypes, the first practical process. Talbot's Calotypes. Projects.

The new invention is used in portrait studios, and for views of distant lands. The first book of photographs. Calotype photography by Hill and Adamson. Projects.

21

Collodion gives better results. Photography spreads, although still very cumbersome. Ambrotypes and stereo views. The carte-de-visite craze. Portraits by amateurs. Projects.

'Dry' plates, rollfilms (1870–1900) 44

Darkrooms are no longer essential. The first 'Kodak'. Muybridge's action pictures. Faster films, better cameras, photographs on the printed page. Painters interested in photo images. Projects.

The search for colour

60

Tri-colour approaches - the Maxwell experiment, and du Hauron book. Shooting and printing separation negatives. Screen plates and film. Special cameras. Devising multi-layer colour films. Kodachrome, Agfacolor transparencies. Colour negative films. Instant colour materials. Colour overtakes black & white.

Improving camera design

From wooden plate cameras to rollfilm types. The Leica, Rolleiflex. Cameras for News work. Development of the 35 mm SLR. Professional equipment, monorails. Amateur cameras leading to 35 mm compacts. Exposure measuring. Electronic improvements take over most technicalities.

Part 2 - Subjects, styles and approaches

Introduction 85

The documentary approach

Starting with distant wars and scenic views, photography began to be used to document social injustices at home. The FSA. The arrival of newspaper photography, photojournalism and picture magazines. Questions of truth distortion and manipulation. Projects.

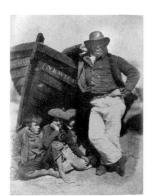

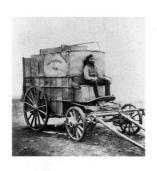

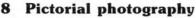

High Art constructions shattered by Emerson's 'Naturalism', Breakaway movements - The Linked Ring, Photo-Secession. Demachy, Evans. Stieglitz and Steichen. The uneasy relationship between painters and photographers. Projects.

Modernist movements

Revolutionary cubist and dadaist changes in art. Abstraction and experimental images. Man Ray. Moholy-Nagy. Realism, 'straight' photography by Strand, Weston, Adams, Renger-Patzsch, Photography separate from other arts. Surrealism. 'Equivalents'. Minor White. Projects.

10 Changes in professional photography (1920–80) 148

Fashion, advertising and portraiture of the 20s and 30s. Wartime roles. Industrial photography. Youth culture – the swinging sixties, 'Family of Man' boosts documentary photography. The concerned photographer. Project.

11 Concern for meaning

As photographs dominate society new issues of meaning develop. Reactions to modernism. William Klein. Robert Frank. Duane Michals. Growth of critical debate. Barthes, Benjamin. Picture/text relationships. New Topographics. Gender issues – Sherman, Kruger, Critical theory values, Projects.

12 Photography in a post-modernist age

179

Integration of photography as central within fine art. Rauschenberg. Pop art. Mixed media. Post modernist photography. Deconstruction and appropriation. Surrealism – Uelsmann, Skoglund, Colvin, Mahr, Friedlander, Pfahl, Josephson, Mosaics and multiples - Hockney. Bechers. Witkin. Hiscock. Interinfluences of art and photography, practice and theory. Projects.

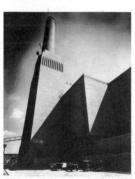

Final word	199
Events by date	201
Glossary	205
Brief biographies	208
Picture credits	213
Index	214

Introduction

This is an introductory guide to the history of photography written for students of photography, art or humanities. It is also for the general reader interested in tracing photography from its beginnings to what has become the imaging medium most used by everyone today. The book covers the period from 1839 (when the first practical process was announced) to about 1990, and is presented in a learner-friendly manner with regular summaries and projects.

Part One is concerned with the technical developments of photography – how things were made to work, including what picture-making was just possible and what simply could not be done. Later, Part Two (chapters 7–12) covers subjects, styles and approaches chosen by photographers as the range of possibilities broadened out. This increasingly concentrates on photography used as an art medium.

For each period a selection of important photographers are identified. It seems more useful to do this in a book of this size than trying to include large numbers just by 'name-dropping'. Main lines of development can also be seen more clearly. Use *Story of Photography* as a structured overall history, backed up by your own further reading on photographers from each period.

For schools this book is complemented by three sets of colour slides (EXP. 1–3) by the same author, produced by Visual Publications, The Green, Northleach, Cheltenham, Gloucester, GL54 3EX.

The basic principle of the camera obscura. Because light travels in straight lines, a small hole forms a crude and very dim upside-down image of the sunlit landscape, inside a darkened room.

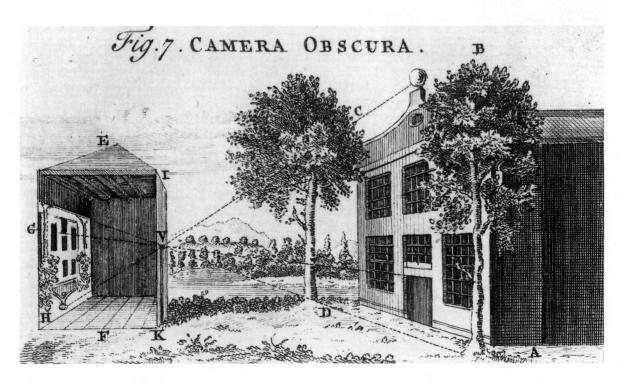

Join the Royal Photographic Society

Make friends and influence people! Become involved with the Society that makes things happen — from discussions on Digital Imaging to field trips with the Nature Group. When you join you will become part of an international group of photographers, and you will be encouraged to work towards a Society Distinction. Photographers world-wide, both amateur and professional, are recognized by the letters LRPS, ARPS, and FRPS, the letters which represent the Distinctions of Licentiateship, Associateship and Fellowship, which exemplify their photographic achievement.

As a member you will receive the informative Photographic Journal, the monthly magazine which is mailed straight to your home, and many other benefits including discounts on hotels, publications and photographic insurance. Enjoy unlimited access to the exciting exhibitions at the Octagon Galleries in the world-heritage city of Bath, and catch up on your photographic history in the museum where you will see many examples of the early photographs.

To encourage your photographic specialism and complement your membership there are fifteen special interest groups which cover the entire diversity of photography. Each Group holds lectures, seminars, master-classes and informal meetings all over the country. More information about the groups is contained in your New Members pack which will be sent to you when you apply for membership.

The Royal Photographic Society is one of the largest photographic associations in the world and readers of 'The Story of Photography' are entitled to the privilege of three free months of membership. For fifteen months of membership for the price of twelve please contact the Membership Department, at The Royal Photographic Society, The Octagon, Milsom Street, Bath BA1 1DN. Telephone no: 01225 462841. Fax 01225 448688, or e-mail at Sara@rps bath.demon.co.uk. Be sure to mark your request SP'97.

Part 1 - Technical evolution

$\widehat{oxedsymbol{oxed}}$ Pre-history and discovery

If only a scene could draw *itself!* If only, in some magical way, reality could be represented accurately without needing drawing skills and intensive labour . . . In the early 19th century naturalism and accuracy were highly prized in the visual arts. Crude, image-forming 'camera obscuras' had been known as novelties and used as artists' sketching aids for centuries, but no light-sensitive recording material existed. By the 1830s however a combination of artistic need and growing scientific exploration led to the first successful use in the camera of light-sensitive chemicals – which is where the story of photography really begins. This chapter looks at the origins of the two vital components (optical and chemical), tracing how they came together at last to form a practical picture-making process.

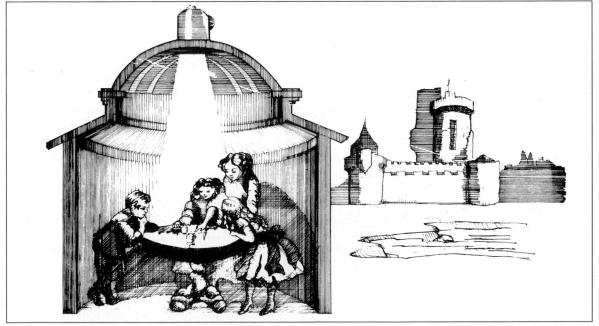

Fig. 1.1. Camera obscuras like this, fitted with a simple telescope lens and mirror, were designed to project scenes of the surrounding countryside onto a white-topped viewing table.

The camera

If light from a brightly illuminated scene is allowed to enter a darkened room through a small hole (e.g. in a blind or shutter covering a window) a dim image of the scene may appear on the opposite wall (see page vii). The image is upside-down because light rays from the top part of objects only reach the lower part of the wall, and vice-versa. This *camera obscura*

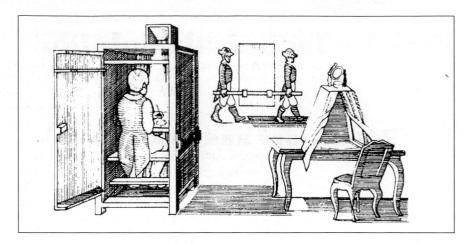

Fig. 1.2. 18th century portable camera obscuras were often converted sedan chairs, left. Folding types could stand on any handy surface, right. They both projected images down on to paper so that they could be traced.

or darkened chamber effect has been known since ancient times. It was certainly mentioned by Leonardo da Vinci and in 1556 Giovanni Porta published a clear description of the device. At about this time too it was discovered that by enlarging the hole and fitting it with a suitable lens from a telescope a brighter, clearer image could be formed. Rooms modified to form camera obscuras were used as novelties in public buildings, parks, etc. and a few even remain today.

By the 17th century smaller and more portable camera obscuras were in frequent use as artists' aids. Sedan chairs (a popular means of transport for short distances) were adapted into totally enclosed boxes with a mirror and lens set into the roof (Fig. 1.2). The mirror reflected the light down onto a drawing board inside and also made the image right way up. Folding camera obscuras were made to be set up on tables (Fig. 1.3), or could

even be held in the hand. In all cases the image had to be traced onto paper, but these contrivances were extremely useful for accurately sketching perspective and scale when drawing landscapes, architecture, etc.

Fig. 1.3. A reflex camera obscura used by artists. The mirror reflected the image right way up onto ground glass for tracing.

The light-sensitive material

It has also been known for centuries that certain materials are affected by the sun – either darkening or fading when left exposed for long periods. Often these changes were assumed to be due to *heat*, as in cooking, instead of the sun's *light*. Some compounds of silver are particularly responsive.

In 1727 Professor J. Schulze was experimenting to make phosphorus using a glass flask containing powdered chalk and nitric acid which accidentally contained some silver. Working near an open sunlit window he observed the white mixture slowly darken but only on the side of the flask facing the sun. Since he could not achieve the same result by the fire Schulze realized that the change must be due to the sun's light. He also discovered that darkening became more rapid when the silver content was increased. Schulze's results were published widely, but only regarded as a trick of science, suitable as a parlour game.

You might expect from this time that the two devices – the artist's camera and the scientist's light-responding chemical – might have been put together to create photography. In practice little seems

to have been done. About 1800 Thomas Wedgwood, son of the famous Staffordshire potter, managed to make 'sun pictures' by placing opaque objects such as leaves in contact with leather which had been treated with silver nitrate or silver chloride. Left to expose in sunlight the uncovered parts of the leather gradually darkened, so when the object was removed its white shape remained. Unfortunately Wedgwood could not prevent these still light-sensitive white areas from darkening too, despite washing the image with soap or varnishing the leather when dry. Results like Fig. 1.4 could only be shown to people by weak candlelight, and even then gradually blackened and so disappeared.

Wedgwood, as a leading pottery firm, often needed camera obscuras for electroning stately homes to incorporate into the design of custom-made dinner services. Tom tried to secure images using one of their camera obscuras containing silver nitrate coated paper, but concluded that it must be too faint to record. He abandoned his unsuccessful experiments, never realizing he was so close to inventing photography. Wedgwood's results were published in 1802, two years before he died, by his friend the scientist

Sir Humphry Davy.

The next stage of improvement was to occur nearly twenty years later in France. Here Nicéphore Niépce (pronounced 'Nee-eeps') was trying to record a camera obscura image direct onto a chemically treated stone or metal surface. He hoped this could then be inked and printed by the newly invented process of lithography. According to Niépce's letters, by 1816 he had been able to record an impermanent form of result with reversed tones – whites reproduced as black (a 'negative') – using silver chloride sensitized paper. But Niépce was looking for a picture with light parts in

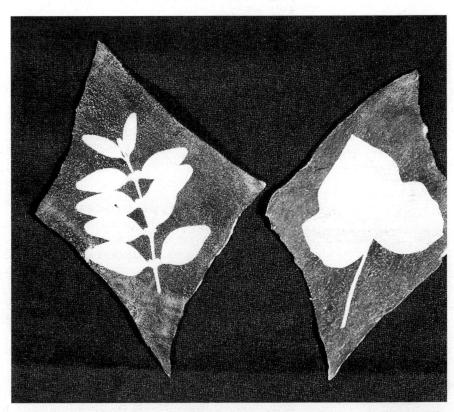

Fig. 1.4. 'Sun pictures'. In 1800, Tom Wedgwood recorded leaf shapes by the action of light – contact printing them onto leather treated with silver nitrate. (Modern replicas by same process.)

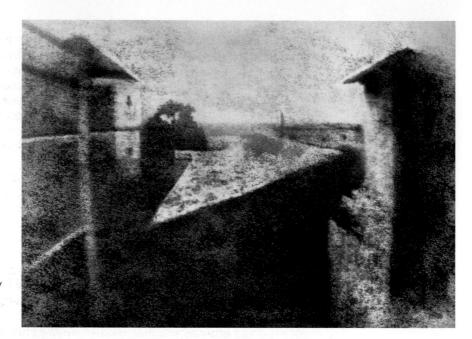

Fig. 1.5. The world's oldest surviving picture produced with a camera, about 1826. It shows the view from Niépce's window – the sloping barn roof, a pigeon house, left, and part of his house, right.

an acid-resisting material, on a metal base which could then be etched to absorb printer's ink. To do this he experimented with a varnish of white bitumen of Judea dissolved in oil and spread on a flat pewter plate. Prolonged exposure to light caused the bitumen to harden, so that when the plate was bathed in lavender oil unhardened parts of the white bitumen were washed away. It left bright parts of the image white against the dark metal. The plate therefore showed a picture with tones similar to the original scene (a 'positive' image).

Niépce called his process 'heliography', meaning sun drawing, and used it for making contact prints from engravings on translucent paper. In 1826 he succeeded in using a plate in a camera obscura to record the view from the window of his top floor workroom (Fig. 1.5). The exposure needed was about eight hours. This crude-looking image is the first permanent picture taken with the camera obscura which is still in existence. Niépce's light-hardening heliography process was eventually used in modified form for printing plates, but always remained too insensitive for direct practical use in the camera.

The daguerreotype process

One of the few people who heard of Niépce's experiments was the Parisian artist, scenic painter and showman Louis Daguerre (Fig. 1.7). Daguerre had already made his reputation staging 'dioramas' – entertainments in which large painted panoramas and specially controlled lighting effects produced a visual spectacle featuring unfamiliar parts of the world, famous buildings, etc. Daguerre used camera obscuras to make accurate sketches for his diorama shows and soon interested himself in trying to record the images chemically, using silver compounds.

Daguerre first cautiously corresponded with Niépce, then eventually went into partnership with him to pool the secrets (and profits) of heliography. The partnership proved barren The bitumen process was not sensitive enough, and Niépce seemed unwilling to experiment further with silver salts, as urged by Daguerre. By the time Niépce died four years later little progress had been made. His son Isidore took over the partnership, but

Daguerre was effectively on his own.

Daguerre continued using metal plates – this time they were copper, plated with silver and made light sensitive by iodine vapour which formed a coating of silver iodide. Even with the best available lenses the material was far too slow in its response to light. The turning point for Daguerre came when he discovered that by holding his exposed plate over warmed mercury the image became intensified or 'developed'. By 1837 he had a workable system (Fig. 1.6). A 30-minute exposure was needed for most brightly lit views, and the finished result was a detailed whitish image on a silvery background.

Daguerre now called his system the daguerreotype process. Unfortunately he lacked the money to promote the process himself, but his discovery was considered so important by the French Government that Daguerre (and Isidore Niépce) were awarded state pensions. In return they were to publicly reveal all the technical details and allow daguerreotyping to be freely practised in France.

A special meeting of the Academy of Science and the Academy of Art was arranged in August 1839, at which a friend of Daguerre was to explain in detail how the process could be worked. The whole of Paris seemed to wait in excited anticipation – at this time there were no illustrations in newspapers and books other than engravings like Fig. 2.7. Only the rich could afford paintings. Yet here was a magic process by which pictures could be drawn 'by the action of light itself'. Newspapers called the shiny metal picture 'a mirror with a memory'.

Here is one published report of the meeting: . . . 'Gradually I managed

Fig. 1.6. A complete Daguerreotype outfit, from an advertisement of 1843. To discover how all these bits and pieces were used see Table 1.1 below.

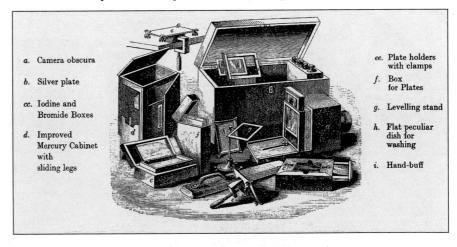

Table 1.1 Daguerre's original process 1839

- 1 A sheet of silver-plated copper is well cleaned and polished.
- The plate is sensitized by leaving it in a small sensitizing box with iodine solution at room temperature for 5–30 min until the silver surface has become golden yellow. (It can be viewed under a red lantern.) The plate can then be inserted in a light-proof holder for taking to the camera.
- 3 Exposure in the camera for about 5–12 min (f11 lens).
- The image is 'brought out' by supporting it face downwards above mercury heated to 75°C (167°F).
- 5 The remaining light-sensitive salts are removed by bathing with hyposulphite of soda.
- 6 Finally, the plate is washed in distilled water, and then dried.

1840 improvements: The following extra stages

- 2a The plate is washed in silver halide solution. Then step 2 is repeated, briefly.
- 5a Bathing in gold chloride solution to strengthen the final result.

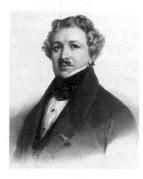

Fig. 1.7. Louis Daguerre, inventor of the first practical method of photography, drawn two years before the 1839 public announcement of his process.

Fig. 1.8. Daguerreotype of Pont Neuf, Paris, 1838. As Daguerre gave about 15 minutes exposure, moving carriages and figures failed to record. Royal Photographic Society Collection. to push through the crowd . . . after a long wait a door opens in the background and the first of the audience to come out rush into the vestibule. 'Silver iodide' cries one, 'Quicksilver' shouts another, while a third maintains that hyposulphite of soda is the name of the secret substance . . . An hour later, all the opticians' shops were besieged, but could not rake together enough instruments to satisfy the on-rushing army of would-be daguerreotypists; a few days later you could see in all the squares of Paris three-legged dark-boxes planted in front of churches and palaces...' Painters were extremely alarmed at this threat to their livelihoods. Paul Delaroche famously exclaimed 'from today painting is dead'.

Once news of the process spread across Europe ideas for chemical improvements soon appeared (Table 1.1). Equally a new lens, designed specially for daguerreotyping by Josef Petzval of Vienna, offered a wider aperture (f3.6 instead of about f11) making the camera image ten times as bright. From 1841 onwards therefore exposure times were reduced to around one minute. Portraiture studios were soon set up and people flocked to them to 'have their likenesses taken'. See Fig. 2.6. Everyone marvelled at the detail and accuracy of daguerreotype images.

The calotype process

Meanwhile, in England, landowner and amateur scientist Henry Fox Talbot had been working on his own system of recording images in the camera obscura. In 1834 he experimented with writing paper dipped in silver

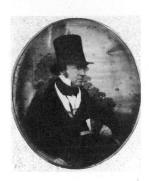

Fig. 1.9. A Daguerreotype partrait (1044), shown here about half actual size. The sitter is William Fox Talbot, British inventor of the rival calotype process.

Fig. 1.10. Replica of an 1835 Talbot camera negative, given 1½ hours exposure. Behind it is the same Lacock Abbey window today.

Fig. 1.11. (below) One of Talbot's early cameras, made for him by the local carpenter. The Fox Talbot household called them 'mousetraps' from the way they were left around exposing.

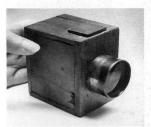

chloride, which was dried and then exposed to sunlight under flat objects such as lace or leaves. As with Wedgwood's experiments the silver salts darkened where uncovered by the object, but Talbot had discovered two important improvements. Firstly, the resulting image could be prevented from darkening overall by bathing the paper in strong salt solution. And secondly, although the picture was a negative (blacks represented as whites, etc.) he realized that it might be printed by light onto another sheet of sensitized paper which would then show correct tone values.

Small wooden cameras were built (Fig. 1.11) loaded with sensitized paper and left about Fox Talbot's estate, Lacock Abbey in Wiltshire. Exposures needed to give a recognizable result ranged from 10 to 30 minutes, The oldest surviving Talbot picture of this period is dated 1835 (Fig. 1.10).

Talbot had many other interests and had made little further progress when in 1839 the first rumours of Daguerre's invention spread from Paris. Afraid they might both be using an identical process, he hurriedly decided to publish his work as far as it went, and prepared papers on 'photogenic drawing' which were read to learned societies in London.

This publicity resulted in several beneficial ideas. Sir John Herschel advised that hyposulphite of soda (today called sodium thiosulphate) would form a better fixing agent than salt. The terms 'negative' for Talbot's camera result, 'positive' for his final correctly toned print, and 'photography' (light drawing) as a general name for chemically recorded camera images were all suggested by Herschel.

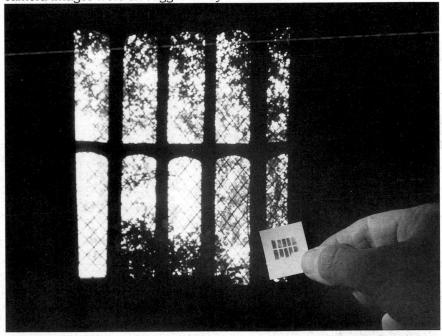

By 1840 Talbot had improved his process by changing to silver iodide and also using a developer solution. Shorter exposure times could now be given and the faint image strengthened by this aftertreatment. The following year he patented his improved routine (Table 1.2) and named it the calotype process. Within the space of three years the world had been

Negative

Under red lighting best quality writing paper is dipped in weak silver nitrate solution, followed by potassium iodide solution, and wiped dry.

2 One side is coated with an 'exciting' solution of gallic acid and silver nitrate, applied with a brush. The sensitized paper is then dried in front of the fire, and placed in a light-proof holder to take to the camera.

3 Exposure in the camera for about 1-3 min.

4 Development, in the same exciting solution as 2 but diluted to half strength.

5 Fixing in hyposulphite of soda, washing and drying.

Positive print

Another sheet of paper is soaked in salt solution and wiped dry.

7 Under red light it is brushed over with silver chloride solution, and dried.

8 Pressed in tight face contact with the negative in a printing frame, the paper is exposed to bright sunlight until it forms a strong brownish image (about 20 min).

9 The print is fixed, washed and dried.

presented with two rival systems of photography. Only one was to survive.

Summary - prehistory and discovery

The invention of photography brought together the camera obscura. an optical novelty and artists' aid, and materials (such as silver compounds) which undergo changes when exposed to light.

In 1800 Wedgwood managed to record shadows of objects placed in direct contact with silver nitrate treated leather, but was unable to fix these results.

Niépce succeeded in making the first permanent image with the camera obscura in about 1826. He used white bitumen on metal. giving a crude positive result he called a heliograph. Several hours exposure was needed.

Daguerre devised the first practical process, the daguerre otype. It gave a direct positive image on a silvered metal plate. The process was

publicly disclosed in 1839 and created great excitement.

Fox Talbot was also working on a light-sensitive process – one which formed a negative image, on paper. When printed by sunlight onto a further sheet this gave a positive, permanent picture. Talbot called his result a calotype, and patented it in 1841.

Fig. 1.12. Using a length of black cloth over your head, as in the figure, you can make the mirror and lens of an overhead projector into a camera obscura and use it as a drawing aid. (See project 1.1.) Compare this with Fig. 1.2.

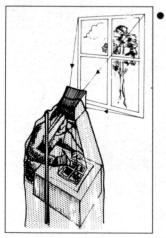

Projects

P1.1 Devise your own camera obscura. Use for example a school overhead projector (Fig. 1.12) switched off and with its lens pointed towards a bright outdoor scene. Place a white paper over the light box. Use a coat or black cloth to prevent light reaching the paper other than through the lens and mirror system. Focus the image onto the paper and trace its outlines.

Experiment with 'sun pictures'. Place keys, a leaf, lace, etc. on photographic paper and leave it in sunlight for about 15 min, until the uncovered areas do not darken further. Now fix, wash and dry your result. The image becomes much lighter during fixing, try to use plain hypo nonacid fixer. You can print this paper negative under glass in the same way as you contact print a film beneath the enlarger, but giving a much longer exposure. Develop and fix this print as normal. Note: today's paper is fibroloss and more even than in Talhot's day, so you should expect to print finer detail.

Early photography (1839-1850)

The news quickly spread that it was possible to record scenes by the direct action of light itself. Everybody wanted to see examples, or be recorded themselves – or even try taking such pictures. Both the Daguerre and Talbot processes had tremendous technical limitations by today's standards, but they seemed magical compared to the slow and skilled business of drawing or painting. People at once began to explore how this novel idea could best be used. Some saw it as an important means of recording, some as a means of artistic expression, others as a method of making money.

Impact of the discovery

The idea of using light waves for picture making was as revolutionary as using radio waves to transmit sounds, more than sixty years later. Newspapers could not reproduce the results, nor of course were they easy to describe in words to anyone who had never seen a photograph. One reporter explained it was 'like holding up a mirror in the street, seeing the minutest details of your surroundings reflected in it, then carrying the mirror indoors and finding these details permanently imprinted'.

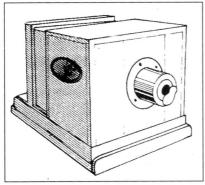

Fig. 2.1. Daguerre camera by Giroux, Paris.

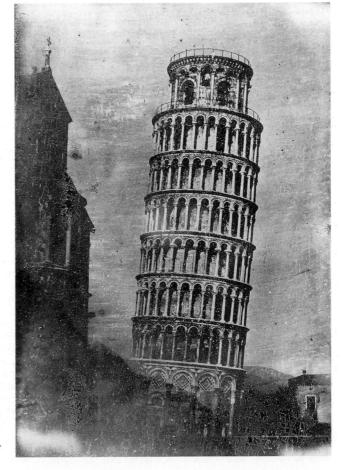

Fig. 2.2. Eight-inch high daguerreotype of Pisa, 1841. Written on the back is exposure time, 3.45–3.52 pm.

The description well fitted the shiny image of the daguerreotype – which was by far the most popular process. Most early pictures were about $13\times18~\mathrm{cm}~(5\times7~\mathrm{in})$, taken with a simple wooden camera, Fig. 2.1 (the word 'obscura' was generally dropped after the invention of photography). In 1839 photographers' subjects were landscapes, buildings and other still-life scenes which could be given exposures of 15 minutes or so.

Portraits were a special challenge. Iron rests were used to clamp the head, and subjects posed in brilliant sunlight until they almost melted. At first photographers even tried rubbing flour on people's faces! It was not until the American Wolcott camera, which used a curved mirror instead of a lens (Fig. 2.4), and soon the f3.5 Petzval lens Voigtlander camera from Germany became available that portraiture was really practical. These improved cameras gave

Figure 2.3. Daguerreotype announcement, Morning Post (London) 1839.

THE MORNING POST, FRIDAY, AUG. 23, 1839.

THE DAGUERREOTYPE.

It having been announced that the process employed by M. Daguerre, for fixing images of objects by the camera obscura, would be revealed on Monday at the sitting of the Academy of Sciences, every party of the space reserved for visitors was filled as early as one o'clock, although it was known that the description of the process would not take place until three. Upwards of two hundred persons who could not obtain admittance remained in the courtyards of the Palace of the Institute. The following is an analysis of the description given on this occasion by M. Arago:—

The influence of light upon colours was known long ago. It had been observed that substances exposed to its action were affected by it; but beyond this fact nothing was known until 1506, when a peculiar ore of silver was discovered, to which was given the name of argent corné, and which had the property of becoming black when exposed to the light. Photographic science remained at this point, until it was discovered that this argent corné (chloruret of silver) did not become black under all the rays of light. It was remarked that the red ray scarcely effected any change, whilst the violet ray was that which produced the greatest influence. M. J. Baptiste Porta then invented the camera obscura, and numerous efforts were made to fix the pretty miniature objects which were seen upon the table of it, and the transitory appearance of which was a subject of general regret. All these efforts were fruitless up to the time of the invention of M. Niepce, which preceded that of M. Daguerre, and led to the extraordinary result that the latter gentleman has obtained. M. Niepce, after a host of attempts, employed sheets of silver, which he covered with bitumen (bitume de Judée), dissolved in oil of lavender, the whole being covered with a varnish. On heating these sheets the oil disappeared, and there remained a whitish powder adhering to the sheet. This sheet, thus prepared, was placed in the camera obscura, but when withdrawn the objects were hardly visible upon it. M. Niepce then resorted to new means for rendering the objects more distinct. For this purpose he put his shoets when removed from the ca-mera obscura into a mixture of oil of lavender and oil of petroleum. How M. Niepce arrived at this discovery was not explained to us; it is sufficient to state that, after this operation, the objects became as visible as those of ordinary engravings, and it only remained to wash the sheet with distilled water to make the drawings permanent. But as the bitume de Judée is rather ash-coloured than white, shadows by more deeply blackening the lines (hachures). For this purpose he employed a new mixture of sul-phuret of po assium and iodine. But he (M. Niepce) did not succeed as he expected to do, for the iodine spread itself over the whole surface, and rendered the objects more confused. The great inconvenience, however, of the process was the little sensitiveness of the coating (enduit), for it sometimes required three days for the light to produce sufficient effect. It will easily be conceived, therefore, that this means was not applicable to the camera obscura, upon which it is essential that the object

should be instantaneously fixed, since the relative positions of the sun and earth being changed, the objects formed by it were destroyed. M. Niepce was therefore without hope of doing more than multiplying engravings, in which the objects being stationary are not affected by the different relative positions of the sun. M. Daguerre was devoting himself to the same pursuit at M. Niepce when he associated himself with that gentleman, and brought to the discovery au important improvement. The coating employed by M. Niepce had been laid on by means of a tampon or dabber similar to the process used in printing, and consequently the coating was neither of a regular thickness nor perfectly white. M. Da-guerre conceived the idea of using the residuum which is ob-tained from lavender, by distilling it; and, to render it liquid and applicable with more regularity, he dissolved it in other. Thus a more uniform and whiter covering was obtained, but the object, notwithstanding, was not visible at ouce-it was necessary to place it over a vase containing some kind of essential oil, and then the objects stood forth. This was not all M. Daguerre aimed at. The tiots were not deep enough, and this composition was not more sensitive than that of M. Niepce. Three days were still necessary to obtain designs. come to the great discovery in the process for which M. Daguerre has received a national reward. It is to the following effect :- A copper sheet, plated with silver, well cleaned with diluted nitric acid, is exposed to the vapour of jodine, which forms the first coating, which is very thin, as it does not excred the millionth part of a metre in thickness. There are certain indispensable precautions necessary to render this costing uniform, the chief of which is the using of a rim of metal round the sheet. The sheet, thus prepared, is placed in the camera obscura, where it is allowed to remain from eight to ten minutes. It is then taken out, but the most experienced eye can detect no trace of the drawing. The sheet is now exposed to the vapour of mercur, and when it has been heated to a temperature of 60 degrees of Resumur, or 167 Fahrenheit, the drawings come forth as if by enchantment. One singular and hitherto inexplicable fact in this process is, that the sheet, when exposed to the action of the vapour must be inclined, for if it were placed in a direct position over the vapour the results would be far less satisfactory. The angle used is 48 degrees. The last part of the process is to place the sheet in the hyposulphate of soda, and then to wash it in a large quantity of distilled water. The description of the process appeared to excite great interest in the auditory, amongst whom we observed many distinguished persons connected with science and the fine arts.

Unfortunately the locality was not judged suitable for the performance of M. Daguerre's experiments, but we understand that arrangements will be made for a public exhibition of them. Three highly curious drawings obtained in this manner were exhibited; one of the Pant Marie; another of M. Daguerre's atellier; and a third of a room containing some rich carpeting, all the minutest threads of which were represented with the most mathematical accuracy, and with wonderful richness of effect.

much brighter images but pictures had to be kept relatively small – about 5×6 cm – because lenses had such poor covering power.

For years cameras were either large with small aperture lenses 'for landscapes', or smaller but with wider aperture lenses 'for portraits'. Even with the best lenses exposures were still incredibly long. The Voigtlander camera instructions suggested 'For overcast dark skies in winter $3\frac{1}{2}$ minutes is sufficient; on a sunny day in the shade $1\frac{1}{2}-2$ mins are enough; and in direct sunlight it requires no more than 40-45 secs . . .'

By 1841 daguerreotyping was demonstrated daily in London at the establishment of Mr Richard Beard who was in business at the Polytechnic Institution in Regent Street, using the Wolcott camera. Similarly Mr Claudet used one of Daguerre's cameras at the Adelaide Gallery. These halls were rival permanent exhibitions of popular science, similar to the Science Museum today. In America Samuel Morse taught daguerreotyping on the roof of the University of the City of New York. An Irish reporter on a New York paper described it 'like fairy work'. Shops in most large cities sold camera equipment, sensitizing chemicals and silvered copper plates.

The popularity of the process varied from country to country according to the patents involved. In France and America anyone was allowed to make daguerreotypes, but in England a patent had been granted to Daguerre's invention, so that everyone taking pictures for money must purchase an annual licence. Talbot had patented all uses of the calotype process in France, America and England (but not Scotland). There is no doubt that this, plus its poorer rendering of fine detail, made it very little used.

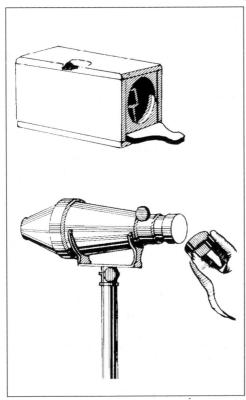

Figure 2.4. Daguerrotypists' portrait cameras. Wolcott mirror camera 1840 (gave right way round images). Above: 1841 Voigtlander camera.

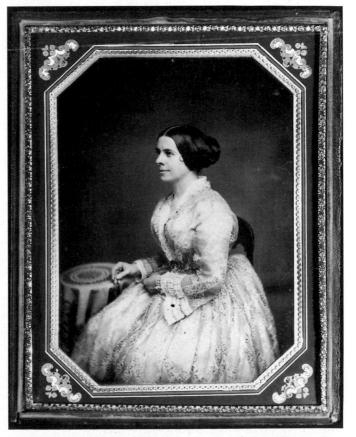

Figure 2.5. Popular daguerreotype portraits were about this size, in pinchbeck frames (mid–1840s).

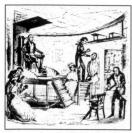

Fig. 2.6. Like many daguerreotype studios, Beard's camera room was located on the roof. Notice the sitter's head clamp, the Wolcott cameras and (foreground) an assistant polishing a silvered plate for sensitizing in the darkroom behind him.

In America and France daguerreotypes dominated completely. Only in Scotland, and at Talbot's own establishment in England, were calotypes to be made in any quantity.

The 'daguerrean parlour'

Within five years of the announcement of the daguerreotype process in Paris, portrait studios were set up in principal cities in most European countries, and in America. Often they were known as 'Daguerrean Galleries' or 'Parlors'.

Being daguerreotyped was really quite an ordeal. You would first be advised what clothing it was best to come in, for the process was only sensitive to blue or white light, other colours mostly appearing black. Ladies had to avoid red or dark green satin; for men a dark grey suit was a better choice than black.

At the appointed hour, and subject to the weather (picture taking was cancelled in overcast conditions), you would climb several flights of stairs from the reception area to the camera room, Fig. 2.6. This was a glasshouse,

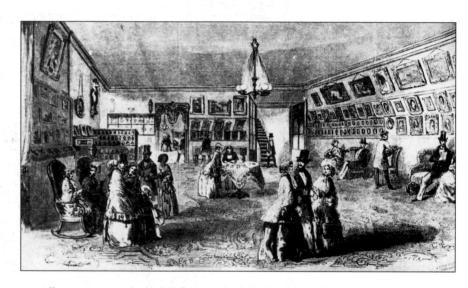

Fig. 2.7. This 1848 engraving shows the reception and waiting area of a 'Daguerrean Gallery' in New York. Daguerreotypes hang alongside paintings. Stairs lead up to the rooftop camera room.

usually constructed on the flat roof of the building. Here you had to sit in an upright chair on a raised dais, with blue tinted glass above your head to reduce the sun's heat without affecting exposure time. The proprietor would adjust a metal clamp hidden behind your neck to hold your head still. Your forearms would rest on the arms of the chair, and you would be told to stare fixedly at the camera, blinking as little as possible, and not on any account to twitch.

The camera was then loaded with the sensitized metal plate by an assistant and the $^{1}/_{2}$ -1 min exposure begun. If you wanted two copies this procedure must take place twice (although sometimes two cameras were exposed, side by side). After a waiting period you would receive your daguerreotype, set in a little frame mounted in a velvet lined case (Fig. 2.5).

Almost all daguerreotypes were given a final treatment in gold chloride which slightly darkened the appearance of the silver plate and made the white image stand out more clearly. For an extra charge results could be hand coloured. Typically a professionally made daguerreotype cost £1–£2 in London, putting them out of reach of ordinary working people, who barely earned this in a month. Of course they were still cheaper than portraits hand painted in oils, and a degree of snobbery grew up – painted

Fig. 2.8. An elaborate trade card sent to likely customers by Richard Beard, the first daguerreotypist to open a studio in Britain, May 1841. Portraiture was the biggest money-spinner. Within a few years Beard had made a large fortune.

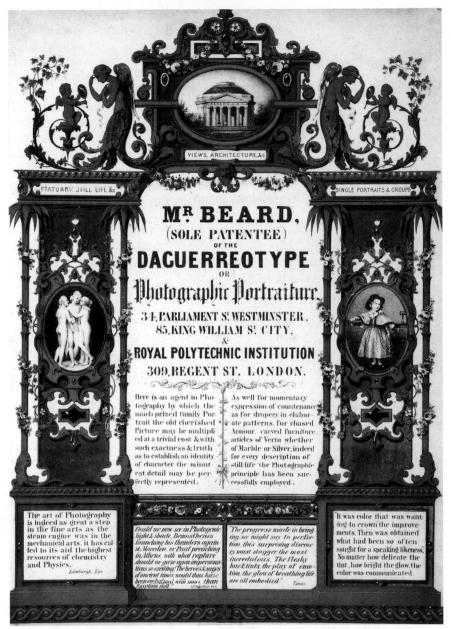

images being called 'portraits' and camera images merely 'likenesses'.

For the painters of miniatures, which had been so popular before the invention of photography (Fig. 2.15), the new process was a disaster. Most of their customers preferred daguerreotypes instead. Many miniature painters turned over to daguerreotyping, carefully calling themselves artist-photographers. Inevitably, there was friction between painters and photographers. The painters could see their skills being taken over by a machine, and they referred to photographers as technicians or tradesmen. Certainly some photographers deserved to be criticized as standards were often not that high. Such was the public demand that many daguerreotypists and their sitters were delighted with any kind of recognizable result.

To be fair the photographer was so preoccupied with chemical and technical matters, and the need to avoid discomfort of the sitter, he had little time to consider the style of his pictures. People were portrayed seated with arms rested and generally flooded with light, because these were all technically essential. Results were judged mostly on their sharpness and clarity. Generally the approach was very simple and straightforward, using a plain dark-toned background. In expensive studios efforts were made to flatter their sitters by including a painted backdrop, or the corner of a good quality writing table or some suitable drapery, vaguely in the style of classical painting.

Travelling exhibitions of the best daguerreotypes from France helped to set standards in other countries, but in general it was a seller's market. People fell over themselves to be daguerreotyped. Vast fortunes were made in these early years by the proprietors of studio chains.

Whereas portraits were subjects mostly for the professional daguerreotypist, amateurs such as artists and tourists turned to views. Pictures of moving water and the tops of trees disturbed by the wind blurred over during the long time exposures, and white clouds against blue skies always disappeared, but other details were excellent. Some publishers sent out daguerreotypists to record landscapes in distant countries. These were then used as references for engravings made to illustrate travel books.

negatives taken at Lacock Abbey, about 1840. The subject here is Talbot's gamekeeper seated with his gun across his lap.

Fig. 2.9. (below) One of

the many calotype paper

Fig. 2.10. (right) A calotype print from the negative. The lens in Talbot's early $8^{1/2} \times 6^{1/2}$ in camera gave poor sharpness and illumination at picture corners. Royal Photographic Society Collection.

Calotype photography

While the daguerreotype grew and grew in popularity, the rival calotype process was used by only a few enthusiasts. Talbot himself took many pictures, mostly still life, character studies, and groups in the gardens of his stately home, Lacock Abbey. Often they look like spontaneous snapshots (Fig. 2.10) but were carefully posed to allow the long time exposure his camera lenses and materials demanded.

Quite large cameras were best for calotypes. As described earlier, the process consisted of firstly producing a paper negative, which was then contact printed in turn by sunlight onto another sheet of paper to give a print. The

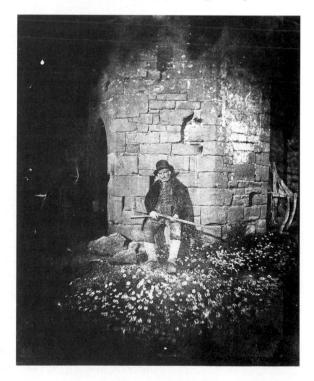

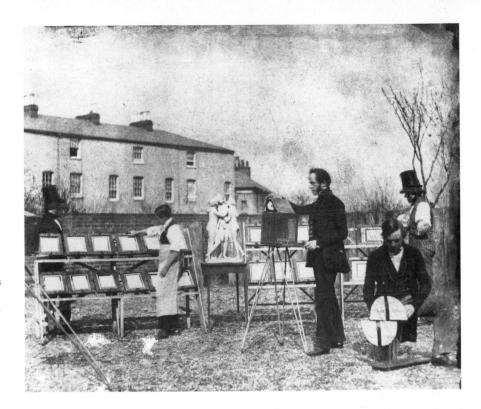

Fig. 2.11. Part of Talbot's works in the town of Reading, which he set up in 1844 to mass produce calotype prints. Assistants here are printing negatives by sunlight in glassfronted frames, and also photographing statuary.

larger the negative the less its pattern of paper fibres destroyed image detail in the final print. Talbot also found that by rubbing wax into the processed negative the paper was made more transparent. Despite this, the slightly diffused detail and mottled overall pattern found in calotype prints was one of the main reasons people preferred daguerreotypes.

Other technical advantages and disadvantages between the two processes are shown on Table 2.1. The most valuable feature of the calotype – namely that having recorded one image in the camera almost unlimited numbers of prints could be run off cheaply – was rather overlooked. Daguerrean galleries could offer a while-you-wait service, and the image detail was unsurpassed. Talbot therefore had great difficulty persuading people to buy licences to use his process.

No photographer in the early 1840s could have foreseen that Talbot's negative/positive process was the real road to the future of photography. The daguerreotype was to lead to nowhere, having practically reached the limit of improvements.

Talbot was a resourceful and intelligent man. He decided he would publicize the main advantage of his process by making and selling large numbers of excellent quality prints. So in 1844 he rented premises in the town of Reading and hired staff to mass produce calotype prints. Negatives were made of well-known buildings, landscapes, art objects such as statuettes, even copies of drawings and paintings. Long racks of printing frames were set out in the sun (Fig. 2.11). Thousands of prints were sold, mostly in stationers' shops, at 1–5 shillings (5–25p) each according to size.

The Pencil of Nature

Talbot's most important project at Reading was to produce a book of calotypes – the first photographically illustrated book in the world. It was called *The Pencil of Nature* and the complete work contained 24 large

Table 2.1 The calotype – comparison with the daguerreotype

Calotype advantages

Unlimited numbers of relatively low cost prints could be made from each camera exposure.

The final picture was not reversed, left to right.

Negatives could be retouched to remove wrinkles, etc. in portraits.

The process was cheaper and easier to use by the traveller.

Pictures on paper were easier to view, and send through the post, mount in albums, etc.

Calotype photographs had warmer tones, and gave broad effects (rather than cold clinical detail), well suited to pictures having mood and atmosphere.

Calotype disadvantages

Photographing onto paper gave results with poorer image detail; pictures were also often uneven.

Calotype materials were less sensitive to light, requiring longer camera exposures.

It also took longer to produce results~the negative had to be processed and dried, then printed, and finally the print processed and dried.

There was a tendency for prints to fade.

The process and equipment was less widely available, and more restricted by patents.

pictures, all by Talbot. Prints were individually stuck onto the pages (Fig. 2.12). In the accompanying text Talbot described the steps leading to his discovery, and explained its virtues and applications. *The Pencil of Nature* was published and sold in six parts between 1844 and 1846. The few still in existence today are now very valuable collectors' items.

A similar work Sun Pictures in Scotland was published from Reading, and

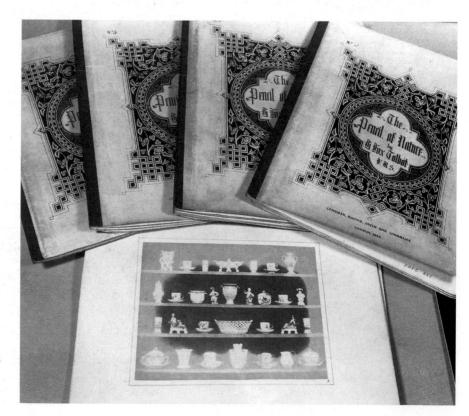

Fig. 2.12. 'The Pencil of Nature', published in six separately bound parts, was the world's first book with photographic illustrations. It contained 24 gummed-in calotypes like the one shown, which are now fading with age.

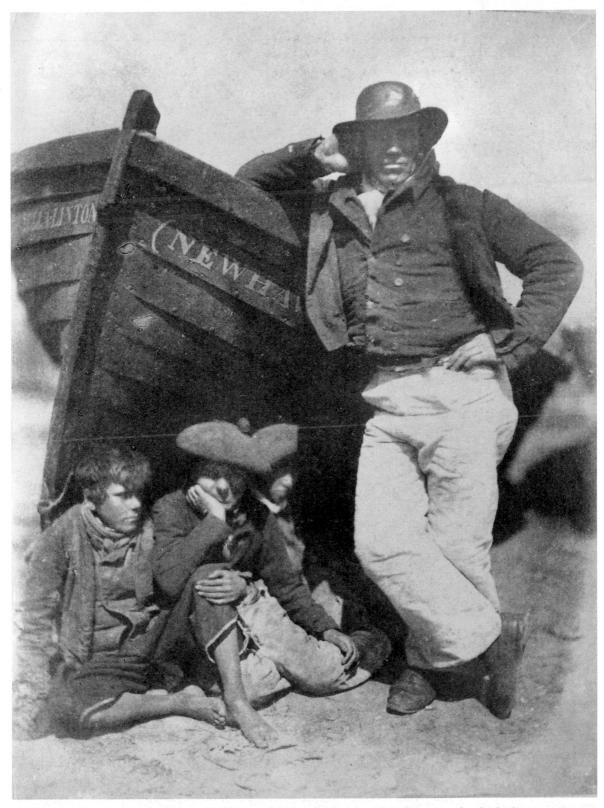

Fig. 2.13. 'Jas Linton, His Boat and His Bairns', an 1845 photograph using the calotype process, taken by the Scots partners David Octavius Hill and Robert Adamson. Hill did most of the subject arrangement while Adamson handled the technical side.

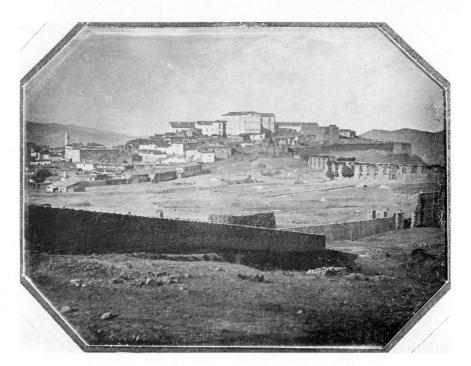

Fig. 2.14. Daguerreotype photographers took hundreds of scenic views of far-away places as references for engravings in travel books. This one shows Medea, Algeria about 1850. As usual, all details are reversed left to right.

Talbot also made an enormous run of 7000 prints which were included in an art magazine special issue. All this activity helped to bring calotypes to the attention of the art world at least. In one respect the publicity was embarrassing, for some of these mass-produced prints began to fade after a few months. Naturally, the defect was gleefully seized upon by artists as yet another defect of photography.

Hill and Adamson

The calotype process had its most important success in Scotland. Here Talbot managed, through friends, to encourage a young chemist Robert Adamson to set up as a professional calotypist. He was soon approached by the Scottish painter Octavius Hill, who had been commissioned to produce an enormous historical painting portraying nearly 500 recognizable people – the ministers who had just rebelled and set up the Free Church of Scotland. Photography was ideal for recording these people, in small groups outdoors, to provide work prints from which the huge mosaic of faces could be painted.

In fact Hill and Adamson became really enthusiastic about the new process. Working in collaboration they not only produced the first outstanding calotype portraits of local celebrities, but took pictures to please themselves of Scottish fishing villages and their inhabitants. Hill seems to have posed the subjects and adjusted the composition, while Adamson handled all the technical aspects. Between 1843 and 1847 this collaboration of science and art produced hundreds of pictures which showed the artistic potential of Talbot's invention. Hill's knowledge of painting helped him compose in a broad and simple way which suited the detail limitations of paper negatives – in fact turned them to his advantage. David Hill is therefore recognized as one of the first artist photographers.

Sadly Robert Adamson died in 1848 aged 27, whereupon Hill effectively gave up photography and devoted his time to painting. It is ironic that

Hill's paintings are now mostly forgotten, whereas Hill/Adamson calotype prints are still admired and respected.

Use and influence of early photography

Although the daguerreotype and calotype remained in some competition throughout the 1840s, only the daguerreotype process was well known to the public. People had their portraits taken to give to their loved ones; the results were considered cheaper, more accurate and more modern than miniature paintings. Of course, the process tended to record faces 'warts and all' (daguerreotypes could not really be retouched) but this was accepted along with the left-to-right reversed image unless a Wolcott camera was used. After all, most people only ever saw themselves reflected in a mirror.

This too was the time of the industrial revolution. The new invention of railways had been sweeping aside the stagecoach, providing transport at half the cost and twice the speed. Everyone became fascinated by travel and accurate records of far away places were extremely popular. Here daguerreotypes were at a disadvantage – you had to hold them up to a mirror to correct the rendering of buildings, landscapes, etc. Calotypes were therefore a better alternative, and began to be taken by a few keen amateurs and professionals in Britain and France.

Both processes quickly became useful as sources of pictures which, like sketches, could be hand copied into steel engravings or woodcuts and so

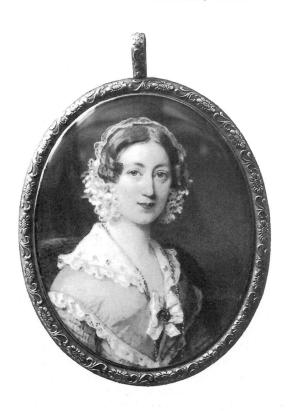

Fig. 2.16. Daguerreotype portraits, finished off in little gilt-framed cases, were in direct competition with painted miniatures. (Both pictures here are about actual size). Photography was cheaper, more accurate and much more modern.

printed in books, newspapers, etc. Although the final results still looked like drawings, photography was already affecting the methods of communication. A few government departments and hospitals began to use daguerreotypes as a means of recording. Photographic likenesses formed splendid factual references for painters, and began influencing the appearance of their portrait work – the posing of chin on hand, or arm on chair for example. At this time all cameras had to be used on stands and tripods – there was no question of taking action pictures, in fact it was to be 30 years before such things were possible.

Photographers could only measure their creative efforts (when they had time to consider them at all) against paintings of the period. After ten years of existence photography was a fine mechanical way of recording accurate information, but clearly painting was not yet dead. In fact painters already sniggered at photographers' efforts to use the new medium artistically, while

quietly using it themselves as a labour-saving device.

People were mostly put off photography as a hobby by its expense and difficulty – particularly the daguerreotype process, which required laboriously prepared metal plates. It was a skilled business which only a real enthusiast with some knowledge of practical chemistry would ever take up.

By 1850 the mere ability to be able to record images was becoming less of a novelty. Would-be photographers were frustrated by the limitations of the processes, and people everywhere were experimenting to discover something better. The answer was to arrive in 1851, with a system which totally eclipsed both Daguerre's and Talbot's processes.

Summary ~ early photography

 Daguerrean galleries offering a portrait service soon appeared in most cities. They were set up in glasshouses alongside or on the roofs of buildings. The daguerreotype process was patented in England; and the calotype in England, France and America.

Being daguerreotyped became very fashionable, despite the discomfort, glare and heat. Some of the first proprietors made large

fortunes. Miniature painting declined.

 The trouble with calotypes was their loss of fine detail, slower (negative/positive) processing and poorer sensitivity to light. To promote his process and demonstrate its multiprint advantages Talbot set up a calotype printing works and published *The Pencil of Nature*.

 In Scotland the calotype process was adopted by David Hill and Robert Adamson, an artist and a chemist working in collaboration to

produce hundreds of fine portraits.

 Throughout the 1840s photographers worked under extreme technical difficulties, due to the long time exposures needed for every subject. Both processes were too complicated and too expensive for more than a few people to enjoy as a hobby.

Projects

P2.1 Try taking photographs on paper negatives. Cut a piece of glossy single-weight bromide paper to fit within the film guides at the back of your camera. Set the meter to ISO 32, then give about 15 times the exposure time indicated. Process in print developer at half normal strength. When fixed, washed and dry, contact print this paper negative onto another sheet of the same paper, unfiltered. Expect to give a long exposure time

2.2 Check with your local museum, all gallery or library to see If they possess any daguerreotypes. (Note: make sure they are not the far more common ambrotypes, see page 30). Examine their fine detail and shiny difficult-to-view appearance. Using books find reproductions of painted portraits and landscapes of

approximately the same date.

The 'wet' plate era (1851-1870)

Photography underwent an important change in the early 1850s. A new process called collodion or 'wet plate' was, in various forms, to sweep the world. The manipulations required were, if anything, worse than the daguerreotype or calotype. However, it offered very important advantages. Through the collodion process far more people were brought into contact with photography, and photographs were used for many more purposes. For a long period – almost a whole generation – wet collodion remained the only practical process.

The search for a binder

Ideally, photographers wanted a process which offered the image clarity and detail given by the daguerreotype, *plus* the ability to cheaply run off prints on paper like the calotype. A better form of negative was needed – on a clear transparent base instead of paper. Film as it is known today did not exist. The obvious choice was to use a sheet of clear glass, but whereas the light-sensitive chemicals could be absorbed into paper they were much more difficult to stick to a smooth glass surface.

Sir John Herschel had experimented along these lines back in 1839, using a sheet of glass at the bottom of a dish of silver chloride solution and allowing the chemical to gradually settle onto its surface. This was slow and impractical, and when you were processing the solutions quite easily caused the coating to float off again. Some sort of 'binder' was essential.

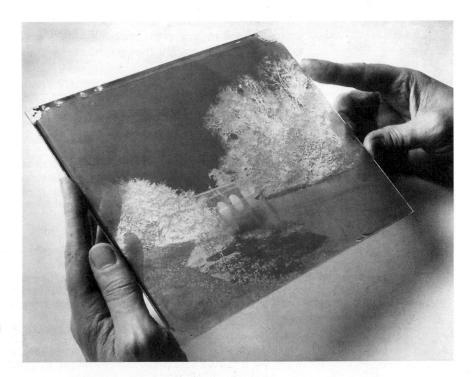

Fig. 3.1. An early 12×10 inch collodion negative. The new process gave excellent quality negatives on glass sheets. These printed without the usual mottle and image diffusion of paper negatives.

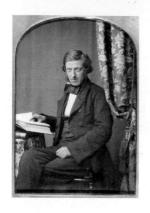

Fig. 3.2. Frederick Scott Archer, sculptor and photographer, who invented the revolutionary collodion or 'wet plate' process in 1851.

Albumen was more successful for printing paper, which did not have to be nearly so responsive to light. Albumenized paper gave a good quality image, less prone to fading than Talbot's salted paper, and with an attractive glossy surface. You could also contact print onto albumen-coated glass to form a lantern slide. This could be projected using a 'magic lantern', a device long used for showing images painted on glass, and now to become really popular thanks to photography.

Collodion

1851 was an important year for Britain, then at the height of her achievements in the industrial revolution. The Great Exhibition was staged in London showing progress in science, arts and manufacturing. Articles were published, papers read to meetings, information exchanged. Out of this melting pot of ideas came news of experimental work by an obscure London sculptor, Frederick Scott Archer. Like so many others he had been trying to improve detail in his photography by using glass plates. But Archer had discovered that a sticky liquid called *collodion* formed a good binder. Collodion is nitrated cotton (gun cotton) dissolved in ether and alcohol. It had been used a few years earlier for dressing wounds – painted over an open cut it dries to form a hard, clear protective membrane. (You can still buy this paint-on sealer at chemists today).

Archer's method, shown in Table 3.1 was to pour a mixture of collodion and chemical over a sheet of glass, then sensitize this and expose it in the camera while still damp (the plate would not work after the collodion dried hard). The image was immediately developed, fixed and washed. This odd requirement meant that collodion negative making quickly became

Table 3.1 Wet plate photography process

Negative

- A sticky solution of collodion in which potassium iodide had been dissolved is flowed over the surface of a cleaned and polished sheet of glass. It is a skilled job to form a smooth even coating particularly over large plates.
- 2 Under red lighting the still-tacky plate is soaked for several minutes in silver nitrate solution. Then it is drained and placed immediately in a light-proof holder to take to the camera.
- 3 Exposure in the camera, typically between 30 sec to 2 min at f11.
- 4 Back in the darkroom a developing solution of pyrogallic acid is immediately poured over the plate. You wait until the image looks fully developed, then rinse it in water.
- 5 The negative is fixed in hyposulphite of soda, washed, dried (over a gentle flame) and finally varnished.

Print

- 6 In the darkroom a sheet of paper coated with albumen and common salt (as sold to the trade) is floated coated side downwards in a tray of silver nitrate sensitizing solution. It is then allowed to dry and used as soon as possible.
- 7 The paper is pressed behind the negative in a printing frame and left in sunlight until a strong purple black Image has formed
- 8 The exposed print is rinsed, usually toned in gold chloride to turn its image dark brown, fixed in hypo, washed and dried.

known as the 'wet plate' process.

The new process had four main advantages:

- 1. Negatives gave great clarity of detail. Look at Figs 3.1 and 3.5. You could make unlimited numbers of permanent prints (e.g. on albumen paper) revealing outstandingly sharp subject information. This made them very attractive to buy and sell.
- 2. It was cheap. People could buy about 12 paper prints for the same price as one daguerreotype.
- 3. Archer never patented his idea, so anyone could practise collodion photography without fee.
- 4. It was more sensitive to light than the calotype or alhumen-on-glass processes.

Collodion also shared all the advantages of neg/pos photography over the daguerreotype, discussed on page 16. Understandably, it became a main photographic process almost at once in England, and within a few years in Europe and America too. (Americans preferred the ambrotype form of collodion photography, page 30.)

Thousands more people, artists, scientists, travellers, now looked at photography seriously. It was practically re-born: the first negative/positive system able to give a really satisfactory image. Most people compared these new paper pictures with the detailed but unreproducible daguerreotype. Within five years hardly anyone made daguerreotypes or calotypes any more.

Wet-plate negatives in practice

Despite the excellence of results, no-one would claim that the collodion process was easy to use. Working at home or in a professional studio, it was a skilful job to flow the thick sticky collodion evenly over the entire glass surface. Then the plate had to be sensitized, exposed and processed (see Table 3.1) – all within the 10–20 minutes collodion took to dry.

This procedure was difficult when your darkroom was just next door to your studio, or wherever the subject was set up. Photography of country landscapes or foreign lands would seem impossibly difficult. And yet the prospect of bringing back detailed, reproducible records of places no-one had photographed before was such a lure that most technical problems were somehow overcome.

People took out with them complete darkroom tents (Fig. 3.4) and as from about 1853 a darkroom unit was made which folded out of a kind of suitcase, supported at a convenient height on a tripod (Fig. 3.3). The wet-plate photographer first used the darkroom device for preparing the plate, then carried it in a light-tight holder to the camera, exposed it to the image and returned to develop, fix and wash the result. Pictures were often taken near lakes or streams, for unless you were prepared to carry your own water barrel some handy local supply was essential to process and wash each plate.

When you see a collodion photograph, like Fig. 3.5, just consider the darkroom and camera which had to be set up, water fetched and chemicals mixed. Remember too that enlarging was not yet possible – the only way to get a large print was by using a large heavy camera. Most of the time the photographer's upper half would be hidden under some form of cloth, so it was not surprising village children sometimes jeered and threw stones.

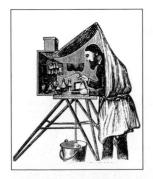

Fig. 3.3. This portable darkroom folded out of a large box. You filled the top tank from any handy water supply.

Despite problems of this kind the collodion negative was considered so versatile, so sensitive to light and of such excellent quality, that a whole range of applications of photography was opened up. Some of these are shown in the photographs on pages 26–30, all taken during the 1850s.

Record photographs of new engineering or building constructions, (or old buildings before demolition) could now be made and filed for reference. This sort of information previously needed laborious sketches and thousands of words to describe. Philip Delamotte for example took regular progress pictures of the rebuilding of the Crystal Palace at Sydenham, London from 1851 to 1854 for the directors of the project. As well as acting as records, many of his photographs are well composed pictures in their own right (Fig. 3.6).

Roger Fenton, already well known as a landscape photographer, was sent from London to take *documentary pictures* of the Crimean War. Action pictures were technically impossible so most of his photographs are still-life views of supplies (Fig. 3.8), also the front line before and after battles, and carefully posed groups of officers in camp. Fenton's pictures were later exhibited and sold in album sets by the print publisher who financed his trip.

Another photographer prepared to work under appalling conditions was Francis Frith. Frith was one of the earliest *travel photographers* to use the collodion process. Between 1856 and 1860 he made no less than three trips up the Nile, and took hundreds of views of Egypt (Fig. 3.7), Syria, and the Holy Lands. Imagine the problems of working in the presence of sand and flies, at temperatures which made the collodion almost dry as it was coated!

Scenic views by Frith and others were bulk printed in thousands on albumen paper – their production became a minor industry in England and France. So many printing frames would be laid out on racks to face the sun that print establishments looked like greenhouses. Assistants walked up and down the rows checking progress as prints darkened, changing paper, washing and toning results. Finished albumen prints were mostly sold direct in print shops, or pasted into travel books.

The first major exhibition of photography was held in London in late

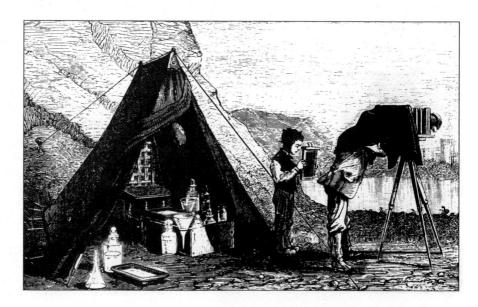

Fig. 3.4. Collodion was awkward because plates had to be coated, exposed and processed all within minutes. Away from the studio photographers needed a darkroom tent and chest of chemicals.

1852, and the following year the Photographic Society of London (now the Royal Photographic Society) came into being. Roger Fenton was its first secretary. Other societies formed in several big cities. One of their most important functions was the organization of exhibitions. These gave free publicity to the professional, allowed amateurs to vie with each other, and the public and press to comment on the current state of the new art.

Perhaps because of the remarks of art critics assigned to the new medium, or a general feeling that the most acceptable approach to 'artistic' photography would be to ape popular painting of the period, many serious photographers chose lofty, sentimental or historical themes for their exhibition prints. Having decided a title such as 'Tis Dark Without, Tis Light Within' they would construct the whole picture.

British 'High Art' photographers of the 1850s such as Oscar Rejlander (Fig. 7.2) became expert at stage managing everything the camera saw. Painters of course often pose models to sketch and interpret in compositions, but the use of the detail-revealing camera to make fake photographs often gave unintentionally ridiculous results. This approach is discussed in Chapter 7.

Another way of working made possible by collodion negatives was combination printing. This meant planning and photographing the various parts of a composition – figures or groups of figures, background,

Fig. 3.5. An 1850s English landscape taken on a collodion negative contact printed on albumen paper. Details are not quite as good as a daguerreotype but the process was cheaper and allowed prints.

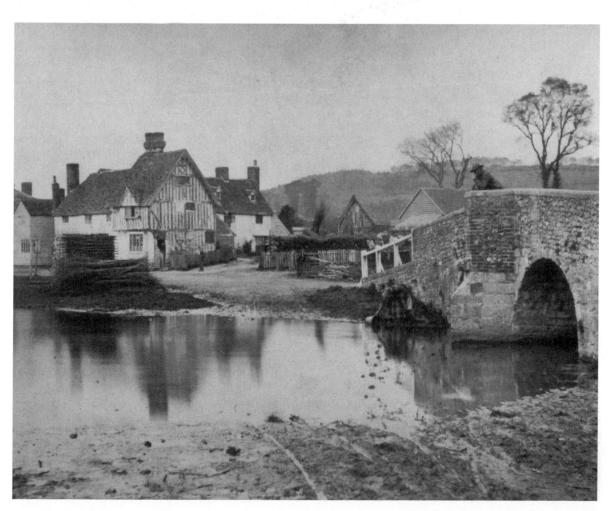

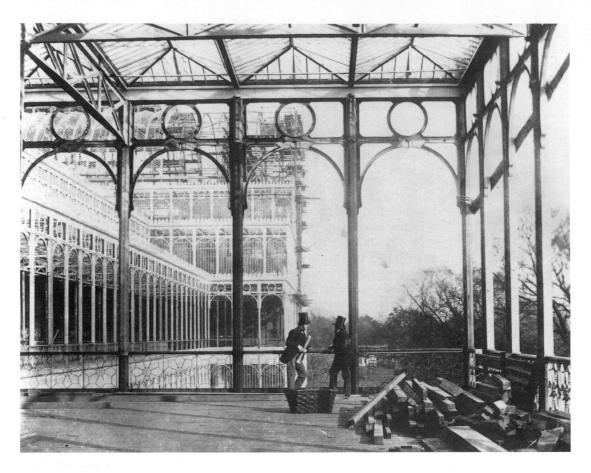

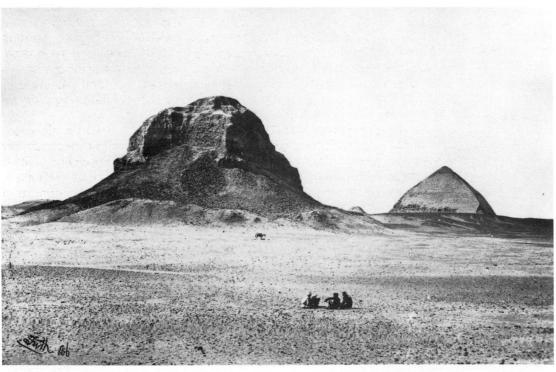

Fig. 3.6. (left) An early 1853 collodion record photograph by Philip Delamotte. It was one of a series showing reconstruction of the Crystal Palace in South London after removal from Hyde Park.

Fig. 3.8. (right) Roger Fenton used collodion to document the Crimean War. Action shots were impossible but pictures like this Balaclava harbour scene in 1855 at least proved that supplies were reaching the troops.

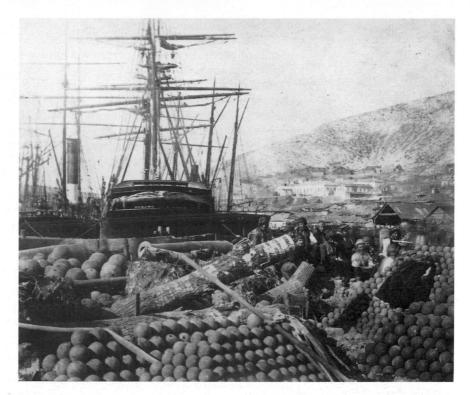

foreground objects, etc. – on separate negatives. They were then all combined onto one final print. The idea stemmed from the problem of recording skies in landscapes. Collodion plates were much more sensitive to blue than green, so by the time you had exposed correctly for grass and trees, the sky and clouds appeared burnt out white. Photographers therefore often took two negatives, one a short exposure to record sky detail, the other longer for ground detail. These were contact printed one at a time onto the same sheet of paper, carefully shading the printing frame so that only the wanted area was exposed to light in each case. You could even use the technique to avoid bad expressions or move figures in a group of people, taking several negatives and then picking and combining the best heads from each. (Today this is done using a digital computer.)

Rejlander patiently used combination printing to build up elaborate compositions such as 'Two Ways of Life', page 109. His fellow member of the Photographic Society and rival exhibitor H. P. Robinson constructed pictures from various negatives in the same way (as well as by making separate prints which he cut out, pasted onto a background print, and re-photographed). Fig 3.10 shows the composition 'Fading Away' which was put together in this way. The final work appeared on a mount carrying tasteful verse by Shelley and when exhibited in 1858 it received great admiration. 'High Art' photographs were bought regularly by important people including Queen Victoria and Prince Albert.

The early collodion period also brought a slightly freer approach to portraiture. This was probably due to the talents of some of the people now attracted to photography as much as any technical improvements. Look at the work of Nadar (real name Felix Toumachon). He opened a portrait studio in Paris in 1853 and during the next twenty years became

Fig. 3.7. (left) Francis Frith, the travel photographer, took this collodion view of the pyramids of Dahshoor during a Nile trip in 1856. Frith's albumen prints of distant places sold in thousands.

the best-known photographer in France. Most of the important writers, artists, and actors of this period sat for Nadar's camera. He had a gift for understanding and being in sympathy with his subject – despite the need for time exposures his portraits manage to show personalities rather than the usual cardboard likenesses (Figs. 3.12 and 3.13).

Nadar was an adventurous man: he was the first to take photographs from the air (sensitizing his collodion plates in a balloon basket) and underground in the catacombs of Paris (using primitive battery-powered electric lamps). But Nadar and other photographers producing high quality work were soon concerned about the way the patent-free collodion process

PHOTOGRAPHY.

On Wednesday week a soirée was given by the Society of Arts, at which the leading photographers were present, and recent specimens of photography shown; it being the first public exhibition of these pictures in this country. The time allowed between the adoption of the suggestion and the completion of the design was exceedingly short; yet there has been gathered together a numerous collection, possessing many examples of the capabilities of photography, and exhibiting at the same time its more prominent defects. It should be remarked that the exhibition has been confined to productions on paper and on glass, to the entire exclusion of Daguerréotypes. We are not satisfied that this is judicious; for, notwithstanding the numerous advantages arising from the use of paper, there are points of excellence in well-executed pictures upon the metallic tablets, which have not been, as yet, approached upon paper, and of which those who practise the Talbotype should be constantly reminded.

It appears that the large majority of the exhibitors have forgotten one point, and that is one, too, upon which entirely perfection in photography depends. A stranger to the art, looking around the room, will not fail to remark that the high lights and the shadows are often placed in the most striking and even disagreeable contrast. When the sun is shining upon the ornamented front of a palace or a temple, the details of all those portions which are shaded by the deep shadow of projections are still sufficiently illuminated by the diffused light of the sky to be seen with their minutest details. Such a subject, copied by the photographic processes employed, is usually a compound of "high" white lights and deep obscure shadows; whereas a little careful attention to the existing conditions would have prevented this. The usual practice has been to remove the primary picture from the cameraobscura as soon as it was thought the sunlit portion of the subject had made its chemical impression, and at a period far too short for those parts in shadow to effect a chemical change. It would, however, be found in practice that a prolonged exposure to the radiations from those points the most highly illuminated, which might equal the extra time required for the dimly-lighted parts to paint themselves, would not so far increase the opacity of those parts of the negative image as to render them whiter than we now find them in the positive copy; while the details in shadow might be brought out in perfection.

"Though the excellence of the specimens now exhibited," says Mr. Fenton, "might allow photographers the indulgence of a little self-complacency, still everybody feels that, as an art, it is yet in its infancy, and that the uses to which it may be applied will yet be multiplied tenfold." We feel conscious of this; and when we examine pictures produced by the chemical agency of the sunbeam, giving us every external detail with mathematical exactitude, and adding thereto the charms of "airy distance" with the harmonious gradation of light and shadow—of such there are many examples in the exhibition—we foresee that the art must become one of the utmost utility.

Fig. 3.9. Part of The Illustrated London News review of London's first major photographic exhibition (1852).

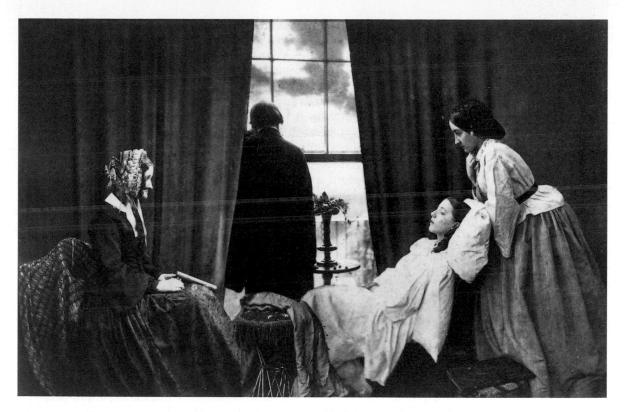

Fig. 3.10. 'Fading Away' by H. Peach Robinson, 1858, was a smash hit at photography exhibitions. The dying girl and grieving family gave a strong narrative theme, like characters in Victorian novels of the period.

Fig. 3.11. Robinson's artistic photographs were planned and made up from several negatives. Figures or groups of figures were photographed separately in the studio, then prints cut out and pasted on a background print, retouched and copied.

was being used in cheap studios to turn out second-rate portraiture. People could pick up the basic techniques of taking photographs without possessing any interest or feeling for pictures. Nadar's concern was to prove well founded.

Ambrotype and tintype versions

Whereas collodion was at first intended as a negative/positive process, Scott-Archer also discovered how the glass plate exposed in the camera could itself show a positive image. You may have noticed with modern film how a very underexposed (weak) negative viewed against a dark background takes on a positive appearance. Fig. 3.14 shows how under these conditions the dark silver image can reflect some light, whereas the clear areas look black. In the same way an underexposed collodion negative could be backed up with black velvet in a little case to form a direct positive picture. (For best results the processed plate was bathed in chemical which gave the black silver a greyish-white appearance.)

This form of result was known as an 'Ambrotype' after the Greek word signifying 'imperishable'. Table 3.2 summarizes its good and bad points. Ambrotypes were rarely used for subjects other than portraits. In America between 1855 and 1857 more portraits were taken by ambrotype than any other process. This is largely because they looked similar to the very popular daguerreotype – in fact they were often wrongly called 'daguerreotypes on glass'.

The advent of the ambrotype meant that people unable to afford daguerreotypes could now have portraits which looked almost as good. In fact, to cut costs further and give a less breakable result which could be

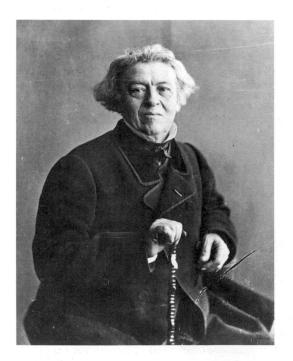

Fig. 3.12. The painter Camille Coot, photographed by his friend Felix Nadar in Paris 1858. Despite the need for time exposures, Nadar's portraits captured the character and personality of his sitters.

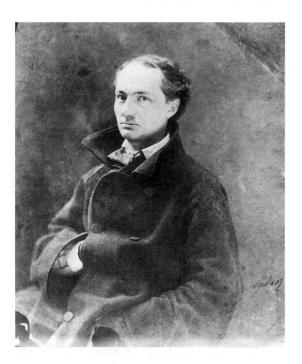

Fig. 3.13. Nadar was an ex-painter and writer who collodion photographed many leuding figures in Paris in the 50s and 60s. This striking and direct portrait is of writer Baudelaire, 1856.

Fig. 3.14. How ambrotypes work. A very underexposed black-and-white negative appears as a positive if you view it dull side upward against a black background

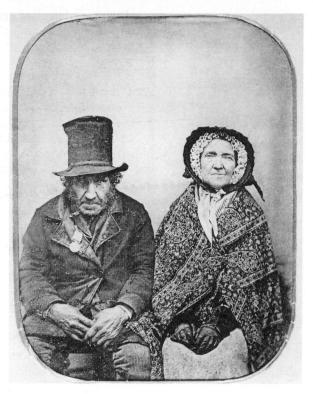

Fig. 3.15. Typical low cost ambrotype portraits were about this size, roughly similar to a daguerreotype at one tenth its cost. There is no painted backdrop, props, or much attempt at arrangement.

Fig. 3.16. A typical low cost ambrotype portrait of the late 1850s. The left half has had its black velvet backing removed, showing that it is really an underexposed glass negative.

mounted in an album, American photographer Hamilton Smith patented a version using black-painted metal instead of glass. These became known as 'tintypes' (or 'ferrotypes') (Fig. 3.19). Thousands and thousands of tintypes were produced, particularly in cheap portrait studios and by street photographers, from 1856 until well into the twentieth century. Tintypes, ambrotypes, and daguerreotypes were all frequently coloured by hand.

The American tintype did not reach Britain and Europe generally until the late 1860s, where it became a 'While-U-Wait' camera gimmick used by street and beach photographers. In fact the most important aspect of ambrotype and tintype collodion photographs was that they were both very cheap forms of portraiture. 'Studios' offering sixpenny (2½) and shilling (5p) likenesses sprung up everywhere. This meant that portraiture had at last reached the working man's family, but every tradesman and every charlatan who could get together camera equipment and a few chemicals now offered to take your picture. The average standard was appalling – 'cheapjack likenesses' became a music hall joke. In the poorer areas of towns customers were fobbed off with blackened, blurred and unrecognizable results which they were assured would 'improve after exposure to air'. Ordinary people were overawed by the process. There were tales of friends 'who never had a day's health after being photographed'.

The stereoscopic photograph

The collodion process also hastened the growth of a 19th century equivalent to television, the family stereoscope. By using a double camera

Fig. 3.17. Although this 1860 picture was probably staged as a joke, it shows the cheapjack kind of ambrotype studio set up among the chimney pots.

with lenses about 65 mm (2.5 in) apart two pictures could be exposed side-by-side on a collodion plate, giving the equivalents of left and right eye views of a scene. Prints made from these negatives were set up in a viewer so your left eye only saw the left-hand camera's photograph and the right eye only saw the right-hand image. When this was properly adjusted your eyes fused the pictures into a three-dimensional image – foreground objects 'standing out' and things in the background seeming to be spaced much further back.

Collodion stereo negatives therefore allowed the making of unlimited quantities of stereo prints on albumen-coated paper or glass. Their quality and detail could be excellent (Fig. 3.22). As from about 1855 shops everywhere sold a wide range of cheap stereo pictures. They included travel views taken all over the world, portraits of famous personalities, events of the day, even story-telling sequences. 'No home complete without a stereoscope' ran the advertisement for the London Stereoscope Co., which

Table 3.2 The ambrotype – comparison with collodion negatives printed onto paper

appeared correct left-to-right, unlike a daguerreotype.

Ambrotype advantages	Ambrotype disadvantages
Results could be produced more quickly. No printing stage required.	You could not make paper prints off ambrotypes. Each picture was unique.
They cost less in materials and time. Less exposure was needed. They resembled daguerreotypes, which had been popular for years although much more expensive.	Results had a poorer tonal range than a paper print or daguerreotype; in particular the image had little detail in dark parts of the picture.
They were easier to view (less reflective) than daguerreotypes.	
By mounting the plate with its collodion surface towards the black backing material the picture	

Fig. 3.18. An 1857 advertisement for a humble but respectable studio, warning people against charlatans.

LIKENESSES.

Have no more bad Portraits!

CAUTION !!!

All Persons are respectfully cautioned against the many Spurious Imitators of the Art of Photography, who not possessing the requisite knowledge of Chemicals,

CANNOT ENSURE

A Correct & Lasting Portrait!!

The consequence is, that thousands are dissatisfied with the Portraits, although they have paid High Prices for them.

This evil can be entirely avoided by coming to

MR. & MRS. C. TIMMS,

PRACTICAL PHOTOGRAPHIC ARTISTS,

41, Newington Causeway.

Who are always at home to take portraits; the certainty of your being pleased is, you are requested not to pay until you are quite satisfied.

C. TIMMS offers advantages at his Establishment that are not to be had at any other in London, and without ostentation assures the Public that HIS FORTRAITS ARE SURPASSED BY NONE, and the Prices bespeak his determination to give complete satisfaction.—Many years experience has proved to him that a tradesman's success is commensurate with his honesty, he is therefore more desirous of gaining the gradually increasing confidence of the Public, than to excite a temporary influx of Customers at the expense of Truth. All Portraits are taken on the Ground Floor, so that the aged are not necessitated to ascend flights of Stairs.

It is particularly necessary to observe the Name over the Door.

C. Timms, 41, Newington Causeway.

An immense Stock of Gold and Bird's-eye Maple Frames to select from, also Best Silk Velvet, Fancy Morocco Cases, Lockets and Brooches made expressly for portraits.

ESTABLISHED TWELVE YEARS.

N.B.---The Waterloo Omnibusses bring you from the Station to the Elephant & Castle, when there, please to enquire for "TIMMS"."

listed over one hundred thousand titles in their 1858 catalogue.

It was true, hardly a parlour was without some form of stereo viewer – either a low cost hand device (Fig. 3.21) or a cabinet type which might accept up to 50 pairs of pictures. People would buy and collect stereophotographs as they might today purchase CDs. On Sundays when relatives visited each other it would be a great treat to peep through the

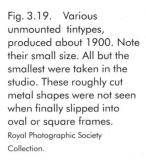

Fig. 3.20. A double lens collodion plate camera which took pairs of photographs for stereoscopes.

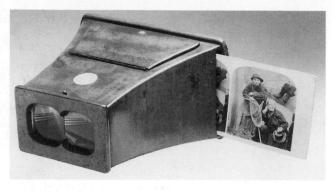

Fig. 3.21. A hand viewer for stereoscopic pictures either on card (shown partly inserted) or on glass.

stereoscope and see the latest additions to their picture collection.

You could buy stereo cameras, and stereo-pairs were accepted and shown in all the photographic exhibitions, but for the most part these pictures were taken by professional photographers for sale. The main publishers were in London and Paris, and they were sold in stores the world over. The stereo boom which really began in 1852 rose to peaks in 1860 and 1870, and at other times declined (particularly during the 1860's carte-de-visite craze, see below). However it remained fairly popular throughout various new photographic processes, until movies and then radio competed for family interests. Even today clubs and competitions exist for photographers taking stereo pictures, mainly on colour slide film.

Fig. 3.22. A stereo pair of photographs. If you look through magnifying glasses so that each eye sees a different picture the effect is a single 3D image.

The carte-de-visite craze

The mass-production of prints, made possible by the collodion process, led to a fashionable new way of using photographic portraits as visiting cards. In the nineteenth century most people – or at least those in 'polite society' – carried calling cards. They were rather like business cards today, neatly printed with your name, rank or qualifications, and address. When

visiting you would hand a card to the maid who opened the door.

In 1854 the French portrait photographer Adolphe Disderi devised a camera giving pictures of the size of visiting cards. It had four lenses (Fig. 3.23) and by exposing through each in turn you could take four poses of the sitter filling one half of a 16.5×21.5 cm $(6\frac{1}{2} \times 8\frac{1}{2}$ in) 'whole plate' size collodion plate. Then the plate was turned around and another four pictures taken, recording eight poses in all. Contact prints from the negative could be cut up and pasted on cards.

Disderi skilfully publicized his visiting card or *carte-de-visite* photography, and the novelty began to grow. Disderi flourished. By 1860 the idea had spread from Paris to London and then New York, sweeping away the last remnants of the American daguerreotype trade. Carte-devisites became a craze – newspapers called it 'cardomania'.

The main reasons for such success were probably:

1 Cheapness. In Britain they were about five shillings (25p) a dozen including the photography.

Fig. 3.23. A four lens carte-de-visite studio camera. Lenses were either opened one at a time, or all together.

Fig. 3.24. Carte-de-visites (shown half size) contact printed from a negative exposed in a four lens camera. The plate shifted sideways to expose the second set of pictures.

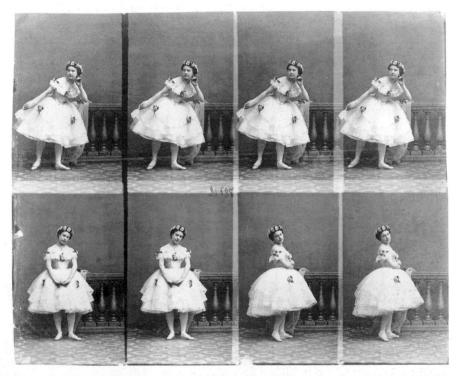

- They were only 6x10 cm $(2^{1}/_{2} \times 4 \text{ in})$, light-weight, and highly collectable. Albums soon appeared which you could fill with several portraits to a page (Fig. 3.27). These became fashionable objects to leave in the Victorian parlour.
- 3 Cartes of celebrities were quickly on sale in the shops. You could therefore collect pictures of people in the public eye as well as friends and relatives.

The craze greatly boosted professional photography. London had only 66 portrait photography studios in 1855, but six years later there were over 200 (35 in Regent Street alone). Some carte-de-visite printing establishments turned out over 3000 celebrity cards daily. Well known

Fig. 3.25. Some photographers went to ridiculous lengths to show sportsmen and others in realistic settings for their carte-devisites. The rocks used in this German studio are papier mâché.

Verlag & Fotografie v.
Lentoch, Salzburg. Royal Photographic Society
Collection.

people were paid to allow themselves to be photographed and published in this way. Royalty, politicians, prize-fighters, actresses, freaks – they all appeared in the catalogues. The London Stereoscope and Photographic Co. 'scooped' Tennyson, Disraeli and Holman Hunt; Marion & Co. signed up Charles Dickens. Seventy thousand cartes of Prince Albert were sold during the week following his death. Unscrupulous firms rephotographed some cards and issued pirated copies.

In all directions business boomed – sales of albumen-coated paper to the trade reached such a level in 1866 that half a million eggs were needed each month in Britain alone. As for the actual photography, this was so mechanized and cut-price the results were all rather similar. Usually the person was shown full-length, standing beside a table with books or a plaster column. The background was draped or, increasingly, consisted of painted scenery (Fig. 3.25).

The carte-de-visite was the height of fashion between 1861 and 1866 but then began to die away almost as quickly as it had come in. By the 1870s the public considered cartes quite old fashioned and dull. The market for stereo pictures revived again and cheap portrait studios returned to ambrotypes or tintypes.

Most better quality establishments now concentrated on cabinet-size prints instead. Cabinet photographs were rather like scaled up carte-devisites – larger prints on 11×16 cm $(4^1/2 \times 6^1/2)$ in mounts.

As the name suggests these could be displayed on a bureau or cabinet. They grew especially popular for photographs of stars of the theatre, who were posed in the studio rather than on stage (Fig. 3.30). The cabinet print also became the size most used for family group portraits. Here much play was made of the fact that the camera, unlike the painter, could 'draw' groups with the same speed as single figures. (In fact the photographer often charged slightly more because of the time and plates wasted trying to keep several people still.)

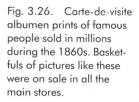

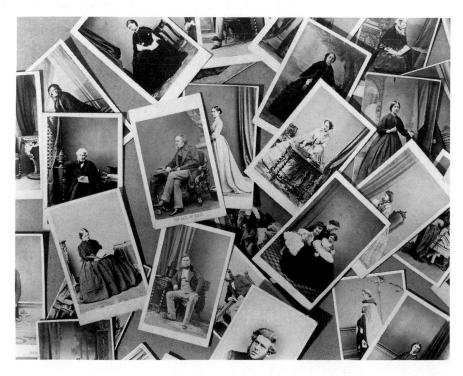

Fig. 3.27. Everyone seemed to collect carte-devisites of family, friends and important people. Because they were uniform in size, cards could be displayed in slip-in albums like this one, designed and sold for the purpose.

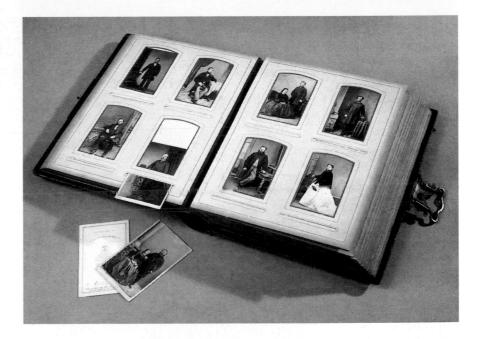

Notice too how people at that time loved dressing up and appearing in apparently 'outdoor' settings. Photographers in the better establishments could offer their customers a wide range of backgrounds and scenic props, and some had wardrobes full of costumes.

Amateur collodion portraiture

The wet plate process greatly expanded professional photography, but amateur photographers had to struggle to produce results of a reasonable standard. You certainly needed to be an enthusiast to prepare all your materials, focus and compose the dim upside-down image in the camera, guess the exposure time, and mix and use the processing chemicals. Most would-be photographers must have been deterred. Others possibly produced interesting important work which has long since been lost or destroyed.

Lewis Carroll – the Reverend Charles Dodgson, author of 'Alice in Wonderland' – was a keen amateur collodion photographer. Not much of his work has survived, but those that do show his lightness of touch and dreamy romantic approach, particularly to portraits of children. He managed to get natural casual-looking poses from children despite the need for long time exposures, and took great care over his compositions.

Julia Margaret Cameron was a totally different personality working with the collodion process. Today she is thought of as the most famous British amateur portraitist of the late 1860s – although very few photographers recognized this at the time. Wealthy, strong-minded, and eccentric, she took up photography in 1864 in middle age, when she and her family had settled in the Isle of Wight.

She was lucky in having contacts with some of the famous names of her day. Alfred, Lord Tennyson was a neighbour; Sir John Herschel an old family friend. As Darwin, Longfellow, Browning and Carlyle came to the island to visit Tennyson each was persuaded to sit for her camera. These people were her heroes, and with immense energy and zeal Mrs Cameron set out to show their 'inner greatness' as much as actual features.

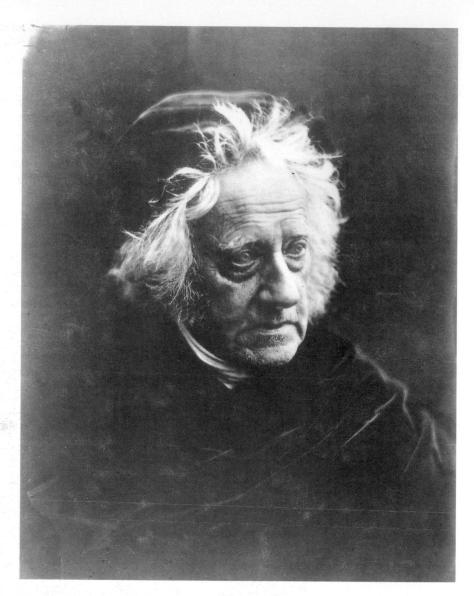

Fig. 3.28. Scientist Sir John Herschel photographed by Julia Margaret Cameron, 1869.

So she concentrated on head shots, using an 8×10 in or 12×15 in camera to get big imposing pictures, and restricted the way daylight reached her subject, to give dramatic effect.

You can see how Charles Darwin's massive domed head is picked out by allowing light to reach him only from above (Fig. 3.29). Sir John Herschel's face and rim of hair are emphasized by daylight directed from the right. The results did not conform in any way to accepted photographic portraiture of that time and were generally disliked by fellow members of the Photographic Society. Mrs Cameron's work was accepted and hung at exhibitions but critics called it 'artistically inferior', 'wilfully imperfect', and 'original at the expense of all photographic qualities'.

Certainly she made things difficult for herself – the limited lighting and use of a large camera with its small aperture meant that long exposure times were needed, often up to 5 minutes. Obviously, the sitter was usually slightly blurred by movement. She was also careless about really accurate focusing and her plates were mostly spotty and marked. Even the final

prints were poorly mounted. In short she blundered her way through technique at a time when photographs were judged by their clarity and accuracy. The great strength of Mrs Cameron's work was the way she used photography to *interpret* the great personalities she admired. In this she was well ahead of her time.

Compare Cameron portraits with those of Nadar (on page 30) who also used plain backgrounds and the minimum of extra 'props'. Mrs Cameron imposed her own will on the sitter, with dramatic results; Nadar's sitters seem to respond to him. Strangely enough, when Mrs Cameron was not photographing personalities and indulged instead in constructed 'artistic' pictures the results look sickly and false. See page 110. This is discussed further in Chapter 8.

Social influences of the collodion process

The invention and use of wet plates is an important milestone in the growth of photography. For one thing, photographs now became really numerous – almost everyone seemed to come into contact with them in one form or another, so people became used to 'reading' this new form of picture information. Unlike today, photography's popularity was due hardly at all to

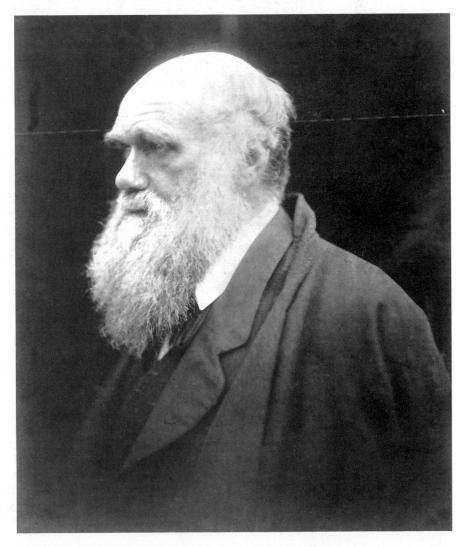

Fig. 3.29. Charles Darwin by J. M. Cameron.

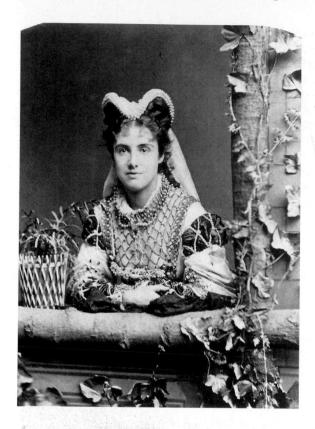

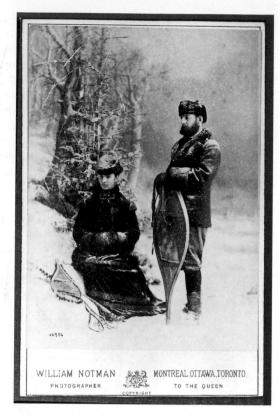

Fig. 3.30. The late 1870s brought larger, $4^{1}/_{2} \times 6^{1}/_{2}$ in 'cabinet' prints. Portraits of theatrical stars in famous roles sold well. High class studios offered expensive scenic effects - the couple, right, chose Notman's snowstorm treatment.

people taking pictures themselves, but more in being photographed, and buying, collecting, looking at and discussing photographs of various kinds.

When you look at old pictures try to see them in the context of how people lived and behaved in the mid-nineteenth century rather than in our own time. They contain signs of the social conventions and attitudes to life that then existed – what was considered *respectable* or *artistic*, and the way photographs were arranged to express *taste* or to present through allegory a moral lesson, like a Victorian sermon. The popularity of photographs also created its own conventions. For example 'being photographed' was a modern wonder which most people tried to afford in some form or another. The same was true of collecting photographic prints. So the custom of having a family album quickly developed; it could be added to and passed down from one generation to the next, just like the family bible.

The carte-de-visite album was an even quicker way of collecting photographs, because you could just go out and buy a complete assortment. It was therefore necessary to demonstrate your taste by purchasing pictures of the 'right people'. These albums were left on parlour tables where visitors might flip through them – and were often useful conversation pieces when visitors had run out of things to say. So it was important to demonstrate your cultural interests by possessing, say, several pages of poets and painters, a composer or two, even a few politicians. Royalty was very safe and respectable, whereas music hall stars gave you a daring, if vulgar, image.

Photographs were commodities which you purchased, collected, gave to people. Portraits of loved ones were carried in lockets and other jewellery. Hardly anyone wanted pictures of bad housing conditions, the tough life of the poor and similar documentary themes. On the other hand photography

opened up a 'window on the world' at a time when travel was suddenly within reach of many more people. Foreign places became of general interest and albumen prints could show all the sights with great accuracy and detail. In fact they often proved how wrong earlier travellers' drawings had been.

Relatively few photographs appeared in books (because of the high cost of pasted-in prints) but albumen-on-glass lantern slides allowed excellent quality photographs to be shown to larger groups. Magic lantern lectures, on subjects such as 'Life in America' or 'Scenes from the Swiss Alps' became very popular. Pay-at-the-door shows were held both in city institutions and village halls, the lecturers travelling from place to place with their gas-powered equipment.

The value of recording works of art by means of photography was also quickly realized. Albert, the Prince Consort, arranged to have photographs taken of Raphael drawings in the royal collection at Windsor Castle. Prints were sent to art museums in other parts of Britain; in return they were encouraged to circulate prints of their important possessions too. (Coloured objects were generally avoided as the collodion process made them turn out rather dark.)

In many ways photography had a strange, levelling effect. It made the world seem smaller and more commonplace. Kings and Queens, poets and politicians, were revealed as flesh-and-blood people looking much like anyone else, instead of distant Gods. Some people in Britain were concerned that this might damage rigid class distinctions. After all, there

Fig. 3.31. J. Croil and His Ladies. People used photographs to impress others with their social position. These Canadians, back from a Grand Tour of Europe, include labelled luggage to prove it.

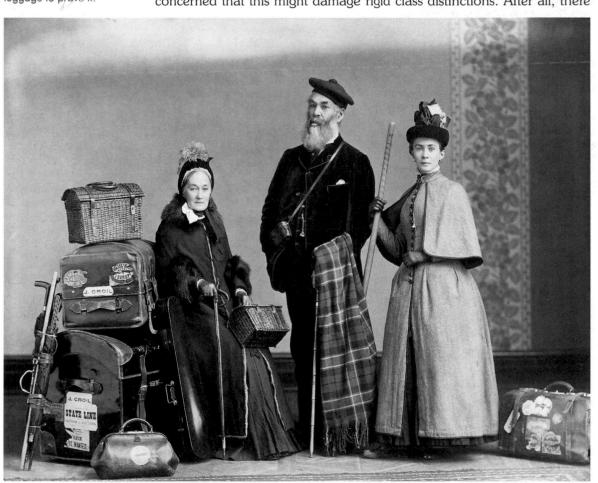

had previously been clear divisions between society people who were painted, and those who were not . . . On the other hand exhibitions of photographs were patronized by royalty and given lengthy reviews in newspapers. The photographic societies and groups were considered highly respectable, and even professional photographers, with their mass-produced pictures of celebrities and far away places, fulfilled a valuable need.

It was the cheapjack, tradesmen photographers fleecing the poor and taking advantage of the gullible who brought the craft into disrepute. The whole procedure of collodion photography – the conspicuous figure outdoors under a darkcloth, the use of fake artistic settings in the studio –

was also something of a joke.

Most collodion portraits look wooden, stilted and pompous by today's standards. Of course, this is partly due to the long drawn out process of being photographed. The setting, the suitable pose and then freezing for the exposure were bound to make people self-aware. But sitters were also very concerned about conveying, or suggesting, their social position. The professional portrait photographer pandered to this need by offering a wide range of picturesque backdrops. (In a typical high quality studio the customer could choose from a variety of painted scenes, pulled down one at a time for his or her inspection).

There was practically no scope for original approaches – the photographer seemingly had to remain timid and conventional in order to sell. As a would-be artist he was limited to shallow ideas, like for example offering a new woodland setting, going for a new size of print or a different

form of mounting or packaging.

Visually talented but non-technically minded people were still generally deterred from attempting photography. Even if you knew what you were doing, the silver chemical stained your fingers and clothes, and the ether had an overpowering smell... Wet collodion was really too impractical for the casual hobbyist.

Searching for a 'dry' process

Throughout the 1860s photographers continued to struggle to find a process that would allow glass plates to be prepared, stored, and then used in the camera at any time. Mostly they experimented combining familiar substances, such as collodion and albumen as binders. Various versions of the 'collodion~albumen' process were put forward. They involved multicoating the glass in complex ways – typically using collodion first and then, after drying, coating twice with iodized white of egg made light-sensitive in a bath of silver nitrate.

Properly made such plates could be stored for months and processed long after being used in the camera. However, they needed exposures around twenty times as long as wet collodion – some 15 minutes at f11 for sunlit scenes. People needed an easier system of photography, with materials which could be bought already manufactured and were more, not less, responsive to light.

Summary – wet plate era

 Collodion, used to bind light-sensitive salts to glass plates, made possible a negative/positive process with results free of paper fibre pattern, Scott Archer discovered this method in 1851. But plates had to be prepared, exposed and developed before the collodion dried out. • Finished collodion negatives were contact printed on albumen-coated paper which the photographer bought and sensitized before use. Similarly prints could be made onto glass to form lantern slides.

 Archer's process gave excellent detail, allowed unlimited prints, and was cheaper than the daguerreotype. Since it was not patented,

anyone could use collodion without fee.

 Location photography was difficult. You needed a portable darkroom, set up near the camera. Here and in the studio long time exposures were still essential.

 Despite all this complexity, record, travel, and of course portrait photography flourished. Serious workers aimed at 'high art' exhibition prints often using compositions constructed from several

negatives.

Important names: Delamotte (Crystal Palace record photography);
 Fenton (landscapes, and Crimean War); Frith (views of Middle East Countries);
 Rejlander, and Robinson (high art compositions);
 Nadar (French personality portraits);
 Lewis Carroll (child portraits) and Julia Margaret Cameron (portraits of famous men).

• Ambrotype and tintype versions of the process gave a direct positive result on glass or metal. They were quicker, cheaper and needed less exposure. Results were especially popular in America, long used to the similar looking daguerreotype. In Europe these versions were used in cut-price studios which almost everyone could afford to use.

Stereoscopic pictures, taken with a double camera, became popular from 1855. Most homes had a stereoscope and you could choose

from thousands of views, portraits, events, etc.

 The carte-de-visite craze (peak years 1861–66) was a marketing idea for small low cost portrait prints. Special cameras made eight images on one plate. People bought cartes of personalities; they were

collected in albums everywhere.

• The collodion process greatly expanded photography and brought everyone into contact with its results. Photographs were used to express taste and suggest status, to remind you of loved ones, to reveal people and places, to educate. Professional photographers however often proved to be more tradesmen than artists and the process was too technical for everyone to join in.

Projects

P3.1 Using your local museum or library seek out examples of albumen prints, and ambrotypes or tintypes. Note: albumen-coated paper is generally thin, curls easily and has a yellowish delicate glazed sheen. The image is black or dark brown. Ambrotypes look like daguerreotypes but are less reflective, and have a darker, less detailed image.

P3.2 Experience what it was like to pose for a collodion portrait. Settle yourself in a chair, brace your head, and stare at a clock or watch trying to keep absolutely still for 40 seconds. Now try one of Mrs Cameron's four minute exposure times.

4

'Dry' plates, rollfilms (1870-1900)

The 1870s brought a long-awaited change to the process of photography. This was brought about by the discovery that gelatin is infinitely better for binding light-sensitive salts to glass than collodion. Gelatin did away with the need to prepare your own materials before taking each picture. Such plates were known as 'dry' to distinguish them from previous plates

Fig. 4.1. By the late 1860s various eccentric aids were sold to try to encourage photographers, but collodion still needed on-the-spot preparation.

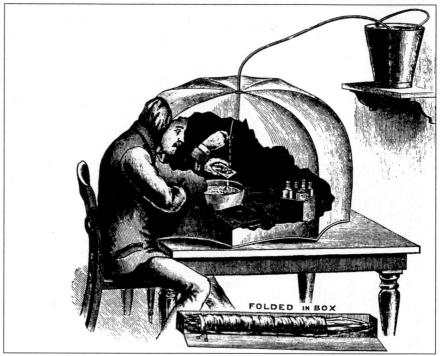

for camera work. Dry plates, and eventually films, could be bought in the shops. The new materials combined with new equipment allowed much briefer exposures to be given, so cameras could be used in the hand. Manufacturers soon stepped in with simplified cameras and a back-up service of processing. The overall result was that photography became something ordinary people could now practise themselves, and the range of pictures taken became much more varied. Gelatin materials mark the beginning of the photographic process as it is still known today.

Gelatin

In 1871 an English doctor, Richard Leach Maddox described in the *British Journal of Photography* how gelatin (as used in jellies) seemed a promising substitute for collodion, since it allowed plates to be used in a dry state. An 'emulsion' of gelatin containing silver bromide could be prepared and flowed as a warm solution over a sheet of glass. When the gelatin emulsion dried and set the chemicals did not crystallize out, as with collodion. At the processing stage this coaling swelled sufficiently for developing and fixing solutions to enter and act chemically, yet did not dissolve or float off its glass base.

Fig. 4.2. Some of the first manufactured gelatine dry plates, 1878.

Other experimenters took up Maddox's idea, making the happy discovery that the new emulsion became very much more sensitive to light by prolonged heating (called 'ripening') during its preparation. By 1878 the complexities of emulsion making and coating had been taken out of the hands of the photographer; instead he or she bought ready-to-use manufactured plates, in boxes.

Dry plates gave the same excellent image quality as collodion, but with three important and practical advantages:

- You no longer had to carry a tent, chemicals, etc., when working on location. All that was needed apart from the camera, was a number of loaded plate-holders. Exposed negatives could be processed later at home or this could even be done by someone else.
- 2 Gelatin dry plates were so sensitive to light that exposures as brief as 1/25 sec could be given outdoors. A tripod was no longer essential.
- 3 Factory manufactured plates were much more consistent and of better quality than the home-made kind.

Gelatin emulsions could also be coated onto printing paper, and by the mid-1870s you could purchase ready-made 'bromide paper' containing silver bromide. This material was sensitive enough to make enlargements using a gas-lit horizontal enlarger. (A few early enlargers had been built for use with albumen paper. But since only sunlight was powerful enough for this print-out material the back of the enlarger was fitted over an opening in the darkroom wall, the sun's rays being directed through the device by an angled mirror fixed outside the building.)

The sensitivity of dry plates to light meant that cameras now had to have something better than the simple lens cap used to control a time exposure. You needed a mechanical shutter to give consistent 'instantaneous' exposures. People also wanted to be able to take several pictures without having to keep changing plateholders. One solution was a magazine camera (Fig. 4.4). In fact dry plates unlocked a whole range of new camera designs.

Fig. 4.3. Dry plates loaded in a magazine plate camera made it easy to go out and about, shooting pictures on location.

The 'Swift' Hand Camera. SPIERS & POND. This hand camera has an achromatic landscape lens of good defining power. It is fitted with set of subsidiary lenses, and has range of focus from 4 feet upwards. The finders are fitted with hoods thus enabling the image to be seen in the brightest light. The body is made throughout of mahogany, covered with best hard grain Morocco leather. Price, 2l. 18s.

Fig. 4.4. This late 1880s magazine camera held up to twelve dry plates. A handle lowered each plate out os the way after exposure.

ADAMS & CO.'S 'HAT'

DETECTIVE CAMERA

FOR THE TOURIST! FOR THE CYCLIST!!

FOR EVERYBODY!!!

42/- COMPLETE.

INCLUDING FITTING.

Takes Plates $4\frac{1}{4} \times 3\frac{1}{4}$.

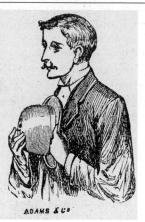

Patented in all Countries.

SIX PICTURES Without Changing Plates. No Focussing Necessary.

The Amateur Photographer, March 23rd, 1888, says: 'The only really 'detective' camers that we have seen is Bobluson's Secret Camera."

PRICES. No. 1.—Complete with Plates for 36 pletures, 32;— No. 2.—The New Large Stre, for labeling size pictures, complete with Plates for 31 pletures, 48;—Four Pictures Without Changing Plates.

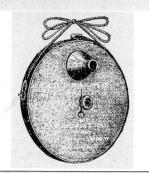

EASE, SIMPLICITY, AND PLEASURE

FALLOWFIELD'S

The Cheapest and most Perfect yet offered. One Movement sets Plate for Exposure, next Changes exposed Plate, and

Carries Twelve Plates 4\frac{1}{4} \times 3\frac{1}{4}, and weighs, fully charged, 4 lbs. 2 02s.

See next pages for full Particulars, Prices, No.

South London Photographic Stores, 35 & 36 LOWER MARSH,

86 OAKLEY STREET, LAMBETH, S.E.

Fig. 4.5 Advertisements for various so-called 'detective' hand-held plate cameras in the mid-1880s. Only the Facile, disguised as a parcel, worked well ~ others were just novelties and gave poor results. The hat camera mechanism was titted to the customer's own bowler. Its lens could be removed on Sundays (when fastidious dress was desirable.)

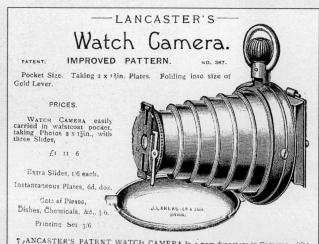

Just being able to use a camera hand-held instead of setting up all the earlier paraphernalia was a great novelty. It led to many so-called 'detective' cameras during the 1880s, which allowed pictures to be taken while the subject was unaware. The camera was made to look like a parcel or a walking stick... or even a hat (Fig. 4.5). When used carefully one or two expensive types gave good results, like Paul Martin's 'parcel' camera picture on page 89. Most detective cameras however were little more than toys, with poor lenses and unreliable mechanisms.

You press the button...

The most revolutionary camera for amateur photography – in fact a complete system – was to appear first in America. George Eastman, a 24 year old bank clerk and amateur photographer, had read about British developments in emulsion preparation and manufacture of dry-plates. After experimenting he invented a plate-coating machine and in 1880 set up as the Eastman Dry Plate Company in a rented loft in Rochester, New York. But Eastman's real genius was in recognizing that the new materials made possible really simplified photography – he therefore set out to remove all the irksome technical stages preventing ordinary people from taking their own snapshots.

The result was the first (1888) Kodak camera (Fig. 4.6). Eastman made up the word *Kodak* as a trademark – it was pronounceable in most languages, easily spelt and distinctive. For years all cameras of this type were called Kodaks, just as people called all vacuum cleaners 'Hoovers'. Look at some of the Kodak camera's unique features:

- It was small enough to carry and use in the hand, yet the negatives were big enough to give album size low-cost contact prints (Fig. 4.7) as well as enlargements.
- It contained a 6 m (20 ft) roll of light-sensitive material, enough to take 100 circular pictures 6 cm ($2^{1}/_{2}$ in) in diameter. (At first this was a roll of paper, negatives being transferred after processing onto

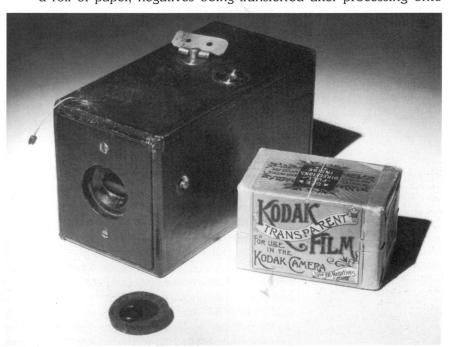

Fig. 4.6. The first 1888 Kodak camera was 6½ in long, 3¾ in high and gave 100 pictures. You pull the cord to set the shutter and press the button to release it. A viewfinder was not thought necessary. It used paper rolls, but by 1889 Eastman introduced celluloid roll-film (right).

Fig. 4.7. Each Kodak contact print, $2^{1}/2^{n}$ dia, was returned mounted on card. Eastman himself took this snapshot of Nadar's son Paul in Paris, 1890.

Fig. 4.8. Here they reversed the roles and Paul Nadar took this portrait of George Eastman on a studio camera. Eastman was 36 years old.

transparent supports for printing. A year later Eastman used emulsion-coated film – the world's first rollfilm).

- 3 The camera had a fixed focus f9 good quality lens which sharply rendered subjects at all distances beyond 2.5 m (8 ft). The shutter worked at one speed, 1/25 sec, which suited most scenes in bright sunlight and was instantaneous enough not to blur, provided you held the camera still.
- The roll of film came ready loaded in the camera. When you had taken all 100 pictures the camera was sent back to Eastman's factory. Here the film was removed, processed and printed, and the camera returned reloaded.
- 5 Its price of \$25 or 5 guineas (£5.25) in Britain plus \$10 for the service of processing and reloading was expensive, but acceptable for something so new and revolutionary.

So for the first time the photographer need know nothing of chemicals and processing. Just pulling a string set the shutter; pressing a button made the exposure; winding a key transported the sensitive material. It was as simple as that. Eastman's Kodak system was an immediate success and sold world-wide. Most of the profits were ploughed back into research and the development of more cameras such as a range of folding types, and (in 1891) rollfilms which could be user-loaded.

The Eastman Kodak Company went from strength to strength. Its founder became a multi-millionaire. But Eastman's great contribution was to simplify and popularize photography. (Within 12 years simple mass-produced cameras sold for only \$1, and films 15 cents each). His slogan 'You press the button, we do the rest' was really true, and changed amateur photography from a process full of technicalities to the start of 'snapshotting' anyone felt they could attempt.

Fig. 4.9. Using the row of cameras shown below Edweard Muybridge could record animal movements too fast for the eye to perceive clearly. This horse was travelling at about 35 mph.

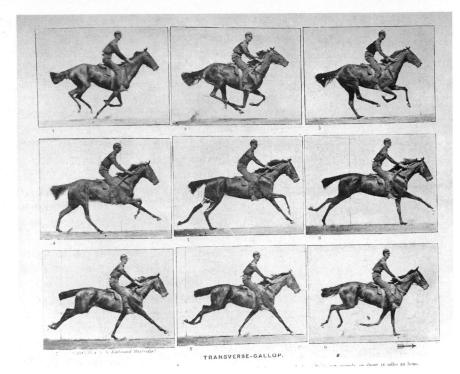

Fig. 4.10. Muybridge used a row of cameras set up under cover, for photographing studies of animal locomotion, 1879. Shutters fired when the animal broke threads, or carriage wheels touched electric wires on the ground.

Movement and action

The shorter exposure times now possible and the 'frozen' records these gave of moving subjects produced interesting – sometimes unexpected – results. Instantaneous pictures really date from stereoscopic cameras of the 1860s. These often had mechanical shutters to ensure that left- and right-hand photographs were exposed together. Stereo street scenes showed how photographs could capture traffic and passers-by in frozen detail missed by the ordinary observer.

One of the earliest and certainly the best-known photographer to record action detail was Edward Muybridge. Born in England as Edward Muggridge he was working as a scenic photographer for the US Government when he became involved in a dispute between San Francisco racehorse owners. The argument centred on whether a fast trotting horse ever had all four feet off the ground at one time. Muybridge reckoned he could check this out by photography. After some promising experiments using wet plates he persuaded railroad millionaire Leland Stanford to provide finance and allow the use of his stock farm.

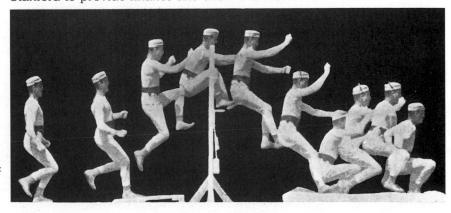

Fig. 4.11. A 'chronograph' sequence of a leaping man, all exposed by a repeating shutter onto one plate. One of many produced by Etienne Marey about 1885.

Fig. 4.12. Revolving this zoetrope drum, and looking through the slits, makes pictures appear to move.

By 1877 the photographer had devised a line of cameras set up beside a specially built section of race track (Fig. 4.10). Here a series of threads stretched across the track were broken by the horse – each thread electrically firing a 1/1000 sec drop shutter on one camera at a time. Results (Fig. 4.9) were technically underexposed but showed how the animal's feet all leave the ground only when bunched under the belly.

More than this, Muybridge proved that if each photograph were presented rapidly in sequence to the eye like a flicker book (or viewed in a zoetrope, Fig. 4.12) the horse appeared to move. It was a first important step towards moving pictures. Between 1883 and 1885 Muybridge went on to record hundreds more sequences, using improved equipment and the faster dry plates. These photographs were mostly made for the University of Pennsylvania and analysed the movements of animals, humans, birds, etc.

In France the physiologist Professor Etienne Marey heard of Muybridge's photographic work and devised his own single camera systems, recording a whole sequence of brief exposures on one plate. Images either overlapped like Fig. 4.11 to show movement *flow*, or appeared spaced out around a circular plate. All these picture sequence records (named 'chronographs') created great interest among scientists and naturalists. As for artists, who mostly aimed at drawing accuracy, they were shaken to realize that many famous paintings portrayed action incorrectly – see page 58.

Meanwhile it is interesting to note that Thomas Edison, working on equipment which might photograph and reproduce moving pictures, approached George Eastman in 1889 for some of his new Kodak flexible film. The 70 mm ($2^{3}/_{4}$ in) wide Kodak rollfilm was slit down the centre, making it 35 mm ($1^{3}/_{8}$ in) wide and, when joined end-to-end, up to 40 feet long. Edison's assistant punched transport perforations down each edge. Later 35 mm became an international standard for motion pictures. Eventually still cameras, beginning with the Leica, were designed to use film of this width too.

Film sensitivity improvements

Collodion, albumen, and early gelatin emulsions were basically only sensitive to blue light. When used to photograph coloured subjects, greens, yellows and reds reproduced unnaturally dark. But in 1873 Professor Herman Vogel of Berlin discovered that by adding a very small quantity of suitable dye when making an emulsion, the plates would also respond to green light. By 1882 manufacturers had 'orthochromatic' (blue and green sensitive) plates on sale. Further research by German chemists resulted in 1906 in the first 'panchromatic' (all-colour sensitive) films and plates. These

Fig. 4.13. The same subject recorded on (below) blue-only sensitive, and (below right) panchromatic emulsions. Central flowers amongst green foliage have red petals. All flowers have yellow centres.

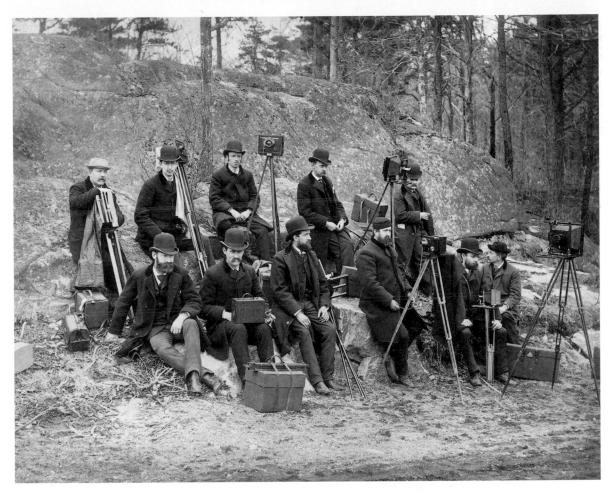

Fig. 4.14. Hand cameras popularized photography, but 'serious' amateurs preferred plate cameras on tripods. A typically maledominated camera club 1890.

gave much better detail and tones in coloured objects, and soon became the most generally used form of black and white camera material.

By the late 1880s dozens of manufacturers produced plates, constantly improving them as they gained experience. Materials were always being advertised as 'extra fast', or at least more light-sensitive than anything offered by their rivals. Of course, in the days of collodion, it was not too important to know the exact sensitivity of your plates. Results were always processed on the spot, so like today's instant pictures it was possible to just take another one until you got the result you wanted. The new dry plates and films however were processed elsewhere, so accurate exposure

Fig. 4.15. (near right) The folding Pocket Kodak, 1897.

Fig. 4.16. (far right) Typical hand-held plate camera with instantaneous shutter, 1903.

Fig. 4.17. Twin lens reflex, 1890s. The top lens gave an image for viewing, like Fig. 1.3. The bottom one exposed onto plates preloaded into darkslides.

had to be guessed, and for this it was helpful to know how the various types differed in light sensitivity.

Rival advertising claims were so confusing that two scientists in Britain, F. Hurter and V. C. Driffield, devised the first independent system to give emulsions speed numbers. As from 1890 materials could be given reliable 'H and D numbers', a system which allowed exposure tables and meters to be prepared (page 81). This eventually led to the system of ISO numbers marked on all film boxes today to show their light sensitivity or 'speed'.

Cameras and lens developments

As you can see from Fig. 4.14, many serious amateurs as well as professionals still favoured plate cameras in the 1890s. Optical glass

Fig. 4.18. The back of an 1880s cabinet print mount, advertising an upmarket London sludio with their own dynamo-driven arc lamp.

Fig. 4.19. Flashpowder device. Releasing a clip on the tube from the air ball blew powder into a spirit lamp flame.

developed in Germany now allowed new lens designs, like the first anastigmatic made by Zeiss in 1889. These lenses gave brighter and sharper images than earlier types. In fact for the next 50 years Germany was to remain the world leader in photographic lenses.

Lenses however, like emulsions, also lacked clear descriptions. At first manufacturers marked their own preferred series of f numbers on the lens aperture control. It was not until 1900, at a conference in Paris, that the present series of aperture settings (f2, f2.8, f4, f5.6, etc.) was internationally agreed.

The original Kodak box-like cameras were soon followed by very popular new folding rollfilm cameras. These gave quite big 6×8 cm $(2^{1}/4 \times 3^{1}/4)$ in) pictures, but still folded up small enough to fit into a large pocket. For the first time too twin lens reflex cameras appeared, made for plates (see Fig. 4.17).

Lighting

Light sources other than daylight were still unusual in photography. And yet the short hours of winter daylight meant that the working day for portrait studios was ridiculously brief. Nadar and others had used battery-operated lamps, but these were awkward and not really powerful enough for portraits. Gas lighting roasted the sitter when sufficient gas jets were put together to give brilliant illumination. (Although from about 1885 gas lamps could be used for contact printing.) Gradually dynamo-powered electric arc lamps were brought into use by the bigger establishments. In 1877 the world's first exclusively electric light studio opened in Regent Street, London. Using 6000 candle power the exposures needed ranged from 3 to 10 sec.

As you can see from Fig. 4.19, the cheap rival to electric light was pyrotechnic flashpowder. This was introduced in the 1880s and consisted of ground magnesium and other chemicals which you blew into a flame or ignited by a spark from a flint. It produced a brilliant flash lasting about 1/10 sec – plus a great deal of smoke, smell and fallout of white ash. Flashpowder was less dangerous and unpleasant used outdoors, provided you avoided wind or rain. But unlike flashbulbs (which were invented in 1925) it was not practical to make flashpowder go off at the same instant as the shutter of a hand camera. So flash pictures had to be taken by mounting the camera on a tripod, opening the shutter, igniting the flash and then reclosing the shutter.

Tungsten filament lamps, forerunners of the type used in homes today, first appeared in 1880. But few towns had a regular electricity supply, and the early lamps gave such a weak orange illumination they were not much used for photography until after the turn of the century.

Photographs on the printed page

As if to complete the technical revolution which was occurring in photography, the 1880s and 1890s at last brought a solution to the problems of reproducing photographs on the printed pages of books, magazines and newspapers. Up until then photographers could only show their work to the public through direct sales of photographic prints in print shops, or prints pasted into books, or shown in exhibitions. To appear alongside text on the printed page all photographs had first to be redrawn by hand onto a wooden block. A wood engraver next cut away the wood in the spaces between the drawn lines, leaving the design in relief like a

lino cut. When inked up and pressed onto paper the result looked like Fig. 4.21. (In practice the engraved wood was used to form a mould for a *metal* relief block which withstood greater wear on the printing press.)

In a sense then the photograph only provided a *reference* for the skilled engraver, who added or subtracted his own details. Notice too how the picture consists only of black ink lines – intermediate grey tones between black and white (i.e. 'half-tones') are suggested by varying the spacing and thickness of the lines engraved.

The search for a means of converting photographs direct to a metal surface which could be inked and printed without intermediate drawing was as old as photography itself (see Niépce's experiments, page 3). By 1866 a process known as Woodburytype allowed negatives to be printed on a gelatin layer which could be converted to shallow impressions in a lead plate. When these hollows were filled with ink a whole range of tones could be reproduced on paper. Results were excellent, but Woodburytype plates wore down quickly; the process was also so costly it was no cheaper than making actual albumen prints. It was therefore only practical for handmounted illustrations in expensive books.

The big challenge was to make photographic blocks which withstood the enormous wear of magazine and newspaper presses. By the late 1870s photographic negatives could be printed onto light-sensitized metal which was then acid etched into a relief, but this could only give pure blacks and whites.

Eventually, following an idea by Talbot 20 years earlier, it was found that by copying a photograph using a camera containing a glass screen with a grid pattern of fine lines, all the grey tones turned into tiny dots of different sizes. When these dots are etched into metal, then printed by ink onto paper, they appear (from normal reading distance) just like the various

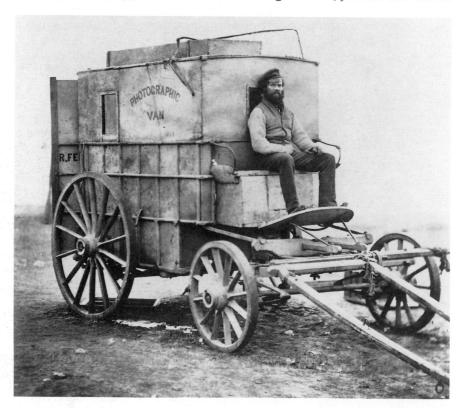

Fig. 4.20. Photograph of Roger Fenton's van, from which he documented the Crimean war. (See also Fig. 3.8.)

half-tones of a photograph. The dot differences act like the engraver's lines of different spacings. (Check the grey part of any photograph in this

book through a magnifier.)

The first half-tone photograph in a daily newspaper appeared in the New York Graphic in 1880. But there were still problems to solve. New steam-driven rotary presses were coming into use; ways had to be found to bend the new half-tone plates onto cylinders along with the type, to allow high speed printing. Wood engravers understandably objected to the threat to their jobs. Some cautious newspaper owners even feared that photographic illustration would 'cheapen' their publications.

However, by the late 1890s newspapers were already using more photographs than wood-cuts. Within 10 years most newspapers and many magazines were exclusively illustrated by half-tone photographs. See Fig. 7.13 on page 96. Thanks to this technical breakthrough the new century held a bright future for new branches of professional photography – press,

photojournalism, advertising and fashion.

Influences of the new materials

Some people argue that practical photography really began in the 1880s. The four most far-reaching effects of all these new materials and equipment were:

1 Everyone could now be his or her own photographer.

2 The photographic industry was born – factories to manufacture reliable materials and equipment, and for developing and printing.

3 The expansion of photography gave rise to quite new kinds of pictures, of interest to both artists and scientists. People began to realize how versatile photography could be.

4 It made movies possible, and contributed to the printing press

reproduction of half-tone pictures of all kinds.

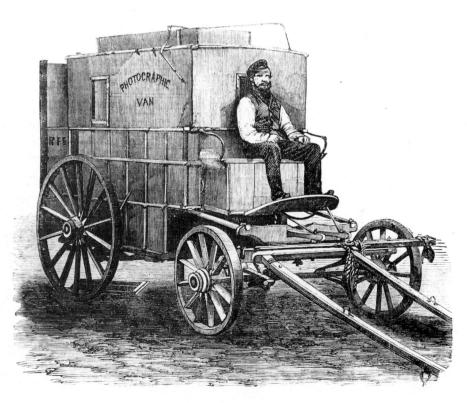

Fig. 4.21. Before the 1880s newspaper photographs were hand-drawn and engraved. The same picture as Fig. 4.20, in *Illustrated London News*, 1855.

Fig. 4.22. Hand cameras and faster materials allowed pictures of everyday events, as if you were actually there. Ludgate Circus 1897.

Snapshots had replaced the old ritual of tripod and focusing cloth in the public mind. There was no need to be technically minded or wealthy. For many having a camera was like being given a time machine which preserved for ever the people and scenes they chose – something no previous generation had been able to do. Often snaps were ordinary and dull, but at least people now took them to please *themselves* rather than flatter a customer or satisfy a stuffy exhibition judge.

Some results had a freshness of approach which overturned conventional 'rules of composition'. Again, the hand-held camera encouraged people to try viewpoints other than tripod height. Instantaneous shutters meant that the exact moment chosen to expose moving subjects made a big difference to their composition.

People also tended to photograph *actuality* – casual pictures of ordinary life as it was really lived, like Fig. 4.22. Such subjects had been taboo among artists because they were considered 'unpicturesque' and therefore unfashionable. (Equally they were technically difficult for earlier photographers, because of the need to set up for time exposures.) Some professional photographers documented city life, and one or two reformers began to take pictures showing the conditions of the poor. Like the novels of Charles Dickens, photography was to reveal dramatically the lives of unfortunates most people chose to forget. The documentary work of Paul Martin, Jacob Riis and others is discussed in Chapter 7.

With all this new spontaneous picture making, society had to re-think what photography was all about. Was it art... or a recording medium? A

scientific tool... or a popular novelty? It was easy to foresee that photography on the printed page could powerfully communicate news, help campaign for better working and living conditions, educate and entertain.

Few painters of the time could afford not to examine carefully the images the camera was producing (although most tried not to admit being in photography's debt). Contemporary artists such as Degas took great interest in the way photographs often 'cropped off' figures near the picture's edges, and the steep perspective given by the camera. Both devices can be seen used in Fig. 4.23; also in several of Degas's ballet paintings. It is strange to think that in the 1870s this was considered quite shocking.

Photography's emphasis of light and shade, and even 'mistakes' – such as movement recorded as blur – interested artists. Corot, Monel, and other impressionists often conveyed movement of figures, trees, etc., by painting them as the camera would have recorded them during a brief time

exposure (Fig. 4.24).

We have also seen how Muybridge's analytical photographs created a sensation. Twice during the 1880s he visited Europe, talking to painters and sculptors and scientists in Paris, lecturing to a crowded Royal Academy and similar institutions in London. His sequences of animal and human figure locomotion published in 1887 were enormously comprehensive. They analysed thousands of movements, from simple walking or lifting, or sports activities, to the jump of a kangaroo and the flight of birds. These were photographed with such precision that direct measurements could be made. The pictures formed a major reference encyclopaedia of artists' studies, and were bought and used by leading figures in many countries. Muybridge's sequences became standards against which the errors of earlier painters (Fig. 4.25) were endlessly compared.

If all this fuss seems strange today, remember that the gallop of a horse and similar actions the eye could not follow had been puzzled over for centuries, until frozen on film. Much the same applied to photographs

Fig. 4.23. The Degas painting 'Cotton Bureau' 1873. Look at the strong perspective, particularly in the foreground. Both this and abrupt cropping (figures on the right) were unusual in painting. Degas was influenced by the way photographic cameras recorded such scenes.

Fig. 4.24. 'Poplars at Giverny, Sunrise', painted by Claude Monet in 1888. Several Impressionist painters chose to represent movement in their subjects by use of blur – a visual effect discovered from the time-exposures early photographers were forced to use. The Museum of Modern Art, New York.

taken through microscopes, telescopes, etc. These were all areas in which the camera gave new, essentially *photographic* pictures. In contrast, the photography of subjects like landscapes and portraits was (and still is) influenced by the way painters had seen them. But there were many examples of artists overusing reference photographs too. So many works sent to major art exhibitions in the 1880s and 1890s resembled coloured photographs it was clear they were being slavishly copied from this new source rather than sketches from nature. (This was an odd reversal of the artistic photographer who was still striving to make his work appear less

Fig. 4.25. Detail from 'First Spring Meeting, Newmarket 1793'. Painters generally showed galloping horses spreudeaglod like rocking horses until Muybridge's photographs proved them wrong. (See page 49.)

mechanical, more like fashionable painting of the time. Compare Fig. 4.26

with Fig 8.7 on page 115).

These and other influences of photography on art, and of art on photography were fiercely argued in both camps, and brought up in practically every exhibition review published in the press. See also Chapter 8.

Summary - dry plates and rollfilm

- Maddox's idea to replace collodion by gelatin led to 'dry' lightsensitive materials which could be manufactured and sold ready for use. They were also much faster and more convenient, and could be processed at any time after exposure.
- The sensitivity of gelatin emulsions made 'instantaneous' shutter speeds possible. Coated on paper they allowed enlargements to be made with an artificial light source enlarger.
- Various hand-held cameras were designed for use with the new dry materials. They included detective camera novelties and the Kodak
 the first simplified camera with a back-up processing service.
- Eastman's Kodak system expanded into a range of simple cheap cameras which allowed anyone to get results under good conditions.
 People could at last take their own snapshots without special technical knowledge.
- There was great interest in the action-freezing effect of short exposures. Edweard Muybridge (USA) made a special study of animal and human locomotion in photosequences. Together with similar work by Marey (France) these could be 'played back' through a viewing device which recreated the subject's movement. Detailed analysis of action too fast for the eye to follow was of special interest to artists, at a time when realism and accuracy were considered very important. It was also a vital first step towards moving pictures.
- Further technical improvements included ortho- and pan-chromatic films, agreed systems of emulsion speed ratings and lens *f* numbers; better lenses; and smaller cameras.
- Studios began to use generators and electric lamps. Magnesium powder formed the first practical flash-light source, although rather dangerous and unpleasant.
- At last magazines and newspapers found a direct method of reproducing photographs alongside text. The half-tone dot system meant that photographs no longer had to be turned into woodcuts and etchings.
- Hand cameras used by ordinary people allowed freer choice of subject; pictures were more natural, less restricted by current art. The scope of photography was immediately widened. Artists were influenced by some of the new images the camera produced sometimes excessively so.

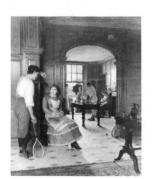

Fig. 4.26. Haylier: 'A Summer Shower' 1883. English and French academy painting of the 1880s frequently resembled coloured photographs.

Projects

P4.1 Using a photocopying machine make two copies of the Muybridge sequence (Fig. 4.9). Carefully cut up the copies, sort them into two repeating sequences and staple them at one end to form a flick book.

P4.2 Try disguising your own camera as a package or bag and take pictures of your friends unaware. (As you will not be able to aim the camera very accurately

enlarge up wanted parts of the negative later.)

P4.3 Seek out illustrated books, magazines and newspapers published at about the turn of the century. (Some libraries keep microfilm copies of newspapers. Look also on market stalls and in second-hand shops for books.) What is the earliest date you can discover half-tone photographs on the printed page?

The search for colour

Although far more people could now take photographs, for most of the first half of the twentieth century photography really meant pictures in black and white. Everyone now expects to have colour prints from their holiday a few hours after returning home, but 60 years ago a skilled photographer would take several days, at great expense, to get one colour image on to paper. Reaching today's position called for tremendous research – firstly to establish the best *principle* on which to base a system of colour photography, and secondly (even more difficult) how to put it into *practice* so that it was simple, inexpensive and gave high quality results. Hundreds of systems for 'natural colour photography' were put forward, often by fakers and fraudsters. Fortunes were lost trying to launch processes which only partly overcame problems and contained some fatal flaw.

Of course, even the earliest cameras and lenses formed images in full colour. It must have been tantalizing to see all that coloured detail on the focusing screen, yet be unable to capture it in other than tones of light and dark grey. Early photographers tried to get around this problem by colouring their pictures by hand. Daguerreotypes and ambrotypes could be hand-tinted with powder or water colours, see below, but this had to be done with great care or the delicate image would be damaged. Usually it was limited to just picking out detail. Albumen and bromide prints were coloured with oils or water-colour.

As early as 1861 the search for *natural* colour took its first important step forward when Scottish physicist James Clerk-Maxwell demonstrated an experiment showing that *three* black and white photographs might be taken of a subject through each of red, green and blue coloured filters. Black and white lantern slides contact printed from each of these negatives could then be projected by three lanterns (Fig. 5.4) fitted with the same filters. If the pictures were made to exactly overlap on one screen all the colours in the original subject would be recreated.

Fig. 5.1. Below: Anon.
Daguerreotype, hand tinted.
Colouring the metal-based image was difficult. Dry colours were often stippled onto different parts of the picture and then 'set' by breathing on them.

Fig. 5.2. Below. right: Anon. Portrait of a girl early 1860s. Tinted wet collodion positive (ambrotype). Royal Photographic Society Collection.

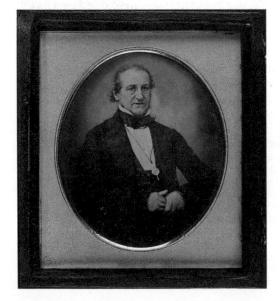

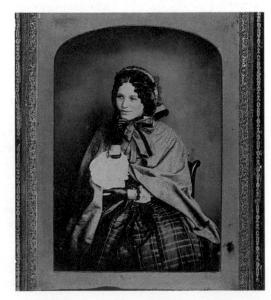

Fig. 5.3. J. Clerk-Maxwell, 'The Tartan Bow'. The three pictures taken through red, green and blue filters onto (then) blue-only sensitive emulsion should not have worked - even to give this crude result. But inefficiencies in the filters and reflectance of some UV by the red fabric produced something judged remarkable in 1860.

In 1868 Ducas du Hauron, a French scientist, published a brilliant book suggesting how a whole range of colour photography methods might work. The trouble was that none of these ideas could really be tested or put into practice. No photographic materials in the 1860s were sensitive to red – so a red filter used on the camera gave little or no result. (The caption to Fig. 5.3 outlines why Maxwell's experiment largely worked.) Vogel's 1873 discovery of sensitizing dyes was therefore of utmost importance in 'unlocking' colour photography.

Once green sensitive and then fully panchromatic plates (page 50) became available in 1906 professionals and advanced amateurs were able to take three 'colour separation negatives' of subjects. It was a daunting procedure. Using a regular plate camera you needed three plate holders and three deep-coloured red, green and blue filters. After each exposure (typically 10–20 secs at f8 according to filter) you had to change the plate holder and change the filter, taking enormous care not to shift the camera or the focus setting. Nothing may move within the scene you were photographing either during or between exposures. Plates had to be given different degrees of development too – the blue filtered shot needed extra processing to match the other two in contrast. Special camera backs and

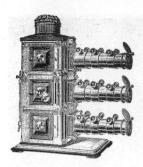

Fig. 5.4. Triple (gas light) projector with red, green and blue filtering to form one combined colour image on screen.

cameras designed to expose all three plates at one time began to appear for professional photographers but these were very expensive.

Remember that people were very familiar with stereoscopic viewers containing glass positives you viewed through an eyepiece. It was therefore a natural step to print separation negatives onto glass, varnish each with a dye matching its taking filter, then put them into a new kind of viewer (Fig. 5.5) designed so that your eye combined all three images into one fully coloured picture.

As for making colour prints from separation negatives, between about 1915 and the early 1940s at first the best that could be done was to adapt a process known as carbon printing to somehow combine the three images on a paper base. From each negative a print was made on special carbon printing paper, which gave a monochrome image in an appropriate pigment. These three images were then transferred one at a time first onto sheets of glass and from there to a common sheet of paper, carefully registered on top of each other to give a final full colour print. The skill in preparing all the materials and perseverance in assembling even one print was beyond the amateur. Nor was it really practical for the professional photographer, given the days of work needed for a single uncertain result. See also carbo print, Fig. 5.14.

Screen plates

Everyone looked for a system of colour photography which avoided the complexities of separation negatives and assembly prints. Colour plates were needed which could be bought and used normally, and for this manufacturers turned to a rather different system – a multicoloured screen. Once again the idea had first been proposed by du Hauron.

The first colour plates to go on sale (1907) were made by the Lumiere brothers in France and known as *Autochromes*. They caused a sensation

Fig. 5.5. Ives Kromscop hand-viewer. The red, blue and green separation lantern slides were taped together to lay correctly over three windows (1,2 and 3 respectively) on the top and reur of the unit. Mirrors then combined the images when you looked through the eyepiece, left.

Fig. 5.6. B & W prints from a set of colour separation negatives. This helter-skelter had a red slide, yellow vertical supports, and blue ground laying struts. Photographed on pan material through (left) blue, (centre) green, and (right) red filters, notice how its colours record in different tones.

and proved a great success for over 10 years because of the quality of the colour transparencies they gave. Leading photographers of the day all tried them out.

Each Autochrome glass plate carried an evenly mixed layer of tiny transparent starch grains (about 5 million to the square inch) dyed red, green and blue. See Fig. 5.10a. Behind this colour mosaic was coated a layer of panchromatic emulsion. When you exposed the plate the coloured grains acted like microscopic size filters. Special processing was needed to form a black and white *positive* image in the emulsion, whereupon the filters gave it a correctly coloured appearance when you held the plate up to the light. Results contained delicate colours and were attractive, provided you did not magnify them too much and reveal the mosaic pattern.

Soon many other European screen mosaic materials appeared, first on plates and later on film. They included Paget, Thames, Agfa, and Finley. The most famous of these was Dufaycolor (Fig. 5.9) made in sheet film, rollfilm and movie film from 1935 until the 1950s.

The main disadvantages with all colour materials of this kind, using screens, was the long exposures needed because so much light was lost passing through the layer of filters. In the case of Autochrome this brought plates down to an effective ISO speed of only 0.2, which meant they required 1-2 seconds exposure at f8 in bright mid-day sunlight. Final results were very dark-looking relative to slides today, particularly when projected. It was also impossible to make acceptable colour prints from screen material.

Fig. 5.7. At first you needed three B & W negatives to make a colour print. This one-shot camera contained mirrors and separately filtered plate holders. Advertisement from *British Journal Almanac* 1939. See also Fig. 5.12.

Equipment for three-colour work

Lack of a satisfactory colour system offering prints was especially frustrating to professional portrait photographers, and remained that way throughout the first 40–50 years of the twentieth century. The better quality studios knew there was a potential market from clients prepared to pay well for portraits and groups 'in natural colour'. Such people were not really satisfied with hand-coloured black and white prints, however skilfully done. They wanted high quality colour images of at least whole-plate $(16.5 \times 21.6~{\rm cm})$, which you did not have to hold up to the light to see.

Photographers were forced to accept that they needed to make three colour separation negatives in the camera – so it was important to have equipment which allowed you to expose the three plates in quick

Fig. 5.8. H. Essenhigh Corke. Mother and baby. Autochrome screen plate transparency, c.1910

Fig. 5.9. Dufaycolor sheet film transparency, actual size, c.1948.

Fig. 5.10a. Enlarged part of the original autochrome (left) shows its mosaic of dyed starch grains.

succession. One way to do this was to have a 'repeating back' for your plate camera (Fig. 5.11). Typically this accepted a long narrow triple plate-holder you quickly slid sideways a few inches after each exposure. Given strong lighting the whole set could be exposed in as short a time as 5 seconds. Better still some 'one shot' portrait cameras appeared, able to expose all three plates with one click of the shutter. Some of the earliest were based on the lens and mirrors systems used for viewing separation positives (Fig. 5.5) but with a shuttered camera lens instead of the eyepiece and accepting three plateholders in place of the three glass images. By the 1930s higher precision 'one-shot' colour cameras, made in wood and then metal were used for portraiture, commercial and advertising photography by professionals who could afford their high cost.

The trouble was that having got your separation negatives – hopefully matching in exposure, contrast and image size – you still had the enormous complexity of printing them yourself. Labs offering a colour printing service were extremely rare (in Britain only Colour Photographs Ltd, London, 1930–39). So professional colour photographers and a handful of amateur colour print enthusiasts struggled on their own with assembly processes such as 'Carbro' (Fig. 5.14.) or 'Wash-off Relief'. At their best their results were technically excellent, but the time and skill required made prints very expensive.

Multi-layer colour films

Stuck with screen-type materials for colour transparencies, and separation negatives plus assembly systems for colour prints, a huge market for popular colour photography was still not being met. Moviemakers too were looking for colour. Hollywood in 1932 adopted *Technicolor*, making separations by running three 35 mm films through a huge movie camera at the same time. The negatives from this three-strip camera were then printed using a mechanized form of dye-transfer to run off large numbers of excellent full-colour cinema release prints. Sixteen mm equipment had appeared for home movies, but colour processes using mosaic screens did not project well and so materials were effectively limited to black and white. Amateur cinematographers looked at what was happening in the commercial cinema and felt they were being left behind. The whole colour situation was frustrating and a great challenge for manufacturers of photographic materials.

Another approach, already suggested in du Hauron's book, was to devise a film triple-coated with three thin layers of emulsion – sensitive to

blue, green and red. Then in some way processing should turn each layer into a positive picture, each in its own distinctive colour dye, so that the film gave a fully coloured result. The effect would be somewhat like an assembly process, but all carried out within the multi-layer emulsion.

The chemical and physical difficulties in achieving a practical multi-layer film were immense. However, by 1912 German research chemists had shown how coloured dyes could be formed when a colourless 'colour developer' chemical liquid united with a colourless coupler chemical contained within an emulsion. The colour of the dye formed depended upon the composition of the coupler, which could be different in each layer. It was very difficult however to get such a system to

Fig. 5.10b. Enlargement of the mechanically ruled filter mosaic used in Dufaycolor films until 1950.

Fig. 5.11. Vivex repeating back clockwork driven, c1930. Filters and focusing screen are shown foreground. Linked by cable release to the shutter this exposed a rapid sequence of quarter-plate separation negatives, and fitted most large view cameras.

Fig. 5.12. Three-colour camera. Two semi-reflecting mirrors in the optical path reflect part of the light to a blue-record plate behind a blue filter, and part to a redrecord plate behind a red filter. The remainder of the light goes through to a third plate behind a green filter.

work reliably within a three-layer film structure because little was known about multi-layer coating in the 1920s. Each emulsion layer had to be coated equally and consistently to much tighter tolerances than black and white, otherwise there were variations in final image colour. Another problem was the coupler chemicals 'wandering' from their correct layers into the other emulsion layers.

During the 1930s Eastman Kodak in America and Agfa in Germany were secretly and intensively seeking solutions to these difficulties. In the end the race to be first was won by Kodak who produced Kodachrome. This was launched in 1935 as 16 mm movie film and as 35 mm still camera film a year later. The quality and brilliance of Kodachrome movies and slides made this colour material a success from the start. (It is still made in an improved form today.) In 1936 Agfa brought out their own multi-layer film, Agfacolor. This used a different chemical structure which made it less complicated to process than the Kodak colour film (Kodachrome needed over 20 processing stages on complicated machinery and until recently simplified was only handled by a few Kodak franchise labs around the world).

It was not until the 1940s, during World War II, that Agfa and then Kodak produced multi-layer colour *negative* films, designed to be enlarged onto multi-layer colour paper. The challenge here was still greater, because colour defects or contrast errors in the negative are further multiplied by any defects in the print material. Kodacolor first appeared in the USA as rollfilm. (Family cameras at the time were predominantly rollfilm – and although use of 35 mm was growing this size was more popular in Europe than in America.) The new film was backed up by Kodak processing and printing stations.

Neither Kodacolor nor Agfacolor negative films were generally available in Britain until about 1950. Germany had been defeated in the war, and

Fig. 5.13. Colour separation negatives (from a one-shot colour camera) used to make the carbro colour print on page 68.

this made Agfa's patented processes freely usable by other manufacturers. A great number of firms – Ansco, Sakura, Fuji, Ilford, Farrania – started producing their own brands of slide films. A few made colour negative films and printing paper. All these were based on pre-war principles which in turn had been suggested by du Hauron.

Instant colour pictures

Instant colour picture material (Polaroid) follows the basic three-colour principle, using multi-layer emulsions and images formed by dye coupling, but carries it through with entirely original chemistry. Dr Edwin Land's Polaroid Corporation research team pioneered their first colour print material in 1963. In a similar way to black and white instant picture procedure you pulled the exposed material from the camera as a sandwich of negative and print, held them for about one minute, then peeled them apart. See page 69. In 1972 Polaroid invented single sheet material which ejects from the camera as a white card on which a colour picture gradually appears. (Kodak introduced their own version of single sheet instant colour picture material in 1976, later withdrawn after a patent-infringement suit brought by Polaroid.)

Instant picture materials took immense skill and technology to produce in a reliable form, yet required no extra shooting or processing skills on the part of the user. In fact all colour materials have progressed in this general direction – from relatively crude triple exposures on regular black and white plates with the photographer doing all the work, to one of the most advanced of manufactured products.

The influence of colour materials

For nearly half the twentieth century photographers were lucky if they could achieve a 'natural colour' image on paper at all. Processes were so complicated, uncertain, prolonged and expensive that most creative workers preferred to use only black and white. People who did dabble in early colour were often technicians seeking colour accuracy – consequently results were often not visually very creative.

But as the cost of colour reproduction in printed publications grew less and results improved in quality, editors and advertisers were more prepared to commission professional photographers to produce colour images. These were mostly shot on multi-layer colour transparency film such as Kodachrome (available to US professional photographers as sheet film from 1938). It set up a preference for reproducing colour from transparencies rather than prints which remained for very many years.

Amateur use of colour films gradually overtook black and white but not until the 1970s; colour TV had also become general by this time, an important influence. As colour photography grew so did the processing laboratories, servicing amateur and professional photography with improved machinery and shortened procedures. Colour printing became easier for enthusiasts to do themselves too and, because of the volume of material sold, colour paper gradually changed from a very expensive commodity to something much closer to the price of black and white.

Although colour has grown to dominate photography, black and white has certainly not been cast aside. Important exhibitions show plenty of

Fig. 5.14. Print assembled by means of the tricolour carbro process, c.1940, a further adaption of the carbon process. From original separation negatives (Fig. 5.13.) final print size positives were prepared and dyed cyan, magenta and yellow, see above. Then each was pressed in turn onto white receiving paper, carefully registered to give the full colour result, above right. Royal Photographic Society Collection.

leading contemporary workers freely choosing to work in colour or black and white according to subject, approach and purpose.

Summary – the search for colour

- As soon as panchromatic emulsions appeared (1906) efforts were made to devise a practical form of 'natural' colour photography. Clerk-Maxwell's 1860 experiment demonstrating colour theory, and Ducas du Hauron's book on possible methods pointed the way.
- One early approach was to shoot three colour separation negatives on panchromatic plates, using deep red, green and blue filters. Negatives were printed onto lantern slides dyed the same colour as their taking filter. You used a viewer containing mirrors to combine all three images, or a triple projector to superimpose them in exact register on a screen.
- Culour prints on paper could be made from the separation negatives only with difficulty – using adaptations of the carbon process to

Fig. 5.16.

Fig. 5.17. A Kodachrome transparency taken in 1939. Kodachrome, invented 1936, was the first colour tilm tree of a mosaic pattern. Images were more brilliant and sharp than any other process. In a faster, improved form the same process is still used for slides today.

Fig. 5.18. Kodacolor negative c.1955. Film like this, supported by colour printing labs, heralded gradual growth in popular colour photography.

Fig. 5.19. Polacolor peelapart colour print material arrived in 1963. It used entirely new dye technology. You pulled a paper sandwich from the special camera, then about a minute later peeled them apart to get this finished colour print.

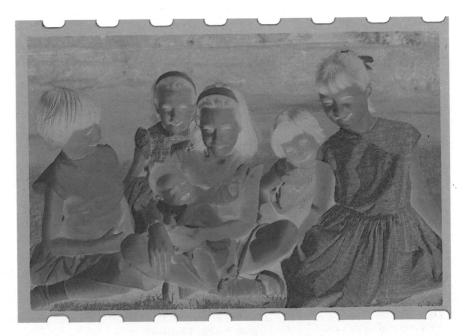

Table 5.1. Comparative film speeds

Material		H&D*	ISO	
1902	fastest B&W	650	20	
1907	Autochrome plate	1	0.03	
1925	fastest B&W	1000	30	
1934	Dufaycolor	125	4	
1935	Kodachrome	320	10	
1942	Kodacolor neg	800	25	
1942	fastest B&W	3200	100	
1946	Ektachrome	260	8	
1954	fastest B&W	13 000	400	
1956	Agfa neg	1250	40	
1956	Agfa rev	1600	50	
1957	Anscochrome	6400	200	
1965	fastest B&W	100 000	3000	
1976	fastest colour	13 000	400	
1987	Konica col neg§	106 666	3200	

^{*} Earliest 'twice the number double the sensitivity' system. Fell out of use in the 1940s.

'assemble' the final picture from a stack of three positive images each in a dye of a different colour.

 The first colour plates on sale (Autochrome, 1907) carried a mosaic of microscopic red, green and blue filters made of dyed starch grains over panchromatic emulsion. After a single exposure reversal processing of this emulsion gave a positive image and resulted in a colour transparency when held up to the light.

 Equipment to speedily expose three separation negatives of a scene included repeating backs, and 'one-shot' cameras. These were expensive items and still left you with the problem of making colour prints

using an assembly process.

 Research into multi-coated emulsions and chemical colour couplers resulted in Kodachrome. (Movie and slide film 1935~36, sheet transparency film 1938.) This could be used in existing cameras and was backed by Kodak's processing service. Agfacolor (1936) used colour couplers in a different way. Both gave excellent quality results for projection and for printed publications.

 The first colour negative films and corresponding colour print paper – Kodacolor, Agfacolor and others – became generally available about 1950. Since then many improvements in speed and colour quality have occurred, and materials have grown cheaper relative to black and white.

 Polaroid pioneered new chemistry to originate peel-apart instant picture material in 1963, and single-sheet material in 1972. Although innovative they still work on the basic principle put forward a century before by du Hauron.

[§] Approx 21 million times more sensitive to light than the original daguerreotype.

Improving camera design

It's true to say that photography was a nineteenth century invention, when many of the optical and chemical principles were discovered. But twentieth century technology has enormously improved the practical performance of equipment and made its use easier and more automatic. This is particularly true of cameras. After all, cameras started off large, clumsy, mostly crafted in wood – but have become tiny, full of micro-electronics, and turned out in metal or plastic.

Often it was developments in other fields such as optical glass, integrated circuits, mass production methods, even batteries . . . which opened up new stages in camera design. Each improvement gave better technical results (although there were one or two mistakes on the way). Photography itself also became much freer since you could mostly rely on getting sharp, correctly exposed and accurately framed images over a far wider range of subjects and conditions. Like the improvements in colour processes (Chapter 5) people were relieved to hand over the technical aspects of cameras to manufacturers, leave developing and printing to laboratories, and so concentrate on the actual pictures.

Equipment in 1900

To begin with imagine how photographers used cameras at the turn of the century. Professionals worked with folding 'view' cameras like Fig. 6.1, not greatly advanced over the old daguerreotype cameras (Fig. 2.1) used sixty years earlier. Plates, typically 'half-plate' 12×17 cm in size, were loaded into wooden holders in the darkroom. Even just half a dozen made up a bulky, heavy load for the camera case. Then having set up your camera on its tripod you focused the dim image seen upside-down on the ground glass at the back of the camera, using a black cloth over your head to shade it from the light. Next the glass was replaced with one of the plateholders, and a 'time or instantaneous' blind shutter fitted over the lens. A tasselled cord was pulled to close and tension the shutter so you could open the plateholder to the inside of the camera. When you pressed a rubber ball on a tube a small bladder at the shutter end inflated to release the blind. For long exposures you kept the bulb pressed and consulted your watch (the term 'B' for time exposures is still used today). When set to instantaneous the shutter opened for about 1/30 sec.

Fig. 6.1. Folding half-plate wooden camera with leather bellows, 1900. A roller blind shutter, left, pushed on over lens. Plate holders, right replaced the focusing screen to take pictures.

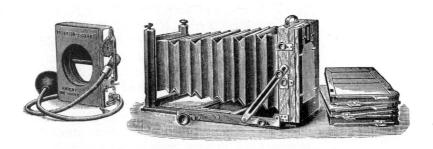

Fig. 6.2. To see the dim image on a plate camera's focusing screen you covered your head with a cloth, or even bought this eccentric device.

The 'Censabul' Focussing Chamber.

ADAMS & Co.

This consists of a bellows body with, at one end, an elastic gusset which is slipped over the back of the camera, and, at the other, cords which can be adjusted to the ears, thus allowing plenty of breathing space, and yet

does not disarrange the head gear. The focussing screen is completely shielded from all light, and there is no chance of its blowing away.

Prices: Quarter plate, 6s.; half plate, 7s. 6d.; whole plate, 8s. 6d.

Cameras used for landscapes or still life work had 'Rapid Rectilinear' lenses or better still an anastigmat Dagor. Widest apertures were typically about f8. For portraiture a Cooke Triplet lens might be used – this worked at a much brighter f3, but gave fuzzy detail in the corners of the picture unless used at smaller apertures. In fact the Ilford Manual of Photography for 1902, which rated quarter plates as small, advised 'When small negatives are taken for the purpose of making enlargements or lantern slides, it is scarcely ever advisable to use a stop larger than f32'.

Rollfilm cameras

Amateurs, if they were beginners, mostly used rollfilm box cameras now sold by several manufacturers. Kodak's simple 'Brownie' box cameras introduced in 1900 were far cheaper than the original Kodak No. 1 and sold in hundreds of thousands. For people who could afford more and wanted a camera less bulky than a box, a range of folding 'pocket' cameras had appeared by 1910. Both these and box cameras were designed to be used at waist level and took rollfilm pictures ranging from 12.7×17.5 cm $(5 \times 7$ in) down to 4×6.3 cm $(1^5/8 \times 2^1/2$ in). The most popular size was 6×8 cm $(2^1/4 \times 3^1/4$ in). Kodak made rollfilms for them all – and since each different model tended to be designed for film of a different width or type of spool a confusing range of about 30 different sizes of film were on sale. Today just one or two remain – size 120 rollfilms for example.

Folding rollfilm cameras had black folding leather bellows and used a little reflective viewfinder (Fig. 6.4) you pivoted 90 degrees when turning the camera for horizontal pictures. Most offered a choice of three or four shutter speeds and lens apertures from about f8 to f32. You could therefore take pictures under a wider range of lighting conditions than a box camera, although having a choice of controls made the cameras less simple to use. Box and folding type rollfilm cameras remained the most popular equipment

Fig. 6.3. The evolution of camera designs. Simple Daguerre and Talbot type cameras, top left, led through folding and box cameras to professional and compact amateur cameras today. Reflex camera obscuras inspired twin lens, then single lens reflex designs.

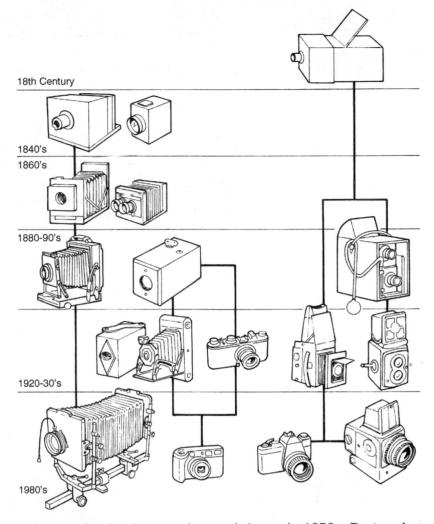

for the average family photographer until the early 1950s. During that time you made use of processing and printing services provided by your neighbourhood chemist – he made up the solutions from the general range of raw chemicals chemists then stocked, and did the work by hand in a darkroom behind the shop.

Better optics, precision cameras

People were torn between having a rollfilm camera which gave contact prints big enough for an album or a small frame, or something smaller (categorized as a *miniature* camera) easily carried but still able to give good enlarged prints. The trouble with enlarging, apart from cost, was that neither lenses nor films were good enough to give results with the same detail as a contact print. New forms of optical glass which had been researched and produced in Germany at the end of the 19th century made possible the manufacture of better lenses. By combining different kinds of glass in groups of lens elements, and making these in different shapes, natural optical errors (aberrations) were increasingly neutralized and image sharpness improved.

In 1914 a designer called Oscar Barnack, working for the German optical microscope makers Leitz, constructed a small camera for himself. It had a rigid metal body and took photographs 24×36 mm ($1 \times 1^{1}/_{2}$ in) using short lengths of 35 mm wide perforated movie film that Barnack

Fig. 6.4. Basic folding rollfilm camera, 1930.

Fig. 6.5. Popular cameras advertised in a catalogue for 1938. All are German made. Leica-type view-finder cameras and twin lens reflexes were usually chosen for serious amateur photography.

managed to obtain. See page 50. Ten years later Leitz put an improved form of this camera on sale as the Leica (a name made up from LEItz CAmera). This was the first *precision* miniature camera. It had an excellent specially designed f3.5 lens, but the limiting factor for quality remained the coarse grain pattern which appeared when such small film was enlarged up. The lack of image resolving power in film of the time remained a discouraging factor against all 35 mm cameras, even the Leica, until emulsion improvements in the 1930s and 40s.

Professional users of hand cameras therefore kept to equipment like the 1925 Ermanox 6×9 cm plate camera with its eye-level viewfinder and f1.8 (then world's fastest) lens. See page 100. Using the Ermanox with the most sensitive plates available you could often give instantaneous exposures with existing lighting indoors, instead of burning flashpowder. 'Candid' photography was possible. Newspaper Press photographers of the 1930s also used plate cameras such as the American made 4×5 in 'Speed Graphic'. These were fitted with a large flashbulb holder and wire frame finder, page 82, for use hand-held at eye-level. Newspapers preferred their photographers to use plates as these could be individually processed in haste.

During the years just before World War II serious amateurs typically used German precision cameras such as the Leica or a Zeiss folding rollfilm type, or a Rolleiflex. The Rolleiflex (Fig. 6.7) appeared in 1928 and derived its name from 'rollfilm reflex'. Its ingenious design was based on twin lens plate cameras 40 years earlier, page 52, was less bulky and yet gave a reasonable size 6 cm $(2^{1}/4 \text{ in})$ square negative. Twin lens design allowed

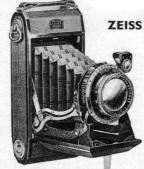

ZEISS IKON NETTAR

With release on body

This is the series for the user who covets a genuine Zeiss camera, but who can only spend a limited amount. The Nettar is basically similar to the Zeiss Ikon Ikonta and only by minor constructional differences has its amazing low price been made possible.

Self erecting — rigid — handy and well finished it is truly amazing value.

All Nettars use $3\frac{1}{4} \times 2\frac{1}{4}$ in. roll films. 8 exposures. Models marked * take 16 pictures $4\frac{1}{4} \times 6$ cm.

Lens and Shutter	No. 510 *	No. 510/2	No. 515 *	No. 515/2
Nettar f/6.3, Derval	£3 7 6	_	_	£3 12 6
Nettar f/6.3, Telma	£4 0 0	-	_	£4 2 6
Nettar f/7.7, Automat	_	£2 12 6	_	-
Nettar f/7.7, Automat D.A.	-	£3 5 0	-	_
Nettar f/6.3, Klio	_	_	_	_
Nettar f/4.5. Kllo	_	_	£5 12 6	£6 5 0
Nettar f/4.5, Telma	_	_	£5 0 0	£5 10 0
Nettar f/4.5, Compur	_	_		£7 5 0
Nettar f/3.5, Compur-rapid	_		_	€9 10 0
Tessar f/4.5, Compur-rapid		_	_	£9 17 6

27

For Easy Payment Terms, see page 3.

ZEISS-IKON 6 × 6 cm. IKONTA

A handy pocket model built to the usual Zeiss Ikon constructional standards—easy to load, rigid and light, with D.V. finder and release on camera body.

87

<u>Ieitz</u>Leica Roll Film Camera

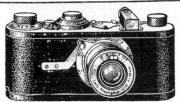

A real pocket camera, size $5\frac{1}{4}'' \times 2\frac{1}{4}'' \times 1\frac{1}{4}''$. Weight only 16 ozs. Focal plane shutter. Anastigmatic lens F/3.5. Automatic film winding Daylight loading Illin. Negatives $1^* \times 1\frac{1}{2}''$. Enlargements to almost any size. Illustration half scale. Complete with film carriers for 108 exposures, in leather case, with shoulder strap and handle. £18 12s. od

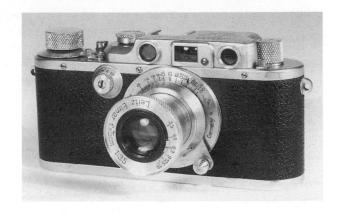

Fig. 6.6. The 1924 Leica, world's first precision 35 mm camera. On the right is a 1960s model of the same camera.

you to compose and visually focus on a full negative-size screen on top of the camera. Above all the Rolleiflex had an outstanding f3.5 Zeiss Tessar taking lens.

SLR cameras

Plate cameras of single lens reflex design were already useful professional tools in the 1920s, mostly for hand-held photography and for portraiture.

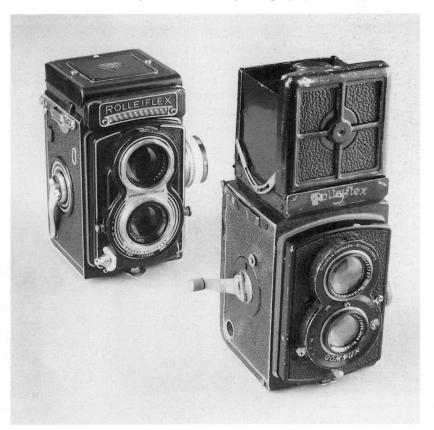

Fig. 6.7. The first rollfilm twin-lens reflex, the 1928 Rolleiflex, shown with its 1960s model. Compare these cameras with Fig. 4.17.

This was because you could accurately check composition, focus and expression right up to the moment of exposure, and the glass negatives (typically quarter-plate) were large enough for retouching faces. Basically the SLR plate camera was designed along similar lines to the reflex camera obscura, page 2, containing a mirror which allowed you to see and focus the image right way up on a horizontal ground glass screen. It looked like a large box (Fig. 6.8), with a leather hood folding out of the top to shade unwanted light when you look down onto the screen.

Turning a knob on the side of the camera moved the lens, (which was connected to the body by bellows) backwards or forwards for focusing. When you pressed the shutter lever the large hinged mirror in the body raised out of the way, allowing a blind just in front of the plate-holder to expose the picture. You could select various instantaneous speeds or a B setting exposure.

In 1936 lhagee in Germany launched the first successful single lens reflex for 35 mm film, the *Kine Exakta*. It was the forerunner of today's SLR, but many improvements to its features were needed before it reached the sophistication of present cameras. Imagine the problems. Using a 1936 Exakta the first thing you notice is that the image on the screen appears reversed left to right. And if you turn the camera on its side to take a vertical picture the image appears upside-down!

To achieve best definition you need to stop the lens down to about f11, making the picture dim to compose and focus. Exposure settings have to be guessed from tables or measured with a separate hand meter. Firing the shutter leaves you with a completely black focusing screen, because the mirror stays up until you wind on the film. And finally, after every shot you must open up the lens aperture from its previous stopped-down setting to clearly compose and focus your next picture. The new 35 mm size SLR was mechanically complex and expensive, but was the first small hand camera which allowed really accurate composing and focusing. And it had the potential for fitting interchangeable lenses. Gradually each disadvantage which put people off SLR design would be overcome.

World War II halted export of German made equipment. Individual countries were forced to rely on their own cameras, lenses and film, now mostly directed to Air Force and military needs. Soon after 1945 new designs slowly began to appear, despite a prolonged shortage of raw

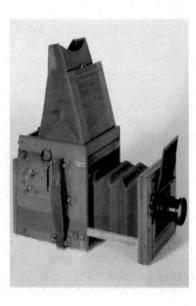

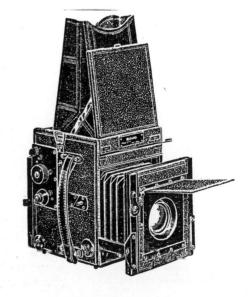

Fig. 6.8. The Soho single lens reflex quarter-plate camera, popular in Britain for portraiture and general hand-held professional photography from 1910 until the 50s. (Near right shows varnished woud 'tropical' version of the most widely used model, far right.

Fig. 6.9. This 1937 German-made Exakta was the first 35 mm single lens reflex camera. It had a small ground-glass focusing screen on top, within a folding hood.

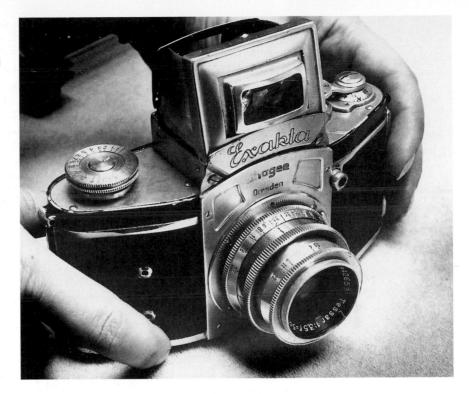

materials. By 1948 for example a precision SLR rollfilm camera first developed in Sweden for the Air Force by Victor Hasselblad started to rival the Rolleiflex.

As the lens and camera industry struggled to re-establish itself in a divided post-war Europe the Japanese began to design and manufacture precision cameras. They seemed more able to relate to new technology and apply skills of mass production. Development of the 35 mm SLR was of special Japanese interest. In 1948 lens aperture pre-setting was introduced by Pentax, allowing you to rapidly alter the lens from maximum (for focusing) to the taking aperture without taking your eye away from the focusing screen. In East Germany Zeiss Ikon were first to fit a pentaprism block of glass over the focusing screen (of the Contax S) to make the SLR usable at eye level – with the image right-way round and remaining upright when the camera is used on its side. Next, in 1954, Pentax introduced the first return mirror, restoring the image to the focusing screen of their cameras immediately after exposure. When miniaturized electronics appeared in the 1960s Pentax were also one of the first with a system of 'through-the-lens' light metering (page 81).

Single lens reflex cameras soon developed into 'systems'. Each manufacturer – Nikon, Canon. Pentax, Minolta – built up their own range of lenses, data backs, motor-drives etc., making their camera bodies ever more versatile. As always, the SLR allowed you to see exactly the image which would be recorded on film. New ways of designing photographic lenses with the aid of computers, plus greatly improved 'coating' of multi glass surfaces to reduce reflections, accelerated development during the early 60s. Designers could combine a dozen or more components in one lens and still get a brilliant, full contrast image. This made it possible to introduce high quality extreme wide-angle and telephoto lenses, 'fisheyes' and zooms. (Most of which were heavily exploited by the new young trendy

generation of professional photographers reaching stardom in the 'swinging sixties', see Chapter 10.)

Professional equipment

Professional photographers have always been more cautious than amateurs in adopting new equipment. And since they make up only a tiny proportion of the total market for cameras far fewer designs have been manufactured for their particular needs. However, the trend has also been towards smaller cameras. During the early 1950s twin lens rollfilm reflexes started to replace plate cameras (now adapted to sheet film) for both studio and Press photography. In fact the Rolleiflex seemed to be the camera without which no aspiring 50s professional was well dressed. It was soon replaced though by the Hasselblad, especially for fashion and advertising work – this SLR's accuracy of framing, interchangeable lenses and quick-change magazines to film-hop between monochrome and colour greatly speeded up studio photography.

After a reluctant acceptance of 35 mm by newspaper darkrooms during

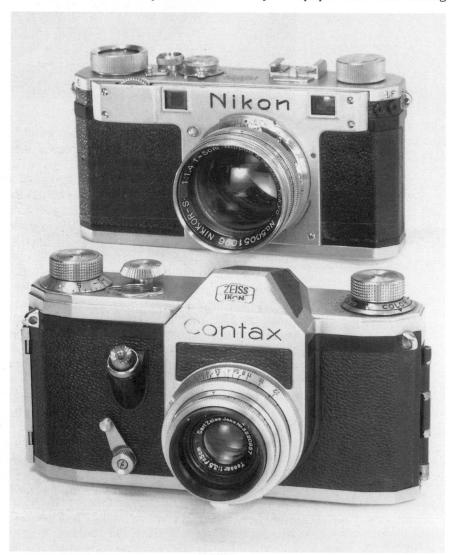

Fig. 6.10. Recovery from the 1939-45 war marked the beginnings of the Japanese precision 35mm camera industry. At first cameras were copies of German pre-war designs like this 1947 Nikon1 based on the Zeiss Contax (see Fig. 6.5). Meanwhile Zeiss, now in East Garmany, produced the first 35mm SLR with pentaprism viewfinder - the 1949 Contax S.

the early 60s, press and documentary photographers could turn to 35 mm SLR cameras (such as the Nikon F). Clinching factors were the speed and quality of new 35 mm films, the extensive range of lens focal lengths including wide apertures, and motor-drive backs. Comprehensive camera kits were easily carried and quick to use.

On the other hand professionals specializing in architecture, studio still-lifes, or any subjects needing older camera features – such as single picture processing or special perspective controls – still found larger format equipment unbeatable. Modern forms of view camera had appeared in the late 1950s still using bellows but replacing wood with metal. See Fig. 6.11. They were known as monorail designs, since they were mounted on a rail on the tripod. This allowed far more extensive 'camera movements' – adjustment of the angle and height of the camera front relative to the back to help control sharpness and image shape.

Monorail cameras mostly use sheet film 10×30 cm $(4\times5$ in) but also accept a range of other backs such as Polaroid and rollfilm types, and this helps to allow them to keep up-to-date. As comparing Fig. 6.11 with Fig. 6.1 will show, monorail cameras still have a similarity to the view cameras of 1900, although using shuttered lenses of far higher quality. In fact the manufacture of a few view cameras in hardwood and brass was re-started in the 1980s. They remained much loved by some professionals not needing a great range of camera movements.

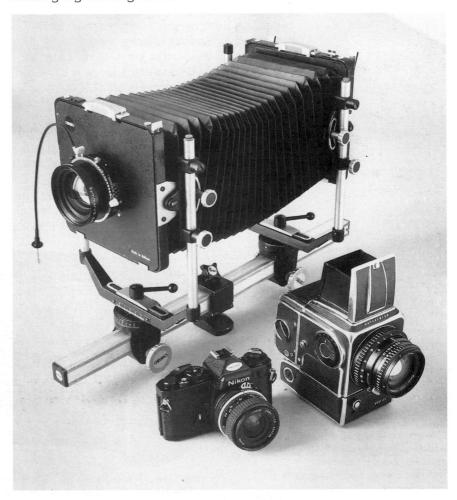

Fig. 6.11. Professional type cameras of the 1980s. Top left: 4 x 5in Cambo. Bottom left: Nikon 35mm SLR. Bottom right: Hasselblad rollfilm camera.

Fig. 6.12. Disc camera, with 15 exposure film disc after processing.

Amateur 'compact' cameras

As for low cost cameras for beginners, the mix of box and simple folding types changed during the 1950s. New plastics and precision moulding techniques then made it possible to make solid body direct viewfinder cameras of acceptable precision for smaller film sizes. Folding pocket cameras with their more costly and complicated bellows design quickly disappeared. The quality of results from these more modern-looking cameras fitted with f5.6 lenses were reasonable for the price. The few controls were marked with weather symbols, and focusing chosen between 'portraits' and 'landscapes'.

Cameras of this kind accepting 35 mm cassette film gradually dominated the market, although equipment for other film formats regularly came and went. 1963 brought the much-hyped cheap 'Instamatic' drop-in cartridge loaded camera, largely replaced in 1972 by much tinier 110 cameras and film giving 13×17 mm images. Ten years later Kodak launched disc cameras (Fig 6.12). These were loaded with a flat disc of (only) colour negative film which allowed 15 pictures 8×11 mm. All these viewfinder cameras were popular for a time but the disc was a step too far. The photolab industry had become enormously improved and mechanised during the 70s but image quality from disc negatives, which had to be enlarged \times 10 to make $3^{1}/_{4}$ in wide prints, varied from different labs and was often not accepted by the general public. Kodak ceased making disc cameras in 1987, by which time good quality cameras for 35 mm cassettes were appearing from almost every manufacturer. The advantage of 35 mm is that no other film size offers a greater range of colour and black and white emulsions, or lower cost per picture. Labs are most geared up to handle this size, already the standard for SLR small format camera designs.

However not everyone is an SLR enthusiast and many people wanted an 'all-one-unit' compact camera (no lenses or attachments to carry about) which would give a high success rate in focusing and exposure, yet handle all the technicalities automatically. The 35 mm compact has since undergone a steady stream of improvements – built-in flash; film speed sensing and programmed exposure setting; auto-focusing; and zoom lenses of high quality. Continual miniaturization of components has allowed all these improvements without much change in the weight or size of the camera as a whole. By making most technical decisions for the user via built-in logic, resulting pictures became somewhat stereotyped – less scope

Fig. 6.13. Simple 35mm cassette camera and (foreground) 110 pocket camera. By the 1970s compact cameras like these replaced old box and folding types for beginners.

Fig. 6.14. Thanks to miniaturized electronics compact 35 mm cameras of the late 80s offered enormous technical improvements ~ metering, auto-focus, zoom lens, flash.

Fig. 6.15. A 1903 actinometer. The hole to expose the sensitive paper is below the word 'meter'. See text.

Fig. 6.16. Photo-electric exposure meters. A light-sensitive cell at the back of the meter converted light intensity into electricity.
Front: First (1932) Weston.
Rear: 1965 model.

for visual experiment and happy accidents. But automated cameras also gave the average user much greater confidence that results would always 'come out'. People were less hesitant in using equipment, found it much easier to concentrate on the subjects of their photographs. In a way the wheel had come full circle – back to Eastman's old slogan 'You press the button, we do the rest...'

Exposure measurement

One of the greatest improvements technology has given us is the ability to give correct exposure over a very wide range of subjects and conditions. Anyone working during 1900–1920 would either guess, perhaps working from notes, or try consulting elaborate tables detailing time of year and day, weather conditions, latitude, subject type etc. Another method was to measure the light with an 'actinometer' (Fig. 6.15), simple devices often styled to look like pocket watches of the period. They contained a disc of self-darkening paper. You moved the disc to make a small unexposed area appear behind a hole in the dial, then timed it with a real watch to see how

long the light took to darken the paper until it exactly matched a standard grey tint. This time was converted into camera shutter and f number settings on a dial around the outer rim. During the 1920s photographers could also use a 'visual extinction meter' — a tube having glass tinted in a range of greys at one end. You looked at your subject through the tube noting the darkest grey through which your eye could just make out detail.

Electric meters able to convert light intensity into measurable electric current appeared in the 1930s. They were much more accurate – vital for the new colour slide films – but were huge in size, heavy, and cost about £20 (two months average wage). Gradually these 'photo-electric' meters became cheaper and smaller, but since they were current generators like solar panels on pocket calculators, the smaller the measuring cell the less sensitive it became. Anything small enough to clip onto an actual camera body really only worked in bright light.

During the 1950s a few viewfinder cameras offered 'automatic exposure' by mechanically linking meter and camera. The built-in meter

Fig. 6.17. A flashbulb gun attached to a professional 4 x 5in MPP press camera (a 1940s British copy of the American Speed Graphic).

read the light level, and as you started to press the shutter release the meter needle was clamped, crudely controlling how far the lens was stopped down by further release pressure. Linked systems greatly improved in the early 60s when tiny (CdS) cells arrived. These required battery power but responded to much lower light levels. Thanks to new button size batteries it was at last possible to build inside cameras meters able to measure the actual image light passed through the lens. During the 70s the system was further improved by shutters timed electronically instead of by mechanical means – they could be wired direct to the meter and so allowed truly automatic exposure control. Ten years later computer-type microchips appeared, making possible a wide range of exposure-setting programmes chosen automatically by detailed factors such as the focal length of the lens in use, and speed and distance of subject. Having so many electronic rather than mechanical components saved space and allowed still more functions to be built into small camera bodies. This helped the evolution of lens auto-focusing systems and other improvements during the 1980s and 90s.

The effects of technical improvements

The modern camera is like a modern car, which has a lot of technology under the bonnet but is designed so that you can concentrate on the road. Industrial developments, especially in optics and electronics, have continually enriched camera design. This in turn gave photographers freer opportunities to tackle new subjects, produce unusual images, take pictures under previously impossible conditions. New ways of using the results opened up too. Back in the 1930s for example, a new American illustrated news magazine *Life* grew enormously popular by publishing the candid type of photojournalism made possible by unobtrusive cameras such as the Leica. See Chapter 7.

Development of new cameras and films extended scientific and technical applications of photography too. Aerial photography became a vital part of map-making, and surveys of environmental and archaeological sites. Photography documented research, and publicized new projects. Specialists in natural history, medicine, astronomy, underwater studies etc., also benefited. Although professionals had been sceptical about features like autofocus and auto exposure born out of the amateur market, they eventually demanded them too when recognized as being reliable and efficient.

As for the amateur, camera design plus huge improvements in processing and printing back-up services changed photography from a hit-or-miss affair. They were no longer put off by meters to be consulted, settings to be made, distances to be estimated. Growth in the use and therefore manufacture of cameras brought prices down (in wage-related terms a late 1990s autofocus, auto-exposure zoom lens compact cost one-sixth the price of a Kodak No. 1 box camera in 1888). And even if you didn't want to invest that much, 'one-use' disposable cameras introduced during the early 90s gave excellent small print results at little more than the price of a film plus processing. Everyone could take photographs, and did so.

Collectively the ease of carrying a camera, assurance in getting results, and consequent mass-usage of photography in society made photography of increasing interest to artists. From being a trade or casual hobby, use of a camera became almost as free as a pencil or brush, a creative activity. Photographs were seen as meaningful – something painters and sculptors realized they must comment on and even incorporate within their own work. The ebbs and flows (battles and arguments) in the ways photographs have actually been used are shown in Part 2 of this book.

Fig. 6.18. A 1946 amateur flashgun. As shullers were not then wired for flash this used a plunger/switch you screwed into your camera's cable release socket.

Summary - improving camera design

 Plate type view cameras were still used by most serious photographers during 1900–1920. Beginners had rollfilm box cameras or folding cameras. View cameras were slow and ponderous to work. Poor lenses of the time had to be well stopped down for subjects demanding detail. This added to the long exposures needed for the low sensitivity materials.

 Box cameras, cheaper but more bulky than folding 'pocket' rollfilm types, had fewer controls and needed good lighting conditions. Both were made in a confusing range of rollfilm sizes. Chemist shops did

amateurs' processing, by hand.

The first precision 'miniature' 35 mm camera, designed by Oscar Barnack, was marketed as the Leica, (1924). Grainy qualities of 35 mm movie stock however showed up badly in enlargements.

 Professionals using hand cameras (e.g. Press) mostly kept to plate cameras like Ermanox or Speed Graphic types. By the 1930s twin lens reflex Rolleiflexes became popular for serious amateurs who could afford them. Rolleiflexes and Leicas began to win over professionals to smaller formats after World War II.

• SLR cameras, originally bulky plate cameras for portraiture, gradually appeared as 35 mm models (1936 Exacta onwards). But refinements taken for granted today were absent. The rollfilm SLR made by

Hasselblad appeared in 1948.

 New technology and Japanese manufacturing during the 50s and 60s brought SLR improvements. Pre-settable aperture, pentaprism eyepiece, fast return mirror, TTL metering . . . by the 1970s SLR 35 mm designs had become tools for serious amateurs and professionals alike.

 Professionals requiring the extra final image quality possible from larger format negatives kept with rollfilm SLRs. For architectural and technical work up-dated sheet film view cameras (e.g. monorail designs) remained appropriate.

 Amateur cameras developed mostly into pocket size solid body types during the 1950s. Instamatics, 110, and disc cameras came and went

as diversions. 35 mm became the dominant film size.

Miniaturized electronics contributed to the automation and therefore
picture success rate of amateur cameras. Direct viewfinder solid body
types improved and competed as 'all in one' alternatives to the SLR
kit. Built-in flash, motor drive, autofocus, zoom lens and totally
programmed operation – all without increase in size – made these
'compacts' the most popular design of the late 1980s and 90s.

 Exposure calculation at the turn of the 19th century grew from paperdarkening 'actinometers' and visual meters to (1930s) photo-electric cell meters. Thirty years later tiny battery-powered cells could be built into camera bodies and electronic links with shutter and aperture

allowed programmed exposure control.

 Developments in cameras since 1900 – mainly during the second half of the century – made possible much more diverse and freer kinds of photography. It became an important tool in science, commerce and medicine. Simpler camera-handling techniques and universal use of photography by society encouraged more artists to explore it as a creative medium.

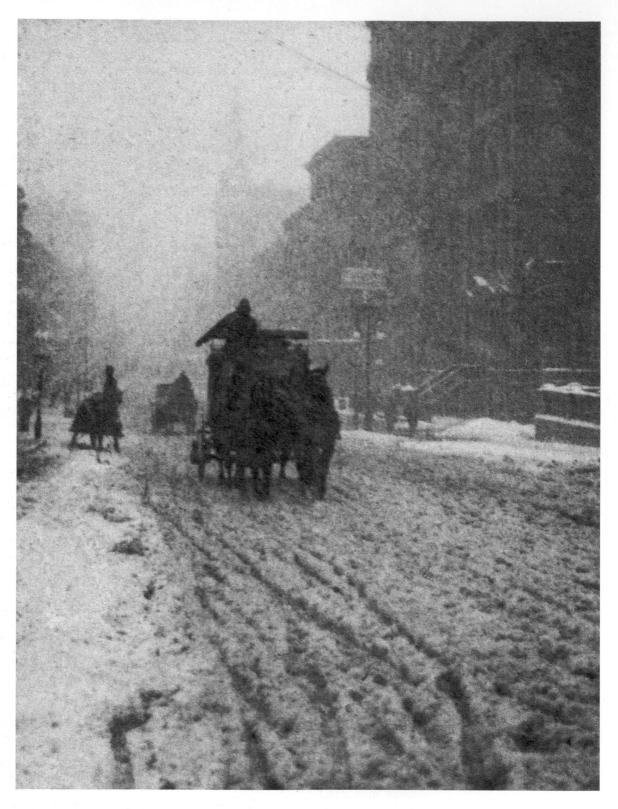

Winter on Fifth Avenue 1892, by Alfred Stieglitz. From 'Camera Work', Octuber 1905.

Part 2 – Subjects, styles and approaches

Introduction

So far this book has been concerned with photography's technical history – its year by year progression of improved processes, better equipment, materials and methods. Where work by individual photographers was seen this was mostly to illustrate the sort of pictures one process or another made possible. Technique is however only a means to an end. Gradually, as the tochnical limitations of photography became less, choices could be made between subjects and the various ways they might be interpreted in pictures. Of course, some subjects were considered more 'suitable' for pictures than others, according to people's taste at the time. But photographers (if they were perceptive enough) could now express a point of view, use the medium as language. For some this meant romantic picturesque studies; for others photographs which documented and revealed situations like poverty, or were harnessed to some scientific and technical application. Still others were absorbed by the visual appearances of shapes and forms, picture structure irrespective of what the subject actually was. A great range of different kinds of photographs therefore grew and developed, reflecting the varied interests of people using cameras - people whose attitude to photography was often so individual that only their use of the process itself linked them together at all.

Photographers have also been hugely influenced by current ideas on 'good art', and attitudes to life generally. Some of these seem quite odd today, for even photographers who were rebels were often rebelling against things which have now completely changed. 'Movements' and 'groups' appeared names used to pigeon-hole various people working at one time and make them easier to recall. However, this categorizing is only a learning aid, for photographers, like painters, seldom join movements as a movement. More often they are individuals concerned with expressing ideas, particularly when these overturn the previous generation's cherished beliefs (art thrives on conflict).

Mostly groups got together to put on exhibitions, the only way serious photographers could at first publicize their efforts. Shows were like religious crusades. Catalogues poured scorn on rival groups while containing extravagant claims of their own importance. Some movements adopted strange fetishes too, like frowning on any manipulation of the image before processing (but approving it in printing). Retouching was expected on negatives but discouraged on prints, etc.

This second half of the book looks especially at photography as a developing art form. It discusses what, for convenience, are labelled documentary, pictorial, modernist, or post-modernist approaches, and deals with abstraction and realism of various kinds. It explains the meaning of these terms, showing and comparing work and discussing the aims of a representative number of photographers. Space limits what can be shown here, so it is especially important to back this up by looking at collections of work by particular photographers. When possible go to see original photographic prints in museums and gallery shows – to experience their artist-intended size, surface texture, and colour.

The chapters which follow concentrate on what and why photographs were taken rather than how they were produced. So try looking at the pictures here as they might have been received at the time they were taken . . . not as seen today, influenced by millions of photographs which followed later. Read generally about the period too. Get acquainted with the pioneering spirit of nineteenth century America, the conventions of living in Victorian Britain, the restlessness of Europe between the two World Wars, the 'swinging sixties', changes in attitude towards social inequality and human rights. The date table on page 201 will help you relate each dry planement to other greats at the time.

relate each development to other events at the time.

The documentary approach

Photography, even in its earliest form, had always been admired for its detail and apparent 'truth'. After all, it needs light from an actual subject whereas a drawing or painting – or a written description – can be conjured up purely from the imagination. Photography enabled accurate records of scenic views, portraits and events to be handed around, or printed as engravings, or used for lantern slides. Later the audience they reached vastly increased when it became possible to mass-reproduce photographs on the printed page. Choice and juxtaposition of pictures in the way they were presented also became important, although not fully appreciated at first. Look at the powerful way life styles can be compared simply by publishing two pictures together (Figs 7.1 and 7.2).

So although documentary photography means pictures of actual situations and events, composition, choice of moment etc., may be used to help communicate the photographer's personal feelings and ideas too. Hopefully he or she will have researched and understood the subject, and will recognize what is significant, what points need to be made...

This chapter traces the growth and achievements of early documentary photography and discusses some problems which arose. It shows why certain kinds of pictures were taken and where they were used. It also introduces a selection of work by photographers famous for documentary projects.

The beginnings

The simple beginnings of documentary photography can be found in the record work of Philip Delamotte (page 26), also travel pictures by Francis

Fig. 7.1. Even 100 years ago documentary photographs could make startling comparisons when presented together. Typical Victorian English family, 1890s.

Frith and photographers commissioned by firms such as the London Stereoscope and Photographic Co. People were extremely interested in detailed pictures of far away places, famous people and important events. Roger Fenton's battlefield landscapes and groups in the Crimea were authentic documentation of war, although dull by today's standards. Sponsored by print publisher Thomas Agnew, Fenton went with the blessing of the British Government. A great scandal had occurred – five soldiers died from disease for every one killed by the Russians. A new government needed to prove that they were now giving troops the right facilities. This is one reason why Fenton's 360 pictures often show orderly camp scenes, supplies (Fig. 3.8), formal groups of officers, and battlefields long after the action Dead bodies are rarely shown. People said 'the camera could not lie', although reality and truth were being distorted even then, in 1855.

Mathew Brady. Fenton was the first but not the most prolific documentary war photographer. The American Civil War (1861–1865) was covered far more extensively, using photography which did not sidestep the carnage (Fig. 7.3). The idea of covering this war was the brainchild – and obsession – of one Mathew Brady, well known proprietor of fashionable portrait studios in New York and Washington. Brady had already published a portrait series of 'Illustrious Americans' and was convinced of the historic importance of documenting the war. He received reluctant official clearance to work in the battle zones, but no financial backing. However Brady spent thousands of dollars putting teams of collodion photographers into the field to cover most important aspects of the war. Some 7000 negatives were taken, mostly by employees, although all credited as 'Brady photographs'.

Of course, other photographers covered war scenes too, but none with Brady's thoroughness and organization. He saw himself as the pictorial historian of his times, and his obsession with the war photographs contributed to his financial downfall. After the war ended in 1865, people were too sickened by the conflict to want reminders. The government were

Fig. 7.2. An Indian family photographed during the Madras famine 1878.

87

Fig. 7.3. Dead Confederate sharpshooter at the Gettysburg battlefield 1864, by Tim O'Sullivan.
O'Sullivan headed one of the many photographic teams Mathew Brady sent out to cover the American Civil War. They used converted wagons as mobile collodion darkrooms.

Fig. 7.4. O'Sullivan later became official photographer to government geological expeditions exploring little-known US western territories. This 1873 view documents Canyon de Chelley, Arizona. The expedition's tents can just be seen near the bottom of the picture.

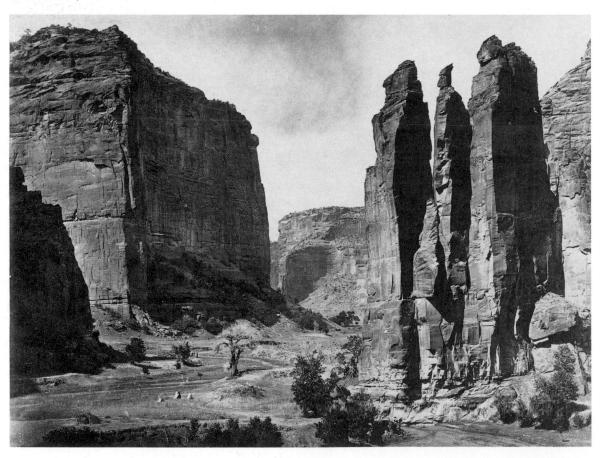

Fig. 7.5. Scenic photographer William Jackson pioneered thousands of pictures like this Provo Falls viewcard, about 1870. He used mostly 10 × 8 in and stereo collodion cameras. Note the man included for scale.

not at first prepared to buy the collection and by the time Brady had been voted a realistic sum he was hopelessly in debt.

Today most of the Brady pictures are housed in the Library of Congress, Washington.

Tim O'Sullivan. A few years after the war an ex-Brady photographer, Tim O'Sullivan, was working at another new aspect of documentary photography. The now United States sent out expeditions to map and discover geological information about its lesser known territories – Nevada and the Rockies, Panama, New Mexico. Photography was the ideal way to document the mountains, passes and other scenic marvels to show in detail to officials back home in Washington DC. Imagine how exciting it must have been to take pictures like Fig. 7.4 of a virtually unknown canyon. They would have been the equivalent of today's space survey photographs of other planets.

William Jackson. Other photographers trekked West with those packhorses and tented expeditions of the late 1860s and early 1870s. The most famous was William Jackson, a professional photographer who

Fig. 7.6. During the 1870s small 'before' and 'after' photographic cards were sold to help Dr Barnardo's East End Juvenile Mission.

freelanced scenic views along the newly completed Union Pacific Railroad, then joined surveys through Wyoming and the Yellowstone region. Like O'Sullivan he had a flair for landscape composition, using 28×36 cm (11×14 in) or 20×25 cm (8×10 in) wet plate view cameras and stereo cameras. Jackson's photographs of the wonders of Yellowstone were exhibited in the halls of Congress as evidence of expedition discoveries. They strongly influenced votes in passing the 1872 bill creating Yellowstone as the first US National Park.

Several of the natural features these surveys discovered were named after members of the expeditions, including their photographers. Hence Jackson Canyon, Jackson's Lake, Mount Haynes, Mount Watkins and others are all reminders of pioneer documentary photographers.

Social documentary

Dr Barnardo. Just as Brady pictures helped to show what war was really like, documentary photography was gradually put to use revealing the lives of the poor and underprivileged. Dr Barnardo, famous British founder of homes for destitute boys, started using photography as early as 1870. He was shrewd enough to have professional photographs taken of boys as they appeared on arrival (Fig. 7.6) and again when they left the Barnardo homes. Each photograph was mounted on a card like a cartede-visite, with text printed on the back explaining the work of the homes. Cards were sold and collected in sets. They created very effective publicity as well as raising funds to pay for food and clothing.

John Thomson. A few years later, in 1877, a book called *Street Life in London* was published by social reformers John Thomson and Adolphe Smith. It described the lives of various specimens of the London poor and contained 36 Thomson photographs (reproduced by Woodburytype). The photographs documented examples of the various trades of the times

John Thomson's collodion pictures are 'set up' in the sense that most of

his subjects were posed in their normal environment, a street crossing sweeper or a newspaper seller. He photographed them in an unsentimental but rather detached way – like carefully recorded examples of an unusual tribe or species. (The painter Bruegel recorded medieval peasants' activities in a similar way.) Nevertheless it was quite a breakthrough to publish photographs of such 'unsuitable' subjects as the poor and neglected . . . some people thought it mis-use of an artistic medium.

Paul Martin. New snapshot cameras from the late 1880s onwards made it easier to create photographic records of ordinary people's lives in a less formal way. Many such pictures have become lost with time, but a few collections remain and now give us valuable information. There exists for example much work by Paul Martin, a London wood engraver who foresaw that the introduction of the half-tone block (page 55) would soon make him redundant and so turned photographer. Martin handled the normal run of professional work but also enjoyed recording people and things as seen by the man in the street in the 1890s.

Mostly he took photographs with a large disguised box camera, shown advertised on page 46. It looked like a parcel or case and was arranged to be operated when held under his arm. Martin could therefore photograph whatever he was looking at without anyone noticing. Fig. 7.7 shows his marvellously candid record of each individual in a group of Victorian youngsters with a policeman. Pictures like this contrast sharply with stuffy posed studio portraits of the time.

None of Paul Martin's documentary photographs crusade for reforms or express a point of view other than his interest in fellow human beings. They simply record the authentic passing scene and as such were dismissed at the time as 'non-artistic'. (It is sad that amateur photographers who grew more advanced and competent turned away from contemporary life and the real world, leaving this to hit-or-miss beginners. Similarly professionals could find no market for pictures of everyday scenes photographed in the cheaper parts of town.)

Jacob Riis. The injustices underprivileged people were forced to live

Fig. 7.7. Children in a tough area of London await a big procession, 1893. Paul Martin's plate camera was disguised as a parcel and used held under his arm.

Fig. 7.8. 'Under the Dump, Rivington Street'. Jacob Riis used photographs to campaign against New York's slum conditions. People were forced to live like this, 1891. Museum of the City of New York.

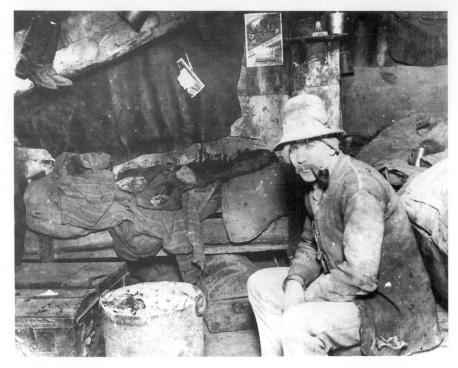

with were much greater in the nineteenth century than today. It was a time of 'self-help' – the poor were accepted as having failed and held up as a warning to others. The public had a detached, morbid interest. They went to lectures with titles like *The Heathen Abroad and The Unfortunate or Improvident At Home*.

Despite this, honest documentary photography could make people become more concerned. It could show convincingly and in great detail just what it was like to live walled up in the slums, or to work 10 hours a day in a cotton mill or coal mine at the age of eight or nine.

Conditions were particularly bad in parts of America, a country hurrying to catch up in industrial growth after the civil war. It seemed people did not matter as much as reducing production costs and increasing profits. A New York newspaper reporter called Jacob Riis cared passionately about the situation in his city, where children worked for 30 cents a day and whole families lived rough in damp cellars. During the 1890s he wrote bitterly about slums, campaigning for better living, learning and working conditions. He discovered for example that a third of a million people, mostly immigrants from Eastern and Southern Europe, were packed into one square mile of the Lower East Side.

People thought Riis was exaggerating, so he took up photography to prove his reports. Flashpowder allowed him to record pictures of destitute people at night and under other technically difficult conditions (Fig. 7.8). Riis was not interested in photography's artistic aspects. He turned his picture evidence into lantern slides and used them to give public lectures. They were also crudely reproduced as illustrations for nine books including his now famous 1890 title *How The Other Half Lives*.

Riis photographs revealed facts and situations most citizens hardly imagined existed. Eventually his efforts resulted in new child labour laws, schools became better equipped, and some of the worst slums were pulled down and replaced by settlements and open spaces. In New York today Jacob Riis Park marks the site of one of the worst areas – a permanent reminder of this early documentary journalist/photographer.

Lewis Hine. Other reformers discovered the persuasive power of photography too. Lewis Hine, an ex-labourer who worked his way to university and a degree in sociology, was sickened by the way the US Government put welfare of corporations before welfare of people. In 1908 he gave up his teaching job to become a full-time documentary photographer, having learnt how to use a view camera and a flashpowder device.

Hine began photographing some of the tens of thousands of people entering America at that time to find the promised land – immigrants who as often as not ended up working in sweat sliop factories, living in slums. Soon he was hired by the National Child Labor Committee (NCLC) and travelled the US as investigator/photographer showing the way industrialists were using youngsters for cheap hard labour. About 1.7 million children were then in industrial employment, but most citizens just accepted this – until Hine turned the statistics into detailed pictures of flesh-and-blood people. Often he 'infiltrated' a factory with a Graflex hand camera hidden in a lunch box, then interviewed and photographed child workers.

Hine discovered situations such as youngsters of six or seven in cotton mills working a 12 hour day (Fig. 7.9). He took statements, recorded their height (against his coat buttons) and general health, then photographed them unsentimentally in their cramped dangerous work conditions. All this sort of human information was paraded publicly through NCLC pamphlets

Fig. 7.9. Candid photograph of a school-age worker in a Carolina cotton mill, 1909, by Lewis Hine.

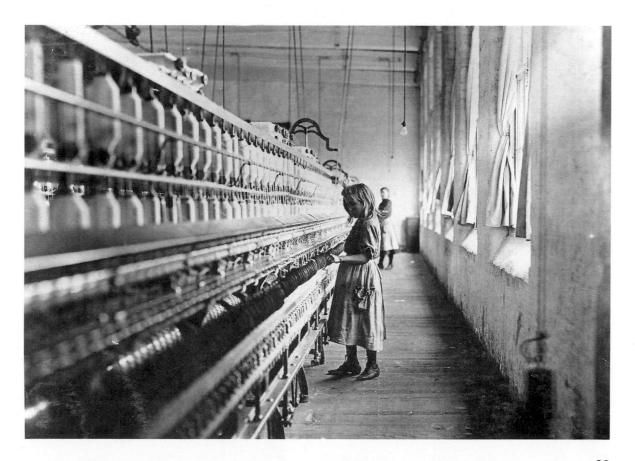

Fig. 7.10. Dorothea Lange captioned this photograph Ditched, Stalled and Stranded. The hollow face of a dispossessed farmer turned migrant farmhand sums up the desperate situation.

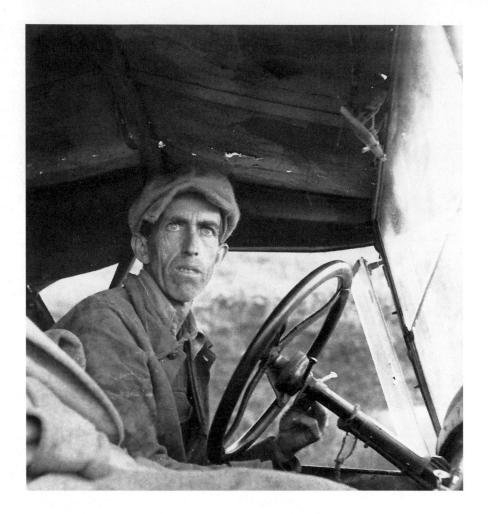

which, thanks to the development of halftone blocks, were now illustrated with photographs.

Some people called Hine a muck-raking journalist; others called him a conscience with a camera. Either way his thousands of photographs and detailed case histories chipped away at the powerful opposition of employers against reforms. Hine carried on this work into the 1930s until a federal law was finally passed against child labour.

Farm Security Administration. In 1929 the New York stockmarket crashed. It was the beginning of a depression which was to last throughout the 1930s. Soon millions were out of work, banks tightened up on credit, many businesses came to a stop. On top of all this a prolonged drought hit the farmland plains of central America during 1932–1936, creating a great dustbowl from Texas to the Dakotas.

Mechanization by tractor had already forced small farmers off the land and reduced the jobs available. Now this combination of disasters made people trek westwards into California. They included sharecroppers (migrant workers who normally followed the season's crop of peas, oranges, cotton, etc.), and failed or dispossessed farmers. Whole families were piled into hallered cars, or pushed their belongings in handcarts. People lived in tents and shanty towns at the side of the highway

A Resettlement Administration was set up by the US Government to help these unfortunate people. In 1935 it was named the Farm Security

Fig. 7.11. Cinafron
Country, Oklahoma, 1936.
Drought, dust storms, and
shortage of money destroyed
many small farmsteads in
the US mid-west during the
1930s. Arthur Rothstein
revealed the situation along
with other FSA
photographers. Royal
Photographic Society
Collection.

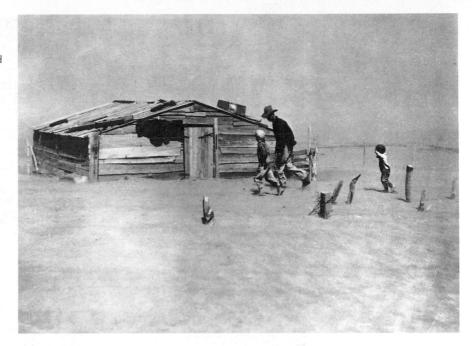

Administration, and college graduate Roy Stryker was hired to run a historical section. In the spirit of Hine and others he decided to employ photographers who could show Americans directly what it was like to live in the stricken areas. Dorothea Lange, Walker Evans, Arthur Rothstein and other photographers (about 30 in all but no more than 6 at a time) were briefed to take persuasive pictures, get to know the refugees' experiences at first hand.

Stryker was a brilliant user of photographs – he had a sense of historical perspective like Brady. Both saw the value of recording events of great social significance. But now that pictures could be fed directly to the nation's Press people throughout the country could see the scandal of these rural

Fig. 7.12. Walker Evans documented these negroes waiting in the food line at an emergency refugee camp, Arkansas, 1937.

Daily Mirror

An Illustrated Paper for Men and Women.

All the News by Telegraph, Photograph, and Paragraph.

No. 154.

Registered at the G. P. O. as a Newspaper,

MONDAY, MAY 2, 1904.

One Halfpenny.

THE LATEST PHOTOGRAPH OF THE KING AND QUEEN.

fhis photograph of the King and Queen was taken by royal command at the Viceregal Lodge during the visit to Dublin.(Photograph by Lafayette, Dublin.)

SATURDAY'S CRICKET.

Sewell, who made 181 for London County agains: Surroy at the Crystal Palace on Saturday.

THE NAMELESS PICTURE.

tak your friends who is the original of this charming picture. Bend your soluilon to the "Picture Puzzle Department," "Dally Mirror" Office. A guinea will be said for the first corroct answer. For Saturday's winner, see page 3.

OPENING OF THE POLO SEASON AT HURLINGHAM ON SATURDAY.

Hurlingham bogan its season on Saturday with a match between A and B teams. The A team consisted of the Earl of Harrington, Captain Godfrey Hesettine, Mr. F. Juy Mackey, and Captain W. O. Renton (back). B team: Mr. Bernard Wilson, Mr. B. Crenfoll, Major F. Egerton Green, and Mr. T. B. Dybrough (back). The A team won cashing by 8 goals to 3. At Raneigh the season proper commenced with a pole match between the Scht Ritles (past and present) and a contingent representing the club. The military team had matters much their own way, and finished up winners by 6 to 1, the solitary goal for Banelagh belong secured towards the ond of the fifth period.

WORLD'S FAIR AT ST. LOUIS-OPENED ON SATURDAY.

Pres 1 periods at the second of the president foosevelt shaking the president foosevelt shaking to a thousand miles sway. All the "biggest things on earth" the gaussiance is the 1740 acres of the habiton grounds, and include everything, from the largest gas-engine ever built and the largest organ ever blown to a full size model of an American battleship.

SCILLY'S MAY QUEEN.

is being carried out with unusual usuplay this year in the Scilly Islee.

Fig. 7.14. Mr M. Farman in his flying machine takes off. This action news picture of the Grand Prix winner really captures the achievement of getting airborne in 1909. Royal Photographic Society Library.

slums. Members of the FSA unit photographed migrant camps (Fig 7.12), denuded landscapes, abandoned homesteads, people on the highways (Fig. 7.10), families helpless, defeated, forgotten. Mostly they avoided pictures which were just picturesque, or smug or false. Stryker even had photographs taken of rich Americans down on holiday in Miami at the time, to strongly contrast the life-styles.

FSA pictures and captions were distributed to newspapers and magazines; exhibitions were sent to Washington DC, New York and other cities. John Steinbeck, inspired by Dorothea Lange's immigrant pictures, researched and wrote *Grapes of Wrath*. Walker Evans' pictures were used by poet James Agee in his book *Now Let Us Praise Famous Men*. Documentary movies were now being made too – they contrasted sharply with the glossy image of America given by Hollywood at that time.

Public support blossomed and soon Government aid for resettlement schemes increased – transit camps were set up, work provided, help given for people to start again. It was a classic example of a small group of photographers succeeding in changing a situation. The FSA unit lasted from 1935 until it was absorbed into the US Office of War Information in 1941. By then photojournalism was well established in both America and Europe.

Fig. 7.13. (left) Daily Mirror front page. Photographs plus short, easily digested stories attracted millions of new readers.

Newspaper photography, photojournalism

Chapter 3 showed how technical problems of reproducing photographs in ink on the printed page were solved in the 1880–1890s. Compulsory

education for children up to 10 years had started at about this time too. This meant that by the turn of the century far more adults were able to read (although not very well). Existing newspapers, with their solid columns of small type, were not very encouraging to this new readership. Newspaper owners realized that news expressed in *pictures*, with easy-to-read captions and short paragraphs would capture a vast new market. This led to papers like the *Daily Mirror*, launched in 1904 as the world's first newspaper illustrated exclusively with photographs and priced at $^{1}/_{2}$ d ($^{1}/_{5}$ p). It was an instant success. Fig 7.13 shows how simple words and sentences were used.

The newspapers employed their own photographers, and also bought photographs from press photo agencies which sent out cameramen covering most main news events. Their jobs were essentially to sum up a situation or a person in one picture, then rush this through ready for the next edition. Speed was more important than technical quality (one reason why plates were preferred – they could be wiped off and enlarged when still damp from processing). Most of the first news pictures were portraits, but as lenses and photographic materials improved more action pictures became possible (Fig. 7.14). Flashbulbs were used for subjects under difficult lighting conditions. By 1907 photographs could even be transmitted by telegraph wire from one newspaper office to another – including country to country. 'Hot' news pictures could be distributed almost as fast as the written word.

The possibilities of using photographs in print became even greater when weekly picture magazines began to appear, in the 1920s. Here the photographer could be given more scope – allowed several pages to tell a

Fig. 7.15. Picture magazines in Germany and Russia made new and adventurous use of layout during 1920–1930s. This double-page 'spread', part of a story of Moscow's Metro, appeared in 'USSR Reconstructs' published in 1935.

Fig. 7.16. A typical spread from the British picture magazine 'Illustrated' in 1940. It is part of a six-page story on the ways ordinary people sheltered from Nazi air raids. 'Illustrated' began in 1939 as a rival to 'Picture Post' (1938).

story and develop a theme through a *series* of pictures. For example, instead of the single press photograph of a goalkeeper saving a goal the magazine could give in depth coverage of 'A day in the life of a goalkeeper'. A picture feature allowed much broader aspects than one news happening to be covered.

Photographers on picture magazines needed to work in ways similar to a journalist, aiming for picture sets with an interesting story line and a strong beginning and end. This sort of work soon became known as photojournalism. It differs from straight documentary photography in that events are more openly interpreted by the photographer or magazine. Like written journalism a picture essay can relay a personal point of view. Nor does it end with the photography, for choice and cropping of prints, text writing, and the way the sequence is presented ('laid out') on the magazine pages can strengthen or weaken the final picture story. The art editor, whose job it is to put the photographer's work together in a meaningful way (rather than just grouping them on the page) becomes an important member of the team. Look at Figs. 7.15 and 7.16).

Picture magazines really began in the mid-1920s in Germany, when that country was the printing centre of the world and also the source of the world's most advanced cameras with wide aperture lenses. These were beginning to make possible photography in quite dim existing lighting, without needing the flash paraphernalia of the press photographer. Probably the earliest picture magazine was the Berliner Illustrierte Zeitung (Berlin Illustrated Newspaper) in 1928.

During the 1930s the new style reporting spread throughout Europe

and America. The publishers of *Time Magazine* began *Life* in 1936; rivals launched *Look* the following year. In Britain *Picture Post* and *Illustrated* appeared in 1938 and 1939, *Paris Match* in 1949. In fact 1935–1955 was the golden age for picture magazines.

Erich Salomon. The most talented photographer working for *Berliner Illustrierte* was a discreet self-effacing Jewish doctor, Erich Salomon. In the early 1930s Europe was a hive of international conferences. Politicians met in Berlin, Paris, Vienna and Rome, hoping to avoid impending conflict, trying to set up a League of Nations. Conferences between diplomats and statesmen were held behind closed doors – the only photographs that people saw were formal wooden groups posed for the Press.

Salomon had a tiny Ermanox plate camera (see page 74). Disguising himself in evening dress and exploiting his ability to speak seven languages, Salomon politely gatecrashed many conferences. He discreetly passed among famous politicians, taking photographs by available indoor lighting, the camera half hidden under his jacket. His unique sets of pictures conveyed the general atmosphere and showed the personalities of those taking part at unguarded moments, engrossed in after-dinner discussions. They contrasted sharply with the blinding flash and smoke which everyone associated with cameramen and made them an unwelcome nuisance.

For the magazine reader this new form of political reporting gave a real feeling of 'being there'. What were these people talking about – what were they plotting? Other photojournalists followed Salomon's lead, mostly with smaller cameras such as the Leica which allowed pictures to be taken in quicker succession and gave greater depth of field. Tragically Salomon was to die in 1944 at the hands of the Nazis at Auschwitz extermination camp.

Henri Cartier-Bresson. Probably the most famous and original of all 'candid' reportage photographers, Henri Cartier-Bresson originally aimed to become a painter. He started taking photographs in the early 1930s when he bought a Leica and found it a marvellous device for capturing what he describes as 'the decisive moment' in everyday situations. In other words he maintained there is one fleeting fraction of a second in which

Fig. 7.17. (below) Dr Erich Salomon, equipped with dinner jacket and Ermanox f1.8 plate camera.

Fig. 7.18. (right) Salomon's after-dinner candid of statesmen, Rome, 1931. Mussolini on left.

Fig. 7.19. Henri Cartier-Bresson excels at documenting ordinary people, producing strongly structured images. © H. Cartier-Bresson/Magnum Photos.

the significance of an event can be summed up and expressed in the strongest possible visual composition.

Cartier-Bresson was mainly a photographer of people – but not as a social reformer or news event reporter, simply as observer of the passing scene. His pictures document ordinary people with warmth and humour, never influencing his subjects but showing them at moments of extraordinary intensity. Typically he would turn his back on a newsworthy event – procession, celebration, etc. – to concentrate on the reactions of onlookers (Fig. 7.19).

Cartier-Bresson never used flash or special lenses, and the whole of each negative is always printed without cropping. He has photographed

Fig. 7.20. Northumberland coal miner at his evening meal, 1937. One of Bill Brandt's documentary pictures strong in compassion and respect. It was taken for 'Picture Post'. © Bill Brandt Archives Ltd.

the people of most countries, but excelled at showing fellow Europeans. His pictures have been used in all the most important magazines, and many books for more than 60 years. They have also been exhibited and purchased by many of the world's art galleries.

After World War II, in 1947, Cartier-Bresson and photographers Robert Capa and David Seymour formed a picture agency called 'Magnum'. Run as a co-operative and owned by the photographers themselves, Magnum has members in various countries. It sells pictures to publishers of all kinds and has become the most famous photojournalistic agency of its kind in the world.

Bill Brandt. One of Britain's most distinguished photographers was also working as a photojournalist during the late 1930s. Bill Brandt was born in London and in 1929 learnt photography in Paris as assistant to Man Ray (Chapter 9). Reportage work was the new most challenging area for young photographers, and Brandt was influenced by the work of Cartier-Bresson and others. He returned to Britain during the depression years, producing pictures of the industrial North (Fig. 7.20) which made pointed comparisons with other richer levels of British society.

Brandt's work appeared as picture books such as *The English at Home* and *A Night in London*. He also undertook many *Picture Post* assignments

(where his pictures often appeared anonymously as was common at that time). Later Brandt was to specialize in landscapes, and books of original experimental photographs such as distorted images of the human form,

see page 139.

During the war years (1939–1945) most photojournalists worked for organizations such as the US Information Service, or the British Ministry of Information, or were drafted into Air Force or Army photographic units. The British Army Film and Photography Unit produced over 137,000 documentary pictures of offensives; there was an equivalent organization in Germany called the PBK (German Propaganda Corp).

Robert Capa, who hated war and tried to show its futility, became a renowned combat photographer. Like many war photographers, both Capa and fellow Magnum founder David Seymour were to die in action a few years later – Capa covering conflicts in Indochina,

and Seymour in Egypt.

The rise and fall of picture magazines

In some ways picture magazines of the 1930s and 1940s were the modern equivalent of the stereoscope cards of the nineteenth century. At their best they offered the ordinary person a window on the world – coverage of great events, a peep behind the scenes, a day sharing the lives of famous people – in greater detail than newspaper press photographs could ever provide. They could also make readers more aware of the gap between what life is,

and might be.

Of course, the magazines always contained a great deal of purely entertainment material such as cute pictures of animals, stills from new Hollywood movies, the latest fashion craze . . . But they could also be powerful moulders of public opinion on more vital issues. Unlike today's colour supplements most of them ran occasional 'crusades' on topics like bad housing, pollution, help for the handicapped, etc. They took sides rather than going for bland neutral coverage. This made a lively and much more interesting magazine but put responsibility on the shoulders of photojournalists, writers and editors. The production team had to be well informed and able to present a reasoned argument rather than propaganda. They were operating possibly the most persuasive visual medium in the days before television – for cinema newsreels were mostly flippant and quickly forgotten.

Picture magazines influenced each other too. Stephen Lorant, a Hungarian Jew and editor of the Munich rival of Berliner Illustrierte left Germany under Nazi pressure. A few years later in 1938 he became Picture Post's first editor. Together with photographers Kurt Hutton, Felix Man and other European refugees, he brought the use of 35 mm cameras and the ideas and layout of German picture magazines to Britain. They filled Picture Post (and its rival, Illustrated) with action pictures and features which looked very different to traditional British weeklies like Tatler or Illustrated London News. In America other European immigrant photographers such as Alfred Eisenstaedt and Robert Capa made

outstanding contributions to Life.

Picture magazines thrived during the conflict and excitement of World War II, despite shortage of paper. They seemed to sell everything they could print and had enormous status. However, by the 1950s Picture Post had begun to lose its sense of purpose. Even the novel use of several regular pages of colour could not revive it. Illustrated closed in 1958, Picture Post in 1957, Look in 1971. Life lingered on in more-or-less its

Fig. 7.21. Photographs are given new meanings by the words written around them. This picture of President Nixon would not normally have rated newspaper reproduction, but due to strong anti-Nixon feelings over the Watergate scandal it was presented this way.

original weekly form until 1972.

Television had taken over as a faster, more universal method of visually communicating news and features; it was also stealing most of the advertisers. By the 1970s photojournalism had lost a lot of its influence, although it remained in magazines such as *Stern* (Germany) and *Paris Match* (France), and in a number of expensively produced company magazines for the oil industry, etc.

Distortion and manipulation

The way the world is presented by documentary photography is often distorted in one form or another – it is almost impossible to be completely objective and truthful. As equipment and materials have improved they gave greater freedom to decide what and when pictures were to be taken. And once photographs could appear in publications the photographer's choice of moment was followed up by decisions on which picture(s) were or were not to be used, the ways captions were written, and how pictures were related one to another across the page.

Half-tone reproduction gave documentary photography a huge audience and made it influential. People soon wanted to manipulate such a powerful medium. Photographers began doing this by posing their subjects, and choosing the viewpoint, lighting and moment in time; editors by selection and presentation of their results.

Manipulation need not always be bad. For Dr Barnardo's before-and-after pictures (page 90) boys were usually dressed up in rags to recreate the 'before' situation. One of the FSA photographers was severely criticized when it was discovered he had shifted a cow's skull several feet from a patch of scrub grass to make a stronger picture. However, neither really distorted the truth of the general situation they were trying to show – they simply communicated it in a visually stronger way.

On the other hand, from the early days of picture newspapers it has

been normal practice to file photographs of prominent people looking confident, defeated, aggressive, stupid, etc. Such pictures are pulled out and reproduced as press portraits to suit the mood of the moment, when that person is either favoured or disliked. Again, an editor can easily select from a photographer's picture series an image he would normally reject, like Fig. 7.21. By adding a headline and caption he gives it strong meaning.

People gradually realized the publicity they could gain through photography. A demonstration often becomes violent when professional photographers or TV crew are seen to be present. In one extreme instance in the late 1960s a public execution was held over for 12 hours, as the evening light was too poor for the press to take pictures. The concerned photographer therefore has to ask him or herself whether something they document would have happened that way had he not been present? Should a wide-angle lens be used, which makes close-ups of people with their arms out look more violent? Would grainy film and dark printing make bad living conditions look worse?

As can be seen, the more strongly the photographer or editor feels about a particular situation the more tempting it becomes to present it in a powerful way. Strictly objective recording is almost impossible – in any case it often gives cluttered pictures which confuse what is being shown. But then, too much concern for clarity of presentation can distort the real events. In practice documentary photography has to function somewhere between these extremes.

Summary - documentary approach

- Photographs, as documents, have long had a reputation for truth and accuracy. They communicate internationally without any language bar, to convincingly reveal situations, describe events, help to explain things. The photographer still uses aesthetic qualities, technical detail, etc., but as a means to an end – to strengthen what he or she considers needs to be shown.
- Roger Fenton's Crimean documentary photographs were intended to sell, and incidentally support government actions. Mathew Brady foresaw the historical importance of documenting the American Civil War. Tim O'Sullivan and William Jackson showed the US Government remote, unknown parts of America. Enormous technical difficulties limited these early photographers' style and approach.
- The fund raising 'before-and-after' photocards of Dr Barnardo, setpiece book illustrations by John Thomson, and Paul Martin's hidden hand-camera shots of London street life are among the few remaining nineteenth century examples of social documentary pictures of the poor. Jacob Riis, and then Lewis Hine, used photography in personal crusades to expose US social injustice in living and working conditions.
- Farm Security Administration photographers Dorothea Lange, Walker Evans, Arthur Rothstein and others, co-ordinated by Roy Stryker – documented the terrible conditions of the mid-west US. Reproduction of photographs on the printed page extended the power and influence of documentary photography.
- Picture magazines, beginning in Europe in the 1920s, brought extended picture essays and introduced photojournalism. Photographers such as Erich Salomon and Henri Cartier-Bresson, using new small format cameras and photographing by existing light,

were able to take candid actuality pictures. Cartier-Bresson's work is renowned for his use of 'the decisive moment'.

• The picture magazines of the 1930s and 1940s – Berliner Illustrierte, Picture Post, Life, etc. – employed some of the finest talent of their

day. They ran crusades, adopted strong points of view.

A good documentary photographer does much more than record. He or she can communicate what a situation really felt like. However, the photographer decides where to point the camera, when to fire the shutter, and (with the editor) which results to use or discard. Each picture may tell a particular truth but a general lie. Even the event itself may be changed by the photographer's presence. Honest reporting is a compromise between recording a confused real world and simpler, more powerful but manipulated images.

Projects

P7.1 Find examples of picture stories published in magazines before or during World War II. (Some libraries hold these on microfilm, as well as in books.) Compare them with how similar topics are covered by picture magazines/colour supplements today.

P7.2 Pick a day when a particular news event (preferably political) is reported by pictures in most daily papers. Obtain a copy of each paper and compare how

the choice of photographs and use of captions slant the reports.

P7.3 As well as the photographers named in this chapter look at books of the collected documentary photographs of Benjamin Stone, J. H. Lartigue, Brassai, W. Eugene Smith, Don McCullin and Robert Frank.

Pictorial photography

This chapter follows the work of photographers concerned with making pictures which are said to be aesthetically pleasing, i.e. which appeal to people's sense of beauty. The terms 'pictorial photography' or 'pictorialism' are used to describe photographs of this kind in which artistic qualities are more important than documenting actuality. For example, people outside a house in a mean back street might be recorded by a documentary photographer to illustrate bad housing conditions. A pictorial photographer, by grouping the people in a compositionally pleasing shape, perhaps using a soft focus camera lens, and waiting until the street surface glistens after rain, may create a moody atmospheric study. One photograph might be called Victims of the housing problem, Glasgow, the other Dusk. Clearly, documentary and pictorial photography can be poles apart.

Attitudes to pictorial photography have changed over the years too. Although difficult to believe today, pictorialism was considered modern and experimental in the late 1880s. This was because it was a breakaway from the earlier constructed 'high art' photography of the mid-19th century, towards art pictures direct from nature. Once again it is important to try to see these photographs from the standpoint of what good art was considered to be at the time. The first part of this chapter therefore looks back at the high art movement, to appreciate

what pictorial photographers were rebelling against.

Fig. 8.1. 'Finding of Christ in the Temple' painted by W. Holman Hunt, 1854-60. This pre-Raphelite style was the most important 1850s British art movement. Themes were sentimental, often poetic, and painted in detail.

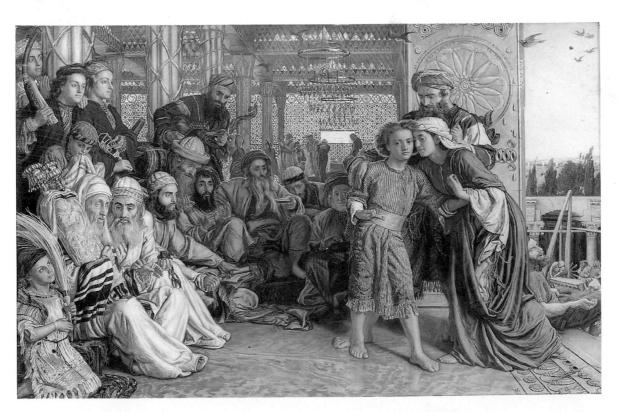

Beginning in Britain, pictorial photography soon spread to Europe and America. It became very much the concern of photographic clubs and societies for the serious amateur. Like-minded pictorial photographers also formed break-away groups; exhibitions were battlegrounds over which reviewers argued and fought. Eventually a newer approach – 'straight photography' – was to take over during the 1920s and 1930s, leaving pictorial work repetitive and diluted.

Pictorialism made Britain the centre of new ideas in the 1880s and 1890s then seemed to hold back the progress of its serious amateur photography. It was left to American and European workers to move on into newer and

more experimental approaches described in Chapter 9.

The background to pictorialism

Like art groups, the photographic societies which had sprung up in many cities during the latter half of the 19th century ran regular exhibitions of members' work. The camera was the new way of making pictures, but photographers were extremely conscious of its being only 'a mechanical recording medium'. Naturally they wanted to be considered as good as accepted artists. So in an attempt to give authority to 'the mechanically produced', the early photographers followed the content and style of paintings of the time. This meant going for a romantic approach, strongly expressing the emotional and the dramatic, and often using subject themes from history or literature. 'Pre-Raphaelite' style painting dominated British Royal Academy exhibitions during the 1850s. Lofty, poetic and religious themes like Fig. 8.1 were chosen, treated sentimentally but painted in great detail and with careful regard for accuracy. They worked in a manner similar to painters before the High Renaissance Art of Raphael.

Art critics sent to review exhibitions of photography naturally compared this new work with painting. They advised photographers to avoid ordinary everyday scenes, draw a veil over 'ugly truth' and beautify their subjects if they were ever going to elevate photography to a high art. This was none too easy to achieve when you consider the subject detail and accuracy the camera gives. To solve the problem (and help with technical difficulties like long exposures) subjects and scenes were specially staged. People dressed in costume and posed artistically in arranged settings (Fig. 8.4). Photographs had to be contrived to be beautiful, just as the professional studios stage-managed portraiture at this time (page 36).

Choice of theme for a would-be 'high art' photograph was also very restricted. It was safest to pick episodes from the bible, or a telling phrase from a then modern poet like Tennyson or Longfellow, or some dramatic scene from life like 'Home From the Sea'. The Victorians loved pictures which narrated stories and pointed morals, like flowery novels of the time. They preferred scenes which unfolded before their eyes in clear precise detail, thoroughly worked and finished. In some ways therefore painting had a story-telling function like movies or TV today, particularly for the large number of people who could not read.

Imagine visiting the Manchester Art Treasures Exhibition in 1857. Full of Rembrandts and Van Dycks, there were also over 500 British and European photographs organized by Philip Delamotte. These included some of the Prince Consort's own collection of photographs such as studies by Lake Price (Fig. 8.4). But the photograph which created greatest stir was Occar Gustav Rejlander's Two Ways of Life (Fig. 8.2). Queen Victoria, who had opened the exhibition, probably stood admiring this work while Prince Albert explained the allegory it showed. A father leads two sons

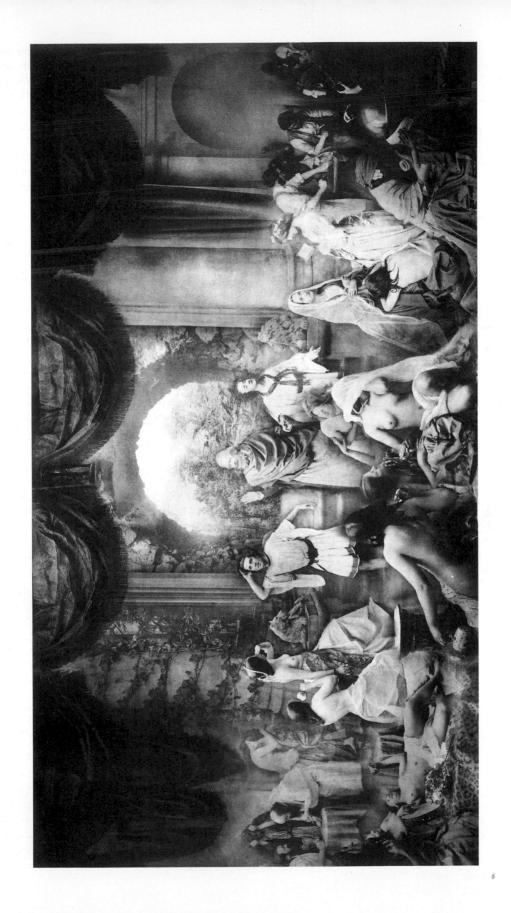

Fig. 8.2. 'Two Ways of Life' a composite photograph constructed with enormous effort by Oscar Rejlander. Exhibited in 1857, its moral story-elling was greatly admired. Copies were bought by royalty.

Fig. 8.3. J. M. Cameron's photograph 'The Passing of King Arthur', illustrating a Tennyson poem, 1874.
Note the muslin waves and cardboard moon.

into the wide world. One, looking rather self-satisfied, turns towards the 'worthy' things of life – knowledge, industry, married life, religion. The other turns away from father's guidance towards 'bad' influences, including idleness, drink, sex and gambling (this naughty half had to be curtained off when the photograph was exhibited in Scotland later).

Rejlander was an ex-painter who ran a studio in Wolverhampton, mostly producing reference photograph figure studies for artists. In a sense *Two Ways of Life* was a catalogue of his wares. He had used over 30 separate negatives to create his tableau – photographing the artistically posed figures singly or in groups. The background was photographed in a friend's garden; the draperies in Rejlander's own studio. He sold full 41×79 cm $(16 \times 31$ in) prints for 10 guineas (£10.50) each, an enormous sum, equivalent to 3 month's average wage. Reduced size copies went for twelve shillings and sixpence (62p).

Other high-art photographers such as the young Henry Peach Robinson (page 29) also used combination techniques, but mostly they stage-managed the complete picture in front of the camera. Settings were made up using whatever bits and pieces could be found around the house. Results were sometimes ludicrous. Julia Margaret Cameron indulged in many such flights of fancy (Fig. 8.3) and these results were much more appreciated by

Fig. 8.4. 'Don Quixote in His Study'. Artistic photographer Willium Lake Price used antique oddments to produce this studio composition in 1855.

fellow-photographers than her 'blurred' portraits (page 38).

The imaginary, literary themes these photographers chose were extremely difficult to portray with something as realistic as photography. (Even today it is difficult to illustrate a magazine story or novel with photographs.) Among artists, photographers began to be sniggered at as visual morons – upstarts who merely knew how to use a mechanical device. Among photographers, high art photography during the 1870s and 1880s was a cosy and enclosed world. Henry Peach Robinson wrote books laying down what was or was not permissible. Apart from better technical skill it really all repeated photographic work done back in the late 1850s, which was itself a copy of academic painting 10 years earlier.

Emerson and 'naturalism'

As one writer described it, 'it was like a bombshell dropped at a teaparty'. The tea-party was the restricted world of Robinson and his followers. The bombshell was an 1889 book *Naturalistic Photography for Students of Art* by Dr Peter Henry Emerson, a physician turned photographer working in East Anglia. Emerson argued that photographers were foolish to imitate the themes and methods of academic painting. It was wrong to use the camera as a convenient machine to construct pictures. Photography was a much more independent art form – fully deserving the status of other fine arts.

He urged photographers to study the appearance of nature rather than paintings. Look at the beauty of the image of natural scenes given by the lens on the camera's ground glass focusing screen – and the moods and emotions it arouses. Use essentially photographic effects such as focus and lighting rather than false techniques of combination printing to give

pictorial qualities.

Photography should also be true to human vision. With his science background Emerson pointed out that the eye concentrates on one part of a scene at a time. Vision is indistinct towards the edges of the viewed scene and is most detailed near the centre. 'Overall' sharpness (considered important in high art) is therefore unnatural. By making some objects less sharp than others and having soft focus effects at the corners and edges of photographs the result was more natural, closer to truth. Emerson added the advice that every photography student should 'try to produce one picture of his own . . . which shall show the author has something to say and knows how to say it'.

Emerson was not just a forceful writer and lecturer, he was a brilliant photographer of the natural landscape. Already, in 1886, he had published a picture album *Life and Landscapes on the Norfolk Broads* containing 40 actual prints (Emerson contact printed his large negatives on platinum paper which gave an extremely permanent image in a soft silver grey colour). Altogether he published eight collections – either with pasted-in platinum prints or reproductions in ink from photogravure-etched metal plates. His unretouched interpretation of 'real' scenes – helped now by faster and more convenient dry plates – had an immense influence on young photographers frustrated by 'accepted' photography. Comparing Fig. 8.5 with 8.4 shows how revolutionary his ideas on pictorial photography were.

Robinson and his followers of course attacked the new trend. Emerson, they argued, has a total lack of imagination and 'healthy human eyes never saw any part of a scene out of focus'. Photography can never be truly

naturalistic. After all a negative exposed for land detail gives an overexposed, featureless sky. But one negative exposed for sky and another for land detail which are then combination printed give results much truer to original appearance.

At the height of his influence Emerson suddenly renounced his naturalistic photography ideal – partly due to the newly published research of Hurter and Driffield (page 52) which he saw as proving that photography gave a fixed range of tones over which the user had quite limited control. In 1891, in a dramatic pamphlet titled *Death of Naturalistic Photography* Emerson took back all he had said about photography being an art form. But by then it was too late. The idea of a more direct form of aesthetic photography had broken in on the rules and pretensions of high art.

'The Linked Ring' and fellow travellers

Every pictorial photographer saw the hanging of his work in an exhibition as a great goal. Exhibiting was taken very seriously. Britain in the 1880s was the world centre for pictorial photography, based on the Photographic Society of London (soon to become the Royal Photographic Society). But in 1891 a serious debate arose between members, due largely to the society's hanging of scientific and 'trade' (professional) photography

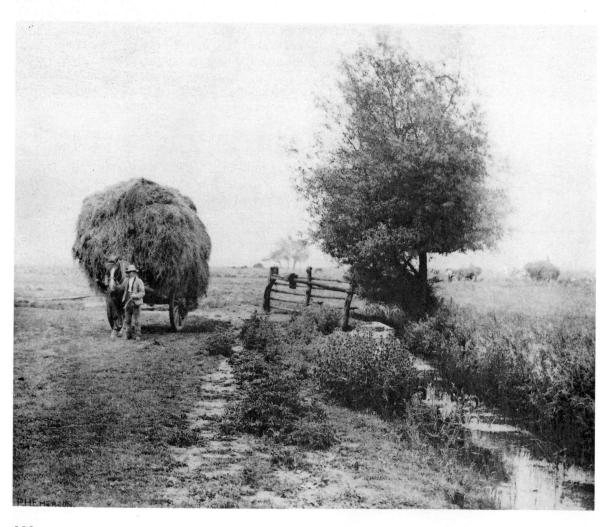

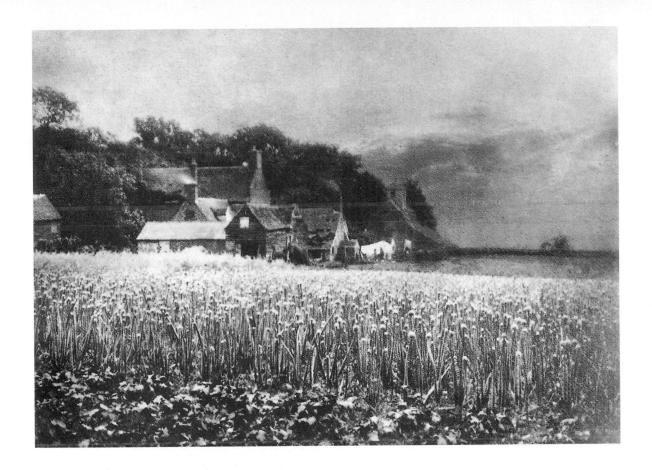

Fig. 8.6. 'The Onion Field' by George Davison, 1890. A soft focus photograph influenced by impressionist painting. The Photographic Society's rejection of this and similar work helped create The Linked Ring.

together with pictures of artistic intent. There was also disagreement over prints from younger members showing soft focus and diffusion, to which older traditionalists objected.

Eventually in 1892, a group of photographers left to found their own breakaway movement 'for the better encouragement of pictorial ideals'. (This was a great time of upheaval in art, with small groups or 'brotherhoods' splitting from formal establishments). They called themselves *The Linked Ring*, a name which relates to the way these photographers organized themselves, with membership by invitation only, and no President or exhibition hanging committee – the group being organized in turn by each 'link' for one month only. Early members included George Davison (Fig. 8.6), Frank Sutcliffe, editor of *Amateur Photographer*, A. Horsley-Hinton, Frederick Evans (page 114) and most followers of naturalistic photography except the self-renounced Emerson. The next year they ran their first annual pictorial exhibition, calling it *The Photo Salon of The Linked Ring*.

Much the same thing was happening in Europe. During the early 1890s exhibitions limited to pictorial photography were held with great success by the Vienna Camera Club, the Photo-club of Paris, and clubs in Hamburg and Turin. The sort of work you would find hung in these 'salons' did not differ greatly country to country. Many photographers had elaborated Emerson's theory of limited sharpness in vision into overall soft focus effects. Spreading the highlights of a picture by diffusion also gave it an effect resembling the style of a relatively new movement in art knows as

Impressionism (page 120).

New variations of photographic printing processes were devised which gave an image in gum (gum bichromate). By daubing this with pigment you could build up a picture by hand with complete control over tone values – defying the grey tone relationship which Hurter and Driffield proved existed in ordinary papers. Various other techniques were used to make photographs lose their sharpness and detail, take on the qualities of painting. People used pin-hole cameras, printed on rough drawing paper coated with emulsion. Images were toned to resemble drawings in coloured chalk or crayon.

This movement was not a return to high art – the subjects in front of the camera were now mostly genuine and natural. Contrivance was directed to making the *process* look as little like a photograph and as much like a painting as possible. Perhaps this was also reaction against the army of snapshotters newly at work with their Kodak cameras. It became important to be something different, more serious, of more advanced status and conscious of painting aesthetics.

Not that all the new pictorial photographers worked in the same way. Some were noticeably 'straighter' in their methods. This is shown, for example, by the difference between the work of Robert Demachy and Frederick Evans (Figs. 8.7 and 8.8), two pictorialists at opposite extremes

of manipulated and straight approaches.

Robert Demachy. He was a banker, amateur painter and photographer, and a leading member of the Photo-club de Paris. Almost all the pictures Demachy exhibited used some form of manipulated process to eliminate the 'uninteresting and unnecessary'. Most were figure studies, printed by a gum or oil process (page 206). He wrote persuasively explaining why he worked this way. A work of art must be a transcript, not a copy of nature, Demachy argued. The beauty of nature does not itself make a work of art – this is given only by the artist's way of expressing himself. Slavish copying of nature, whether by brush, pen, or camera, can never be called art.

Demachy had no time for fellow pictorial photographers who worked straight. He pointed out that in all the best paintings you can see that the artist intervened between commonplace reality and the final work. Did Turner's sunsets exist just as he painted them? Were Rembrandt's scenes just as they would have appeared to the eye? A straight photograph cannot possibly be a work of art even when taken by an artist, for it may be repeated exactly by someone else who is no artist simply by setting up a camera immediately in the same spot. Straight prints may suit documentary photographers who have special factual interests in the subject, but the whole idea of the pictorial photography movement was surely to break away from recording?

Frederick Evans. Although he became a member of The Linked Ring a few years after it began, Frederick Evans believed in a 'straighter' approach to pictorial photography. Evans was a London bookseller and amateur photographer, turned professional. His subjects mostly ranged from portraits to architectural studies for *Country Life* magazine. Fig. 8.8 is typical of the type of photograph for which he was best known at salon exhibitions. It is called *Sea of Steps* and shows the Chapter House steps at Wells Cathedral. The fact that the subject is a particular thirteenth century staircase is less important than the way Evans communicated his feeling for wave after wave of worn steps.

Evans believed that seeing was the most important single aspect in photography. Picture making was best carried out on the focusing screen

or viewfinder of the camera, using factors such as choice of viewpoint and the direction of light at a particular time of day, or the softness or hardness of shadows given by different weather conditions. Having spent hours walking about a cathedral deciding the area he would portray, Evans would return at different times to see the changing effects of light and shade. All this was done before his large 20×25 cm $(8 \times 10$ in) plate camera and 19 in Zeiss lens were even unpacked.

Frederick Evans believed in 'plain, simple, straightforward photography' although taking great care technically to ensure his negative reproduced all the delicate tone values he saw as important in the subject. Printing was equally straightforward – prints were made by contact onto platinum paper, using the whole picture area and with absolutely no handworking

of the Image.

Evans' idea of making the creative decisions behind the camera, instead of in the darkroom 'like the gummists' was directly opposed to Demachy. He argued that it would indeed be possible for two photographers to

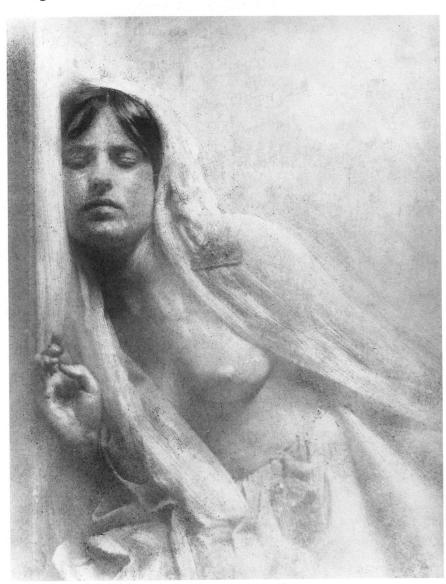

Fig. 8.7. A typical Robert Demachy figure study, 'Dormeuse' (1902). He printed negatives by gum bichromate, which allowed great manipulation, disguising the normal photographic image and even adding brush marks.

Fig. 8.8. Frederick Evans' photograph 'Sea of Steps', 1903. Evans took enormous care in choice of lighting and viewpoint, but unlike Demachy believed in 'straight' technique.

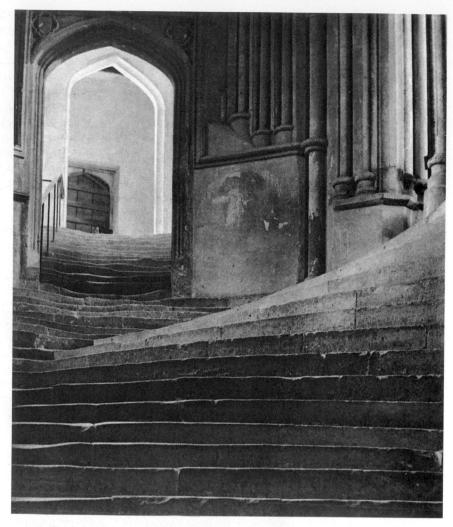

occupy in turn the same spot with the same size camera . . . but only one might produce a picture perfect in proportions, atmosphere and sense of space. The other would fail owing to wrong choice of lens, camera height, moment in time etc., but above all by not responding to the mood and delicacies of what he actually saw. Too many photographers tried to fake results into a work of art by disguising its photographic qualities later . . .

Stieglitz and Photo-Secession

In 1887 Peter Henry Emerson was the judge for a competition run by Amateur Photographer magazine. He awarded first prize for a naturalistic study of street urchins sent in by Alfred Stieglitz, a young American student at Berlin Polytechnic. Stieglitz was in Germany to study engineering but had become increasingly interested in photography. He attended classes in photochemistry by Dr Vogel (page 50) and made his own study of the work of artists. The photographs Stieglitz took were pictorial but straight and generally unmanipulated, although he was less obsessed by the importance of this than Emerson. Mostly they featured simple daily life (Fig. 8.9). Many were hung at the 1891 Vienna Salon and were greatly admired.

It was therefore a shock when Stieglitz returned home to New York to

find the American photographers there were still struggling with a high art approach – years behind Britain and the Continent. For a time he worked as a partner in the new business of photoengraving, making printing plates of photographs. He continued taking pictures mostly with a hand-held plate camera in and around the New York streets. But unlike Riis and Hine, Stieglitz saw the city as a source of beauty and form, even in the most commonplace daily scenes. He was particularly interested in the visual effects of weather conditions, sometimes waiting hours for the right juxtaposition of people and objects (page 84).

The idea of a pictorialist using a hand camera was unusual, but Stieglitz also dared to crop his images, often printing only the part of the negative which gave best composition. Some of his photographs at this time liad the softness of detail and delicate use of tone similar to impressionist

paintings he had admired in Europe.

By 1894 Stieglitz's work had won him election as one of the first American members of The Linked Ring. The following year he left the engraving business with a small private income, determined to encourage creative photography in America. Appointed editor of American Amateur Photography Stieglitz wrote knowledgeably on both creative and technical matters (thanks to his studies under Vogel) as well as setting high standards for the pictorial photography he chose to print. In fact this was his undoing, for he insulted readers in turning down their work and had to leave.

Soon he was editing a house magazine, Camera Notes, for The New York Camera Club, of which he was vice-president. Stieglitz was determined it should crusade for modern pictorialism. He discovered and reproduced work by unknown young American photographers such as Clarence White, Edward Steichen and Gertrude Kasebier, but club members complained he failed to devote enough space to

their own photographs.

Squeezed out for being too ambitious, in 1902 Stieglitz was offered the chance of exhibiting his own work and the work of his discoveries at the prestigious National Arts Club. On the spur of the moment he called this show the work of the 'Photo-Secessionists' (secession in art means breaking away from accepted ideas). At first Stieglitz was the only photo-secessionist, but he quickly organized the other exhibitors as founder members. The group's aims were 'to hold together those Americans devoted to pictorial photography and exhibit the best that has been accomplished by its members'. Many of their ideas for advancing photography were similar to The Linked Ring – one closely knit group, membership by invitation only, and emphasis on exhibitions. However they had a much broader acceptance of style – from straight photography to the diffused manipulated gum print processes used at the time by Alvin Langdon Coburn (Fig. 8.11) and Edward Steichen.

In Stieglitz they also had a very dictatorial leader. He would only permit photo-secessionists to show their work as a group and then only on the understanding that all work (approved by him) was hung without submission to any exhibition selection committee. Despite this arrogant attitude, Stieglitz's brilliance in maintaining high standards across a wide range of pictorial styles paid off. Group work hung at most of the major European exhibitions proved what a distinctive medium of individual expression photography could be.

From 1903 Stieglitz financed, published and edited the secessionists' own quarterly magazine called *Camera Work*, to show contemporary pictorial photography. It contained work from all over the world, written

Fig. 8.9. Sunlight and Shadows, Paula, Berlin 1889. Alfred Stieglitz's photograph of a friend taken when he was a student. Other Stieglitz prints appear here on the wall. © The Art Institute of Chicago.

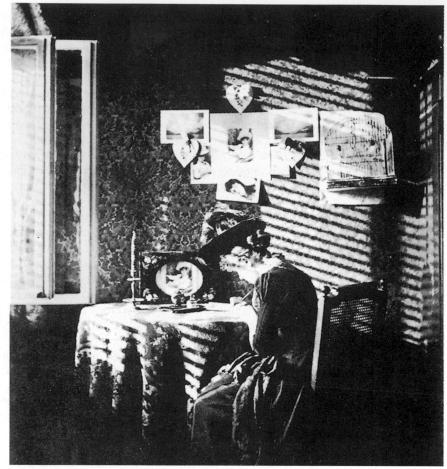

criticisms, exhibition reviews, and articles on trends in art and photography. The gravure-printed illustrations, on the finest paper, were of outstanding quality (Stieglitz's photoengraving experience no doubt helped). By 1905 Stieglitz had also opened a small gallery at 291 Fifth Avenue to show and sell photographs, and later modern drawings and paintings.

Both gallery and magazine helped to introduce the work of British and European photographers to America. Within the first year this ranged from retrospective photographs by Hill and Adamson, to the current work of Frederick Evans. Once again Stieglitz insisted on selecting exactly which prints he would hang, however distinguished the photographer. He also showed his own work which included portraits of fellow artists and photographers as well as his city scenes – sombre, atmospheric, full of rich tone values. In many ways one man's efforts as critic, writer, art dealer and photographer had shifted the centre of new ideas in pictorial photography from Britain to America.

Edward Steichen. Born in Europe but brought up in the USA, Edward Steichen was an apprentice lithographic artist and amateur photographer. Some work he submitted to an exhibition judged by Alfred Stieglitz led to photographs published in *Camera Notes*. After a period studying in Paris, mostly with the idea of becoming a painter, Steichen's soft-focus low-key portraits and landscapes were included in the first 1902 Photo-Secessionist show of which he was a founder member.

Having designed and helped set up the 291 gallery for Stieglitz, he

returned to live in Europe. Here he both painted and photographed, including portraits in colour using Lumiere's new Autochrome plates. From Paris he arranged for drawings and paintings by then unknown artists like Rodin, Matisse, Cezanne and Picasso to be sent for hanging at 291.

Later, after 1914–18 war experience as a US photo-reconnaissance officer, Steichen gave up painting and totally changed his earlier manipulated style of photography. He taught himself to use images with crisp hard edge detail and full tone range. By the 1920s he had become chief fashion and portrait photographer for *Vogue* and *Vanity Fair* magazines. Steichen was to end his career as curator of photography at The Museum of Modern Art, New York during the late 1940s and 1950s (page 160).

Winds of change

Meanwhile, in the period just before World War I time was running out for what had been the new movements in pictorial photography. By 1909 The Linked Ring had become 'the establishment' stifling rather than encouraging new ideas; lack of leadership now produced argument and

Fig. 8.10. A low key portrait from Edward Steichen's early, manipulative period when he used the gum print process, 1915. The subject is his friend and fellow photographer Alfred Stieglitz. © The Art Institute of Chicago.

in-fighting between the 'links'. Within the Photo-Secession many members had turned professional and drifted away by about 1912. The group's sense

of purpose seemed to be lost.

The '291' Gallery and Camera Work now featured modern drawing and painting more often than photographs. The last two issues were devoted to the strikingly direct straight approach of a young American photographer Paul Strand, but already subscribers had dropped to less

than 40. Both the publication and gallery closed in 1917.

In the general state of change which followed World War I Stieglitz rather dropped out of sight. His own photography was changing and he was exploring a more personal form of image, expressing feelings about life through symbolic pictures of trees, clouds, etc., which he called 'equivalents'. See Chapter 9. Stieglitz went on to open the 'Intimate Gallery' in 1925, and its successor 'An American Place' which he ran until he died in 1946. Always these were meeting places for creative people working in photography or paint. He remained dedicated to the new and the emerging, always opposed to institutions which had a repetitive deadening influence. Thanks to pioneers like Stieglitz, seeds were sown from which public recognition of photography as an aesthetic medium separate and different from painting would slowly develop. In fact, a few American art galleries began buying photographs on the same basis as other forms of art as early as 1910. It took almost 50 years for British galleries to follow suit.

The forms of pictorialism promoted by The Linked Ring and by the Photo-Secessionists lived on in hundreds of amateur photographic societies, even to today. Meanwhile young imaginative photographers of the 1920s and 1930s had moved on to a far more modern approach,

described in the following chapter.

Influences of painting on photography

It is difficult to prove the two-way influences between painting and photography. However, the period of the formation of The Linked Ring and Photo-Secession also related to revolutions in other areas of the art world. In France back in 1874 painters Monet, Renoir, Pissaro, Cezanne, Degas and others formed themselves into a secessionist group. They exhibited their work in Nadar's recently vacated Paris studio. (Like Stieglitz, Nadar believed in encouraging young artists.) One work shown, 'Impression: Sunrise' provided a name for the new group, who were thereafter known as Impressionists.

The movement was against established painting of the time and aimed to achieve greatest possible naturalism by trying to render the play of light on object surfaces, and exact control of tone and colour. Most impressionist paintings have an atmosphere of light, and objects lack a firm outline. Many were painted out of doors where fleeting changes in natural conditions could be observed. All the impressionist exhibitions held in France between 1876 and 1886 (when the group disbanded to work separately) were received with hostility. The first exhibition of impressionistic work to appear in London did not take place until 1889, three years before the formation of The Linked Ring. At the same time Photo-Secessionists admitted that they were influenced by the styles of painters of their day like Corot or Whistler.

Painters on the other hand preferred not to admit to the use of photographs, allhough they often took or commissioned them for reference. Nor could they afford not to notice the new kinds of images adventurous

Fig. 8.11. (opposite) 'St Pauls from Ludgate Circus' 1908, an atmospheric gum print by A. L. Coburn, most versatile member of Photo-Secession.

photographers were producing. Look at the way Monet painted moving figures in city streets, or the shimmering leaves of trees, as discussed on page 58. The general growth of black and white photography as an art form must have encouraged impressionist painters to emphasize use of colour. In fact the general movement among painters towards more personal expression and less realism was probably influenced by the need to distance

themselves from photography.

One odd feature of the pictorial movement is that, whereas Britain in the 1890s provided probably the most important breakaway photographic movement of its day (The Linked Ring), twenty years later there was little further development – in fact British photography had lost the initiative to America (and later to Europe, Chapter 9). Much of this was due to the importance in Britain of tradition, of avoiding novelty. New ideas were considered threats. Beauty should be sought by the pictorialist using the principles of composition set down long ago by traditional painting. Developments which included breaking the rules of composition were judged 'disturbing'. Some photographers working in Britain just before World War II, such as A. L. Coburn, still managed to be adventurous – but in general the pressures were strongly against individuals stepping out of line.

Summary - pictorial photography

 Pictorial photography, a wide-ranging term, generally means photographs having picturesque qualities considered of greater importance than subject information and significance.

At first pictorial photography was a breakaway from the limitations of 'high art' (self-conscious artistic studies) like the work of Lake Price,

Reilander, Robinson, and even Cameron.

 Dr Emerson's photography and 1889 book on 'naturalism' urged photographers to observe the lens image of actual scenes, not to construct photographs which ape painting. The photographer should be true to human vision and use photography to express personal impressions of natural subjects. Emerson's revolutionary views greatly encouraged the growth of pictorialism.

 Naturalistic photography began to appear in European exhibitions during the 1890s. In London the Linked Ring formed as a breakaway movement (1892) from the Royal Photographic Society and founded

an annual Photographic Salon exhibition.

 Pictorialists often pushed chemical techniques to their limits to make results look like painted or crayoned art. Gum or oil processes of photographic printing were common. Demachy was expert in this area; other pictorialists such as Frederick Evans believed in 'straight' technique with the accent on seeing in the first place.

 In New York Alfred Stieglitz, an outstanding straight pictorialist in his own right, wrote about, judged, published and generally encouraged American pictorial photography. Forming a group of Photo-Secessionists (Steichen, White, Kasebier and others) in 1902, he also published Camera Work 1903–1917 and opened a secessionist gallery ('291') for selected work by photographers and painters.

 Stieglitz showed a wide range of pictorialist photographers' styles, and also introduced modern art painting into the US long before it was

considered respectable.

 Edward Steichen, a young Stieglitz discovery and gum print pictorialist, helped to set up the 291 gallery. From Paris – current world centre of modern art – he sent back work by then unknown impressionist painters for Stieglitz to exhibit and publish. Later Steichen gave up manipulated pictorial photography, became a famous professional portrait and fashion photographer.

World War I ended many of the breakaway movements begun 20 years before. Stieglitz continued developing his own unmanipulated work and ran other galleries promoting pictorial photography, remaining always anti-institutional. Pictorial photography lingered on in amateur clubs and societies.

 Pictorialists were influenced by breakaway movements in painting such as Impressionism, as well as individual artists (Whistler for example) who considered aesthetic approach more important than subject. Equally painters borrowed from and reacted against the new images photographers were now producing.

Projects

- P8.1 Working from books look for examples of straight (or 'pure') pictorial photography by Frederick Evans, Frank Sutcliffe, James Craig Annan, or Alfred Stieglitz. Compare these with pictorialists of the same period who favoured a manipulated approach, e.g. Alexandre Keighley, Alvin Langdon Coburn, Frank Eugene and Robert Demachy.
- **P8.2** Find examples of paintings of ballet dancers during the 1870s by impressionist Edgar Degas (who admitted the influence of amateur snapshots on his compositions) and compare these with the same subject photographed by Robert Demachy 20–30 years later.

Modernist movements

The early decades of the new century brought important changes within the art world, and these were about to affect photography too. Europe was in a state of economic and political upheaval which came to a head in World War I (1914–18). People no longer accepted all the old conventional patterns of life – it was a time to break with leisurely tradition. What became known as 'Modernists' looked for new values and new ways of expression in art, architecture, music and literature. There was a restless urge to experiment using modern materials and approaches. In painting the idea that art always meant pictures in gold frames was felt to be

Fig. 9.1. (opposite) Marcel Duchamp's 1912 futurist painting 'Nude Descending a Staircase' inspired by photography.

Fig. 9.2. One of A. L. Coburn's many
'Vortographs', 1917. He directed the camera to look down angled mirrors to create these cubist-style abstract photographs. Royal Photographic Society Collection.

finished. Revolutionary movements like Dadaism followed Cubism and led on to Surrealism (terms which will be explained shortly).

For many Americans the 1913 New York Armory Show – a huge exhibition featuring the work of avant-garde modernist artists' such as Cezanne, Matisse and Marcel Duchamp – first showed what the Europeans had been up to. It was far larger than anything Stieglitz had been able to put on at his tiny 291 gallery. Reaction ranged from hostile to hysterical. Duchamp's 'Nude Descending a Staircase' was particularly singled out for mockery, the Press describing it as 'a lot of old golf clubs and bags'. The exhibition was no less controversial when it moved to Chicago, where outraged art students burnt effigies of Matisse. For Stieglitz's circle of young photographers – Steichen, Coburn and Strand – who had already started to absorb modernism the Armory Show was enormously stimulating. Pictorialism having lost its momentum the time had come to re-discover photography as a modern creative medium, used honestly, separate from any other medium and *not* trying to masquerade as something else.

As this chapter will show, photography in the 1920s and 30s became modernist through two different lines of development. One was the growth of abstraction (graphic shapes and patterns) centred mainly in Germany. The other was the extension of 'straight' photography, strongly exploiting photography's strengths of detail, sharpness and tone range to intensify realism, and often choosing subjects previously overlooked as ordinary and mundane. Realism developed most in America but also independently in Germany too. Both were seen as offering photography exciting, avant garde possibilities. As this new modernist photography evolved sentiment and the picturesque were discarded.

Modern abstract art began well before the war. The parent movement (1906–1914) started in Paris and was labelled *cubism*, which most people remember through work by Picasso and Braque. Briefly, cubists represented things not as they appear, but as chunky geometric forms increasingly broken down and 'analysed'. Often several aspects of an object were accented at once. Side views, front views, etc., were grafted onto one another to convey an idea instead of any single viewpoint. Whereas impressionists had been concerned with light and surface, cubists concentrated on forms.

Cubist work was of course greeted with confusion and hostility but became enormously influential. Soon offshoots appeared as modern art movements in other countries – they differed mostly in what was considered suitable twentieth century subject matter and the way paintings were organized.

In Britain a small group of painters led by Wyndham Lewis called themselves *vorticists*. For a short while (1912–1915) they produced entirely abstract compositions or based their work on forms like the stark modern architecture which, they felt, expressed the vitality and energy of the new century. A series of photographs from the tops of tall buildings in New York in an exhibition by Alvin Langdon Coburn greatly interested Lewis, Etchell and other painter friends. Compare Fig. 9.4 with Fig. 9.3. Forceful diagonal composition (often achieved by angling the camera or picking high or low vantage points) plus rhythmic contrast of light and dark gave such photographs a strong dynamic.

For a while Coburn became one of the vorticist group. In fact he made

Fig. 9.3. Frederick Etchell's vorticist painting 'Stilts' 1915. A cubist approach to architectural forms.

an experimental series of 'vortographs' – probably the first abstract photographs – using three mirrors clamped together like a kaleidoscope. The camera looked through this arrangement into an area where pieces

of glass, wood, etc., were placed (Fig. 9.1).

In Italy a group calling themselves *futurists* were particularly concerned with painting moving figures and machines as a way of expressing dynamic modern times. Subjects were broken up and reassembled as flow lines or 'lines of force'. Naturally futurists were interested in movement analysis photography by Muybridge and particularly Marey (page 49); similarly the sort of photography produced with stroboscopic lamps and flash. Marcel Duchamp, who painted *Nude Descending a Staircase*, one of the most famous of all 20th century works of art (Fig. 9.1) was clearly aware of Cubist techniques of dismantling an object into its constituent planes and then reshuffling them. He also explained that Nude was inspired by the mechanics of movement, and based on analytical photographs by Marey and others. Duchamp was later a leading member of the *Dadaist* movement, formed in Switzerland during World War I by artists bitterly rejecting the society and traditions which had brought about such a

Fig. 9.4. 'The House of a Thousand Windows' 1912, from A. L. Coburn's series 'New York from its pinnacles'. This photograph balances description and abstraction. The left half breaks down into triangular forms, contrasting with the main rectangular shape right to create an active composition. It predates and leads into his completely abstract vorticist images.

Fig. 9.5. Photogram by dadaist Man Ray, 1921, using a gyroscope, string and a length of movie film.

senseless waste. (Even the name Dada was picked at random from a dictionary - it means rocking horse). Dadaist works were anti-Art, antilogic, and intended to outrage - the absolute rejection of previous values and so perhaps 'cleansing' the past.

The movement believed that in a creative work both the subject and the medium must be transformed. Ordinary ready-made objects, random cut-out pieces of paper etc., were exhibited in galleries as works of art, and it was thought an advantage to add all sorts of oddments to pictures. For example, tickets, newspapers, sandpapers were glued onto canvas, often in new ways to represent textures, forms etc. In other experiments objects were placed in random positions on photographic paper, which was then exposed to light to produce abstract shadow pictures.

This fitted in with Dadaist ideas utterly rejecting traditional art composition, materials and techniques. The extremes of Dadaism therefore helped to break down previous notions of any fixed relationship between

photography and art.

Man Ray. As one of the first American abstract painters. Man Ray was a member (with co-founder Marcel Duchamp) of the New York group of Dadaists in 1917. Naturally he had come into contact with Stieglitz and the 291 gallery, although when he originally took up photography it was purely to record his own paintings. Ray began experimenting seriously with the process soon after moving to Paris in 1921. He tried placing objects directly on to photographic paper and exposing it to a distant light bulb. The processed paper carried a strange shadow image like Fig. 9.5 with darks and lights reversed, and parts of objects not in exact contact given a softer edge. The effect was like having used a spray of black paint from the same position as the lamp. (Man Ray often made paintings with an airbrush.)

Photograms – or as he preferred to call them, 'rayographs' – well suited the Dada approach to picture making. After all, they were unfamiliar abstract images produced almost at random by direct chemical means, free of all the irksome traditions of art. Dadaists must have been delighted to abuse the conventions of both photography and art. (It was incidentally a return to the very early experiments of Wedgwood and of Talbot, Chapter 1.)

Man Ray pioneered other forms of experimental photography such as solarization - a part positive, part negative image given by fogging photographic materials to light during development. At the same time he made his living in Paris from creative portrait and advertising photography,

while continuing his main interest, painting.

Laszlo Moholy-Nagy. While Ray worked on photographs in Paris, a Hungarian abstract painter Moholy-Nagy was making similar experiments in Berlin. Moholy-Nagy was already well-known as a writer and experimenter in new art forms, and was associated with Dada artists. But his most important contribution was as a teacher at the Bauhaus, Germany's famous school of architecture and design.

The Bauhaus was the most adventurous and influential art school of the 20th century. In the mid-1920s when other schools were still sketching classical plaster figures or studying William Morris designs for hand-made products, the Bauhaus staff and students attempted to face the problems of machine production. They explored the visual possibilities of contemporary materials like plastics, chromed steel and sheet glass, using modern industrial machinery to develop new forms of art and design.

Modern design was to be based on the function of products, buildings etc., plus the special qualities of the materials themselves. It was an attitude which is accepted today but was revolutionary at the time, and helped to put German and Italian products well ahead. Bauhaus ex-students had world-wide influence, giving a functional streamlined appearance to objects from chairs and teapots to screwdrivers and electric kettles, from poster or textile design to complete metal and glass buildings.

Abstract painters such as Klee, Feininger and Kandinsky taught at the Bauhaus. Moholy-Nagy ran the first-year course which was concerned with exploring the widest range of materials. Their method of teaching made students look at ordinary things around them afresh, to make their own discoveries of form and design in things often taken for granted. The effects of light on an object's shape, the effects of unusual viewpoints (Fig. 9.6) or reversal of tones, could all be explored by use of photography,

Fig. 9.6. A snow scene photographed from Berlin Radio Tower by Moholy Nagy, 1928. Pattern and viewpoint were explored as new sources of design.

Fig. 9.7. (above) An x-ray photograph of a sea shell reveals the pattern of its internal structure.

Fig. 9.8. (above right) An object dropped into milk. Lit by electronic flash 1/100,000 sec, 1936.

photograms and movies. Photography helped to intensify seeing. Equally photomontage was a wide-ranging method of combining reality and fantasy, discovering ways space and scale can be deceptively presented, and creating strange juxtapositions.

Moholy-Nagy also taught the importance of looking for sources of design in new forms of image which modern photography in the 1920s now made possible. For example, photographs from aircraft, or through microscopes or telescopes, X-ray images (Fig. 9.7), pictures taken by high-speed flash or stroboscopic lamps all revealed natural structures which had not previously been visible to the eye. Moholy-Nagy preferred to ignore the exact scientific purpose of such photographs. *The New Vision* as he called it was an aesthetic of its own, encouraging greater awareness of form and design.

Bauhaus ideas and examples, including Moholy-Nagy's fascination for creating effects by direct use of light such as photograms, maintained a powerful influence for over 50 years. (Remember too that at about this time Germany was dominant in the growth of photojournalism and picture magazines, Chapter 7). Inside Germany itself however this exciting period came to a sudden end. In 1933 the Bauhaus was closed by the Nazis, who condemned modern artistic experiment and free expression as decadent. Paintings were confiscated and the teaching staff, like many leading magazine editors and photographers, dispersed to other countries. Their ideas and influence therefore quickly spread beyond Germany. After a short stay in Britain, Moholy-Nagy emigrated to America in 1937 to direct the New Bauhaus in Chicago, which later became the Chicago Institute of Design.

Experiments in realism

In America during the 1920s few photographers involved themselves much with total abstraction. But Dadaist painters' choice of subject and treatment of form was intriguing, showed that 'ordinary' objects could be revealed in a fresh light. By photographing forms close-up information could be abbreviated – significant detail still remained recognizable, although not

intended to strictly document the subject. This new kind of realism had roots in the straightforward unmanipulated photography Stieglitz had promoted over 10 years earlier.

The ways in which photography was moving in response to modern art clearly showed at the international 1929 Stuttgart exhibition 'Film & Foto'. On the one hand there were abstract photograms by Man Ray and Bauhaus photography, plus the scientific and technical photographs of 'New Vision'. On the other hand the exhibition gave Europeans their first comprehensive viewing of new straight photography – intensified realism – from young American photographers such as Paul Strand.

Paul Strand was the first important twentieth century photographer to turn his back on pictorial photography and to create aesthetically pleasing

Fig. 9.9. A shadow pattern by Paul Strand, 1915. Part of an ordinary sunlit veranda, imaginatively seen and composed. Strand's image uses photography's own rich qualities 'straight'.

Fig. 9.10. 'The White Fence', 1916. Strand's choice of viewpoint and lighting gives a strange perspectiveless effect, and strong design. Older pictorialists called this new realism 'brutal'.

pictures which were 'straight', i.e. showing the subject realistically and not by manipulating the photographic process. About 1907 he had learnt photography at his New York high school from biology teacher, Lewis Hine (page 93). Strand flirted with the usual soft-focus scenes of pictorialism, then became interested in what was being shown and discussed at Stieglitz's 291 gallery. Here he was also introduced to the work of modern European painters.

Strand's pictures therefore contain a combination of the documentary (Hine) and the aesthetic (Stieglitz). Other influences seem to include Emerson's original ideas on naturalism, some of the geometry of cubist painting, even Frederick Evans' careful use of qualities of light on form. Strand was encouraged by Stieglitz who recognized the importance and originality of his new approach (considered 'brutal' by many older pictorialists).

In 1916 when Strand was in his mid-twenties, his work was shown at the 291 gallery, it was also published in the last issue of *Camera Work*. Pictures like 'The White Fence' (Fig. 9.10), created special interest because of its stark tones, simple shapes and semi-abstract flattened forms. This was not someone slavishly following the 'isms' of art, but a photographer working with everyday scenes to explore freshly how geometric shapes relate to one another on the picture plane.

Strand's later work became less abstract and graphic, but more documentary. This included modern portraits, particularly photographs showing the role of the working man. For twenty years he made his living as a news and documentary cinematographer, returning to still photography again after World War II.

During the period around 1920 Paul Strand often wrote about his ideas on what photography should be. They express well the views of straight photography enthusiasts. Gum prints and diffused images may once have been valid as experiments, wrote Strand, but they destroy the qualities of the subject, and seemed to be used by people with a frustrated desire to paint. Photography is not a short cut, either to painting or being an artist,

or anything else. It is a separate set of equipment and materials with strengths and limitations of their own. He stressed that talent or lack of talent stemmed from *the photographer*, not from photography itself – and because many workers failed to really understand their medium the public did not take it or them seriously.

To use photography honestly two things were essential in Strand's view; firstly, respect and understanding for the materials you use; and secondly feelings for and recognition of the subject qualities in front of the camera. The visual forms of objects, their textures, relevant colour values, relationships of lines, etc., are like instruments of the orchestra. The photographer must learn to control and harmonize these elements, then by mastery of technique express them strongly, fully exploiting photography's unique qualities such as sharpness of detail, richness of tones.

Strand stated that beginners should learn to observe the world immediately around them with a kind of extra-sensitive vision. If the photographer is alive it will mean something... and he or she will want to photograph and intensify that meaning. 'If photographers let other people's vision get between the world and their own, they will achieve that extremely common and worthless thing, a pictorial photograph'.

This new American movement towards realism or 'new objectivity' had originated on the East coast of the United States. But 2500 miles to the West, in California, it was to influence a whole group of talented photographers, beginning with the work of one man.

Edward Weston. In 1915 Edward Weston was running his own commercial portrait studio in California. He also contributed soft-focus type pictorial work to photographic exhibitions and salons, and was even an overseas member of The Linked Ring. But this was the year of the San Francisco Fair which brought modern art, music, and literature to the people of the area. Weston was stimulated by the new abstract forms of art, and for this and other reasons decided to break with his former life

Fig. 9.11. Edward Weston could photograph an ordinary cabbage leaf and without manipulation, make a dramatic image of its flowing lines, 1931. Collection of the Centre for Creative Photography.

style and concentrate on his own experimental photography.

In the early 1920s he met Stieglitz and Paul Strand in New York. Like Strand, Weston's approach was developing towards straight photography of natural and man-made forms. This was intensified during a period in New Mexico (1923–1926) where he was influenced by artist friends.

Subjects which he found interesting ranged from the rolling sand-dunes of desert landscapes to nudes, close-ups of vegetables, weathered materials, and industrial plant. In all these the rhythms and forms are expressed with a superb technique which helps the illusion of subject texture and substance. Weston could do so much with so little – for example, the play of light on a simple cabbage leaf (Fig. 9.11).

Technical quality was always of great importance. Like Strand he used a 20×25 cm (8×10 in) plate camera, contact printing the whole of each negative. Prints were made on regular commercial paper, aiming for a

rich tone range and avoiding all print-embellishing techniques.

Weston's attitudes to photography (shared by Strand) summarize what has since become labelled photographic modernism. He argued that every method of making images has its own unique characteristics. Therefore photography as an art is different from other visual arts such as painting, a difference which must be not just accepted but actively cultivated. If photography is to be seen as new, independent, in a separate compartment, it needs to be judged in a different way too – tools of fine art criticism are not applicable to photography unless modified.

Few modernist photographers said much about what conceptual meanings lay behind their work beyond the need for remaining true to the qualities inherent in the medium. Modernist photography was thus isolated not only from pictorialist photography but from fine art generally. Like Strand, Weston believed that the photographer has a special way of seeing which creates his or her picture, while exposure records it, and developing and printing execute the final result. Weston's reputation became

Fig. 9.12. 'Nude, 1934'. Weston's nude is depersonalized. In the photograph, the human body is seen and lit as a still-life arrangement of forms.

Collection of the Centre for Creative Photography.

Fig. 9.13. 'Clearing Winter Storm, Yosemite' by Ansel Adams, 1944. Dramatic US landscape photography – emphasizing natural beauty. © The Ansel Adams Publishing Rights Trust/ Corbis.

international at the 1929 Stuttgart Exhibition.

Three years later, in 1932, a group of like-minded young photographers (including Imogen Cunningham, Willard Van Dyke and Ansel Adams) together with Edward Weston, formed *Group f64*. The name was taken from the smallest aperture setting given by most lenses and giving greatest depth of field. This loosely formed group consisted mostly of professionals and it was dedicated to 'straight photographic thought and production'. In fact Group *f*64 soon disbanded (Weston withdrew within a year, preferring to work alone) but its name became a symbol which captured the imagination of all anti-pictorial photographers.

Ansel Adams. One of the original members of Group *f*64, Ansel Adams was the only photographer to continue their concern for straight, objective images into the second half of the 20th century. Back in the 1920s he was a young concert pianist who enjoyed taking pictorial landscape photographs of the nearby Yosemite valley (between San Francisco and Los Angeles). Then in 1930 Adams discovered Paul Strand's fresh approach and technical quality. He decided to devote all his time to photography, concentrating on the natural beauty and grandeur of American landscape.

Fortunately Ansel Adams possessed the unusual combination of a poetic eye for a picture, and the skill and interest in technique to really control his materials. Conservationist, mountaineer, writer and teacher, most of his photographs seem to express the mysterious living forces in nature.

They have also been likened to musical compositions. Fig. 9.13 for example to a dramatic Beethoven symphony, other gentler pictures of ferns and

trees as sonatas or fugues.

Adams used the scientific researches of Hurter and Driffield in a positive way rather than seeing them as restrictions like Emerson (page 112). He devised a system – 'the Zone System' – whereby the use of an exposure meter and precise control over film development and enlarging allows the photographer to predict and control the tone values on his final print. With experience the camera user can pre-visualize the eventual black and white print at the time of shooting.

Adams also followed Stieglitz in closely concerning himself with the way his pictures were reproduced on the printed page. He had already brought out his first technical book on photography when Stieglitz gave him a one man show at 'An American Place' (1936). More publications followed – some of these were collections of landscapes such as the National Parks, others on how-to-do-it photography. He helped to create the first department of photography at the California School of Fine Art and ran annual photographic workshops in Yosemite valley. Through all these activities – photographing, writing, teaching – Ansel Adams had a long lasting and world-wide influence promoting the objective, straight approach to photography.

Realism in Europe

Although the development of straight photography is often thought of as an American trend, there was also an independent movement towards objectivity by several German photographers. The 1929 Stuttgart show included work by Albert Renger-Patzsch and Karl Blossfeldt, both photographers who could be said to be part of the New Objectivity (Neue Sachlichkeit) movement.

New Objectivity was a phrase first used in 1924 to describe contemporary painters' interest in realism – mostly a reaction against the 'muzziness' of

Fig. 9.14. One of the Renger-Patzsch photographs from 'The World is Beautiful', 1928. His subject is simply German suburban housing.

Fig. 9.15. Plant forms, looking like man-made cast iron decoration. From Blossfeldt's famous book 'Art Forms in Nature'.

impressionism. To such people the actual subject was all-important and should be represented in an accurate detailed way. (Eventually this was to develop into Surrealism, page 141). New Objectivity soon spread to photography and movies, for the camera seemed to allow the greatest realism of all.

Albert Renger-Patzsch. In 1922 Renger-Patzsch, a young photographer at an art publishing house in Hagen, Germany, began a series of photographs of what he preferred to call 'things'. These were everyday objects – basic materials, plants, buildings, people, industrial machines. He often photographed these 'things' close-up and he chose viewpoint and lighting to intensify their appearance. One hundred of these uncontrived objective photographs were published as a picture book *The World is Beautiful* in 1928. The book was influential amongst painters and

writers and praised by them for its sensitivity.

Pictorial photographers were hostile. In Britain the Royal Photographic Society called the Renger-Patzsch pictures 'stunts' and 'soulless record work'. However, he maintained his photography was not copying things, but exploring and displaying them – capturing our modern surroundings in pictures which should endure, *and* without any borrowing from art.

Renger-Patzsch created several other picture books, on portraits, flower studies, and on German landscapes and towns (Fig. 9.14). Unlike the Bauhaus photographers he saw no need to extend the boundaries of photography. Abstract designs for their own sake belonged to graphic art. Self-conscious manipulation was for the pictorialists. He found ample scope working within photography's powerful quality of realism.

A year later, in 1929, Professor Karl Blossfeldt published a book called Art Forms in Nature consisting of 120 big close-ups of plant forms, each photographed in diffused light against plain backgrounds (Fig. 9.15). Their likeness to works of art produced by human hands was fascinating, and added further strength to New Objectivity. Clearly there were links here with New Vision (Moholy-Nagy and his colleagues' use of photographs through microscopes, telescopes, etc.). Equally most of the opinions Renger-Patzsch held about photography matched those of Paul Strand, who he never in fact met.

Although the New Objectivity movement in Europe always remained on a much smaller scale than the American version, it had a strong influence on German and French professional photography in the 1930s, as will be discussed shortly. It also had its critics – not only die-hard pictorialists, but fellow Germans working in the equally new area of journalistic and documentary photography. They accused Renger-Patzsch and his followers of having a superficial approach, or of encouraging 'seeing for the sake of seeing'. Subjects shown with such photographic clarity often had other, deeper meanings, such as the housing problem, unemployment, dehumanizing effects of industry, etc., which were totally ignored. Eventually everything is seen as worthy, stated his critics – a beautiful mindless picture can be made from the pattern of advancing stormtroopers' boots . . .

Some influences of the new movements

Most of the modernist art movements were influential on approaches to photography and its uses in society. Germany's New Objectivity gradually changed and broadened photography in Britain from the midthirties onwards. The Americans' straight photography had a slower but eventually stronger influence, reaching other countries mostly fifteen to twenty years later.

The four main trends were:

- The objective or straight approach a direction which was adopted in both advertising photography and photographs which are ends in themselves.
- 2 Photography as a source of design affecting art college teaching of visual perception.
- 3 Photographic surrealist images often in the form of cut-and-stick photo-montages.
- 4 Photography as metaphor affecting personal expression.

Fig. 9.16. Advertisements in the 1930s began using new objectivity style photography to show products in a much more direct way. This approach is still used today.

1 Objectivity. Work by Group f64 and similar photographers – rich in detail, very considered and pre-visualized, and calling for large format cameras – was greatly admired and followed by photographers concerned with the richness of the photographic image. The result was and still is an end in itself, a 'fine print', a kind of communion with nature and the photographic process for the photographer. This realism approach gained ground mostly through books by Ansel Adams and others. The quarterly US magazine Aperture (from 1952), published and edited by Minor White (page 144), has also been very influential.

The New Objectivity of Renger-Patzsch's photography and the visual impact it gave to unfamiliar aspects of familiar objects was an approach closely related to 'clean-cut' superior craftsmanship. The one direct application for this objective style was advertising photography – of products, tools, machinery, etc. Throughout the 1930s 'German photography' became sought after by advertising agencies in Britain and most other continental countries, helping to expand professional photography in directions other than portraits and photojournalism. (See Chapter 10). It also provided material for the then (Germany, 1920) novel idea of photo-books, collections of well reproduced photographs. Berlin at this time was an enormous attraction to creative writers, poets and painters. To such people the new realism of photography and movies in the late 1920s and early 1930s became almost an obsession. Later, as Nazi policies forced the immigration of talent, these influences dispersed abroad.

2 Design. The experimental approach to photography initiated by the Bauhaus had its greatest influence on art college courses. Ideas such as exploring photographic materials alongside more traditional methods of making graphic images, the investigation of accidental effects, and design irrespective of subject – plus the New Vision of scientific and technical photographs – became a basic part of first-year work. Photography as a means of developing a designer's or artist's sense of 'seeing' spread throughout Europe and Britain, especially after World War II (1945). From the late 1930s, when the Bauhaus was re-established in America, it was to affect the US scene too, although never with the same influence as in Europe.

The general atmosphere of experiment influenced all sorts of photographers. For a time during the 1950s for example *Bill Brandt* (page 102) produced a highly original series of photographs of the nude form in which close viewpoint and use of wide angle lens gave extraordinary de-personalized shapes (Fig. 9.18). They were published as a photo-book *Perspective of Nudes* 1961. You can also find distorted images in pre-war photography by Andre Kertesz.

The Bauhaus spirit abroad can be traced most directly through the work of individuals, people like *Harry Callahan*. Callahan began teaching at the Chicago Institute of Design the year Moholy-Nagy died there (1946) and three years later became Head of the Department of Photography. His work includes simple linear designs based on plants, the facades of buildings, figure studies, etc. – often presented as semi-abstract graphic shapes. See Fig. 9.17. Although Harry Callahan explores accidents too, his approach is cool, personal and like most Bauhaus photography somewhat detached from the subject matter.

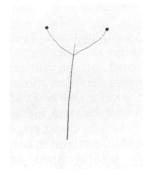

Fig. 9.17. 'A Weed', 1951. Harry Callahan's photograph has such extreme simplicity it looks drawn. Callahan was an influential US teacher of photography and design.

Fig. 9.18. Like a Henry Moore sculpture, this distorted nude form relates to the sea-shore, cliffs and pebbles. The photograph was taken by Bill Brandt in 1953. © Bill Brandt Archives Ltd.

3 Surrealism. One modernist art movement developing from Dada was known as Surrealism. Surreal pictures are based on thought – on subconscious mind and vision rather than reason – like a detailed dream in which familiar things are mixed up in strange ways. Look at the paintings of Salvador Dali or Rene Magritte (Fig. 9.20). Since surreal pictures usually feature highly detailed likenesses of objects (straight or distorted) in unexpected relationships, photography's realism made it an ideal medium to use.

The growing existence of so many photographs in print encouraged new techniques of surrealist art. For example, some Berlin Dadaists had discovered the possibilities of photomontage – pictures constructed from photographs cut out of newspapers and magazines. The technique fitted in well with their obsession for machine-made art. Not only were the pictures made with a camera, but they had also been photomechanically reproduced in the press.

Moholy-Nagy used photomontage combined with drawn graphics to explore visual problems such as the suggesting of space through changes of scale. This was an instance of combining the visual and technical experiment of the Bauhaus with the reality of documentary photography. Max Ernst in Cologne was more concerned with the disorientating power of detailed factual photographs when combined in odd ways. Known realistic objects were brought together to create strange poetic situations outside normal experience. John Heartfield, a communist who specialized in the use of photomontage for book covers, etc., was probably the first Dada artist to realize how effective this technique might be for political attack. By cutting out documentary pictures of politicians and combining them with pictures

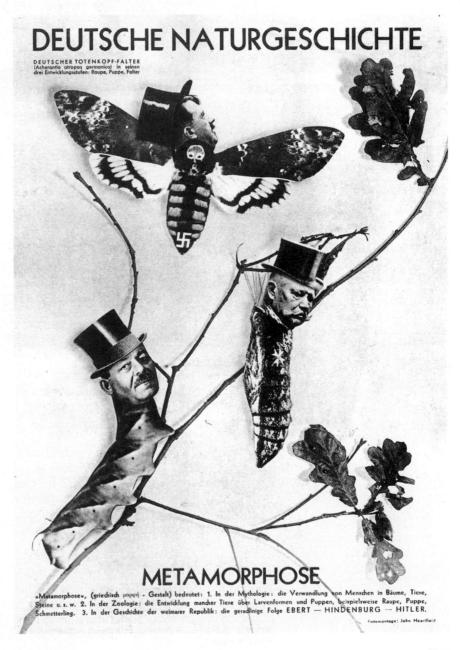

Fig. 9.19. Heartfield photomontage 'German Natural History' shows politicians Ebert (caterpillar) . . . Hindenburg (chrysalis) . . . resulting in Deathshead moth Hitler, 1934. The butterfly too was a favourite surrealist symbol for metamorphosis.

Fig. 9.20. Rene Magritte's 1937 surrealist painting 'La Reproduction Interdite'. It contains a cunning mixture of truth and fantasy, drawn with photographic detail.

from other newspapers, magazines, books or even specially taken photographs, he created brilliant posters and magazine covers against the Nazis. The people looked real, yet now they were shown in ridiculous poses which related to the current political situation (Fig. 9.19).

Heartfield's photomontages published in AIZ (Arbeiter-Illustrierten Zeitung) became increasingly vicious as the Nazi party took over the government of Germany. By 1933 he was hounded out and had to work from Prague; in 1938, like many others, he took refuge in London. The use of montaged and retouched photographs to ridicule people continues today in satirical magazines such as the British Private Eye.

Theatrical photographer Angus McBean was one of few British photographers to respond to the continental spirit of experiment during the 1930s (Cecil Beaton was another, see page 153) McBean's professional work was mostly publicity pictures documenting new London stage productions, and during 1938–1939 he made a brilliant series of montaged or otherwise faked surrealist portraits for *The*

Fig. 9.21. The actress Gladys Cooper, photographed and turned into a fantasy cut-and-paste montage by Angus McBean for popular British magazine 'The Sketch', 1938.

Sketch magazine (Fig. 9.21). Angus McBean's specially planned studio photographs mixed theatrical scenery, double exposure and photomontage to create light-hearted surrealist fantasies based on a performer's role in some current play.

All categories of photography sooner or later overlap and merge. Notice how we are now almost full circle back to those old constructed

images of Rejlander and Robinson (see pages 109 and 29). The difference is that here photographic realism is openly used to deceive. Much of the picture's effect depends on knowing it is a photograph and accepting it as truthful, yet realizing the situation it shows is impossible. The viewer is no longer expected to regard the result as a 'work of art', but the expression of a point of view, dream-like fantasy or a piece of visual humour.

4 Metaphor. This area of influence is again mostly American inspired and can be traced from 1920's expressionist work by Stieglitz and by Weston. In Stieglitz's view photography's rise in independent status should go beyond straight imaging, and allow some measure of self-expression. The two – realism and expression – sound conflicting but might be achieved by a photograph showing the subject as recognizable for what it is, but containing a kind of inner meaning which can be related to something else. For example, a fine close-up photograph of rock formation can also be seen as signifying ageing and death. The photographer's feelings about his or her relationship with someone might be summed up in a photograph of clouds, and so on.

These 'equivalents' as Stieglitz named them therefore attempt to express a social meaning or metaphor. The *viewer* is expected to be a creative audience and work at interpreting the equivalent in his or her own way – which may or may not be that of the photographer. Equivalents are like visual poems, and in fact may be presented in sequences with or without words. Through work of this kind the photographer may be able to convey and evoke feelings about situations which cannot themselves be photographed easily – emotions such as anger, love, joy, despair, or various qualities of character.

Minor White has been described as the high priest of photographic metaphor. A poet turned photographer, which he taught at various American colleges, White also worked at the Museum of Modern Art where he met Stieglitz, Weston, Strand and others. Like Ansel Adams he regarded mastery of technique as vital, in order to previsualize the final print when photographing. However his main interest was in the inner significance of pictures and the viewer's response to the photographic result. Equivalent photographs are steps in a process towards self-discovery of feelings and spiritual beliefs, not end products.

Minor White produced several books of photographs – one titled *Mirrors, Messages, Manifestations* covered mostly nature and natural forms (Fig. 9.22). He was also editor of *Aperture* publications from 1952 until his death in 1976. As teacher, publisher and mystic, White influenced many expressionist American photographers and also created numbers of followers in Europe. See also page 167.

The modernist trends discussed in this chapter were basically all movements away from the old idea of pictorialism, although the divisions made between each are not clear-cut. Bauhaus ideas on new sources of images relate through photomontage to documentary photography, and again the scientific, aerial, technical images of 'New Vision' overlap work by Albert Renger-Patzsch and other 'New Objectivity' enflusiasts. In America there are clearly similarities between the attitudes of Paul Strand and Albert Renger-Patzsch; also links exist between documentary work and 'straight' photography by

Fig. 9.22. Photography as a metaphor – images with inner meanings to the photographer, beyond the actual subject shown. A Minor White study from his book 'Mirrors, Messages, Manifestations' 1970.

Weston and his followers. Farm Securities Administration photographer Dorothea Lange was for some time a member of Group f64.

Divisions occurred more between countries, because exhibitions, magazines and books, and travel generally were not as international as they are today. Individual photographers too tended to be forceful characters, seeing themselves as crusading a new approach. They sometimes created new categories and movements which were not quite so original as they made them out to be.

Summary - modernist movements

- The years before and after World War I were a period of intensive experiment and rediscovery in photography. This centred on Germany and America. It covered graphic-conscious abstract images as well as various forms of 'straight' photography – both based on ordinary, everyday subject matter.
- In fine art the form-conscious cubism had replaced impressionism. The British vorticist group (including photographer Alvin Langdon Coburn) produced abstract images based on modern architectural forms. Italian futurists were concerned with dynamic movement. Dadaists, the most revolutionary group, were out to reject all previous 'painterly' values. The machine-made imaging aspects of photography were therefore of interest. Dadaist techniques included random photogram prints attached to canvas, also works montaged from cut-up bits of photographs.
- Man Ray (France) painter and photographer, was a leading influence in the making of photograms, solarized prints and other experimental photographic images. All these were put to original creative use mostly during the 1920s–30s.
- Moholy-Nagy (Germany), multi-media artist, encouraged his Bauhaus students to experiment with photography as a design tool,

helping to intensify their 'seeing'. Similarly technical photographs of all kinds – The New Vision – offered new sources of design. Bauhaus principles were widely followed by other colleges and brought to

America by Moholy-Nagy in 1937.

• In contrast, Paul Strand (America) mainly developed his own less abstract 'straight' approach. Observation and feeling for the qualities of the subject, plus understanding for photographic materials and respect for the special characteristics of photography were essential. Strand's work and writings on photographic realism during the 1920s influenced other workers.

 US west coast professional Edward Weston also produced outstanding studies of natural and man-made forms. Subject qualities were revealed perceptively, and expressed with extreme realism and detail.

Group f64 formed in 1932.

• Ansel Adams, a younger f64 member, continued Weston's straight approach, concentrating mostly on landscape. He devised an exposure technique (Zone system) to help in previsualizing the final black and white result at the time of photographing. Adams was a master of print quality, and his teaching, writing and exhibited pictures 1930–60s converted others to the possibilities of realism through large format photography.

Meanwhile the New Objectivity movement (mid-1920s) in Europe was pioneered by Albert Renger-Patzsch. Its emphasis was on showing form and structure of everyday things – including landscape but also man-made objects ranging from buildings to machinery (reflecting Germany's industrial growth). Karl Blossfeldt's close-ups of plant forms also proved the power of objective

photography.

• Four main trends developing in the 1930s: (1) Objectivity – 'considered' images rich in photographic quality and visual impact which still show the subject in a realistic way. Important in commercial advertising photography. (2) Design – photography used freely as a medium of visual experiment and discovery, to develop an aware 'eye'. Important in art training. (3) Surrealist photographs – images, often Press pictures, used in an openly abused form to construct powerfully communicating photomontages (Heartfield's anti-Nazi propaganda; McBean's theatrical portraits). (4) Metaphor – photographs which evoke an inner meaning to the photographer, e.g. Stieglitz and Minor White's 'equivalents'. For some people this opened up an important means of combining straight photography with self-expression.

 Modernists promoted the idea that photography has its own (here and now) particular characteristics, separate from any others. Use them fully: exploit what photography can do well. No need to pretend that it's something else, or apply the critical theories used in other

fine art media.

Projects

P9.1 Try making photograms. Stand flat and three-dimensional objects on bromide paper in the darkroom, then expose your arrangement to light from a hand torch, i.e. a small torch dimmed down with tracing paper and fitted with a cone of black card to narrow its light beam. Hold this light at different angles, still or moving, for each photogram – like using a black paint spray. Process the paper as normal.

P9.2 Find examples of paintings which (a) use the futurist multi-image technique to suggest dynamism e.g. works by Giacomo Balla, Marcel Duchamp; and (b) use actual photographs attached to or printed on canvas e.g. Kurt Schwitters,

Max Ernst, Robert Rauschenberg.

P9.3 Using photographs clipped from magazines, mail order catalogues, newspapers, etc., try constructing a photomontage. Suggested themes – *The Consumer*

Society; Size and Scale; Multiplication.

P9.4 Find examples of a landscape photograph by a pictorial photographer, e.g. one of The Linked Ring (Chapter 8), and another by a photographer dedicated to a 'straight' approach typified by Group *f*64. The subject itself should be as similar as possible. Then make similar comparisons with other subject choices – portraits, still lifes, etc.

Changes in professional photography 1920–1980

Professional photography – that is market driven photography as used for selling, informing and presenting public images – changed and expanded enormously during the middle of the 20th century. Back in the earlier 1900s professional photography mostly meant family portraiture, or simple recording of products, events, and locations. Later, as photography became the most universal form of illustration, professional photography grew much more sophisticated and lively. In Britain and America of the 1960s particularly it exploded as a youthful culture, reflecting changes in society and also influencing them in return.

Bear in mind that many of the creative photographers discussed as avant garde exhibitors in previous chapters also needed to make a living. After all, few had private incomes and the sale of photographs as art objects was virtually non-existent before the late 70s. Through their practice of professional photography changing stylistic ideas – the decline of pictorialism and arrival of New Objectivity for example – fed the look of commercial work. Other important influences were the technical improvement of full-colour printing in publications, the growth of movies and later TV (which made the public much more used to visual communication via photography) plus changes in commerce and industry themselves over the years.

Politics had an indirect but strong influence on professional photography during the years leading up to World War II. Thousands of intelligent, creative individuals decided the best way to avoid repressive regimes they hated was to leave continental Europe. Photographers and designers such as Andre Kertesz, Alex Brodovitch and Edwin Blumenfeld reached America; Felix Mann, Walter Nurnberg and many others came to London. They brought with them new ideas, a different culture. Some of these people soon became influential editors and art directors. Others succeeded as photographers in various fields. By applying their skills to fashion, advertising and industrial photography they raised professional work to new levels of style and approach.

Fig. 10.1. Russian magazine photographers used the heroic realism approach of other official Soviet artists, 1935.

Growth of advertising and fashion

Originally the use of photographs in advertisements was just to show the product – typically recording it in conjunction with a satisfied, and often titled 'up-market' customer. The idea of photographs that would appeal in themselves to purchasers began in a few of the more extravagant fashionable magazines. American publications like *Vogue* and *Vanity Fair* had the money to afford high quality (black and white) reproductions, and attract photographers such as Baron de Meyer, who joined *Vogue* in 1914. De Meyer was chosen in part because of his society life status, name, and artistic reputation, and he was briefed to 'decorate' *Vogue*'s pages. De Meyer's images and life-style were still strongly influenced by the Pre-Raphaelite aesthetic movement. He used a special soft focus lens and 8×10 in plate camera and photographed fashionable society ladies (there

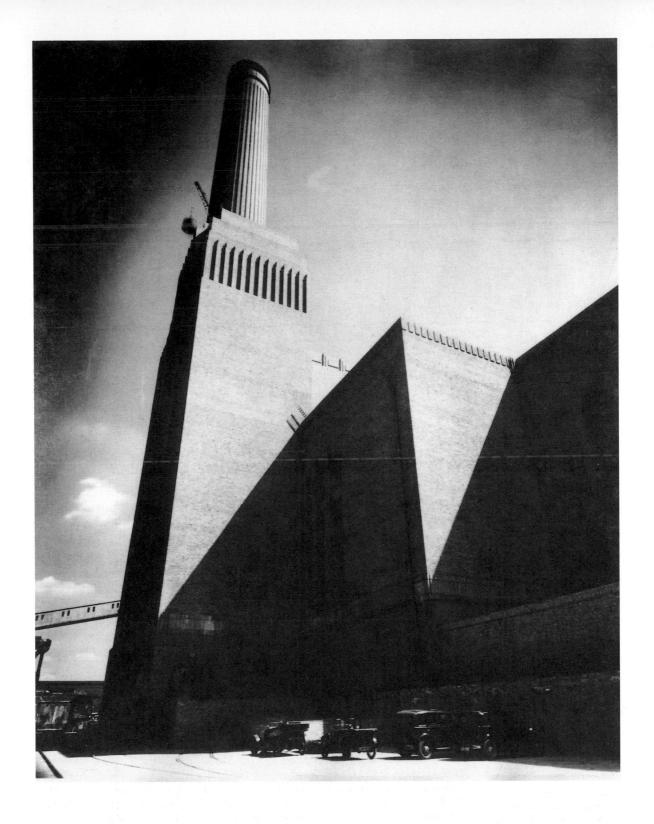

Fig. 10.2. Battersea Power Station, 1930. By Noel Griggs. This commercial photographer gave a strong modernist look to his architectural work, often using a wide angle lens with combined rising and cross front camera movements. Royal Photographic Society Collection.

Fig. 10.3. The romantic approach – back lighting and elegant setting for a wedding dress fashion illustration. By Baron de Mayer, 1920. © The Museum of Modern Art, New York.

being no such things as photographic fashion models) to convey elegance and beauty. See Fig. 10.3.

During the 1920s *Vogue* altered from being a society journal to an elite fashion magazine, published in Paris and London as well as New York. When Edward Steichen took over from de Meyer in 1923 he brought a completely fresh look to both its fashion and advertising photography by means of sharp focus realism and concern for natural forms. Meanwhile in Britain Cecil Beaton rose to fame in the 1930s as an outstanding fashion and portrait photographer. Beaton was also a stage and fashion designer in his own right and devised specially built studio sets for his lush fantasy portraits. Originally influenced by de Meyer but much more versatile, Beaton often introduced flamboyant elements of surrealism into his work. His sheer love of theatre showed in his pictures and his life-style. Beaton remained under contract to *Vogue* magazine London from 1928 until the mid-50s, a period which traced great changes in fashion design as well as in his own development. (Compare Fig. 10.17 with Fig 10.12).

But whereas editorial work in magazines provided the photographer with an important showcase, bigger money lay in photography for

Fig. 10.4. Aldous Huxley by Howard Coster, 1934. A new severe style of realism in portraiture.

Fig. 10.5. This fashion magazine advertisement of 1932 has an 'open air' look but, like most movies at that time, was shot in the studio.

advertisements. Advertisers also had the funds to promote the first colour photography reproductions. Hold-ups here were not just the bind of the photographer's colour separation negative processes (page 63), but development of mechanical printing presses, inks and paper to ensure acceptable and consistent quality results throughout the printed run of a magazine. Advertisements in colour first began to appear in American quality magazines in the early 30s, but concern for accuracy in product appearance (particularly foods) discouraged photographers from any subtleties of approach.

Professional photography for 'soft sell' advertising – needing the ability to use symbols to communicate subjective factors like status, sexuality, trendy sophistication – grew in importance. From the 1950s onwards more use was made of actual locations rather than studio sets too. And as advertising was directed towards the young it was executed by younger photographers and art directors. See page 157.

Portraiture

There was of course a world of difference between the work of leading, highly paid professionals working for advertising agencies and magazines and the ordinary high street portrait photographer. Magazines were

receptive to new styles (and also more demanding). But when the actual sitter was paying for the photograph a much safer, more traditional approach was needed. People expected flattery and wanted their portraits retouched, so until mid-century it was still routine to shoot quarter-plate or 4×5 in black and white negatives, then have them pencilled over by hand by the photographer's studio retoucher. In this way all traces of skin creases and blemishes were removed, see Fig. 10.6. In fact the overall slightly stippled surface appearance this gave to the face of every sitter was very much accepted as part of the look of professional portraiture. (Find and examine photographs of your own grandparents).

In the better city studios attempts were made to glamorize sitters by adopting some Hollywood-style lighting, such as spotlights directed from above to rimlight the hair and shoulders. This remained the portrait stereotype (sustained by television and changed only in the 60s from black and white to colour) for both family and corporate business portraits. One development has been a move to shoot more portraits 'on site' in the boardroom or family home, but otherwise portraiture remained a very conservative facet of professional photography.

Portraits of famous people formed a continuing market in magazines and book portfolios. Styles here have varied with individual leading practitioners. Yousef Karsh of Ottawa for example, dominant throughout 1940–70, makes dramatic use of film type lighting to convey strength and 'greatness' in his dominantly male portraits. His contemporary, the American Arnold Newman on the other hand is well known for the brilliant way he makes use of his subject's surroundings which relate to their occupation (Fig. 10.14). Portraits by Richard Avedon typically have a stark directness and naturalism, totally devoid of environment.

Fig. 10.6. Prints from the same negative before and after retouching. Portrait studios always preferred large negatives, which were easier to handwork with pencil or dye to flatter the sitter.

Fig. 10.7. The flamboyant studio style of Cecil Beaton. This is a portrait of the writer Nancy Mitford, taken about 1932.

Wartime roles

World War II had a greater effect on the lives of ordinary civilians than any previous conflict. In Britain travel was restricted, and paper for publications of all kinds, along with petrol and food, was severely rationed. Cut off from Germany, then the world's prime source of precision cameras, professional photographers mostly worked with existing or second-hand equipment. Those who registered with the Institute of British Photographers received a quota of materials from Kodak and Ilford, but this excluded Ektachrome and Kodacolor newly available in America.

The Photographic (Prohibition) Order prevented anyone taking pictures in sensitive zones such as coastal areas, railways, bombed cities or the military installations which were everywhere. Professionals too old to be conscripted in to the forces (mostly into the air force) mainly ran portrait studios. For reasons of love and fear portraiture boomed. In the US there were fewer limitations, but the lack of equipment from Europe, diversion of materials and manpower to war needs and drafting of young people slowed up visual development of photography.

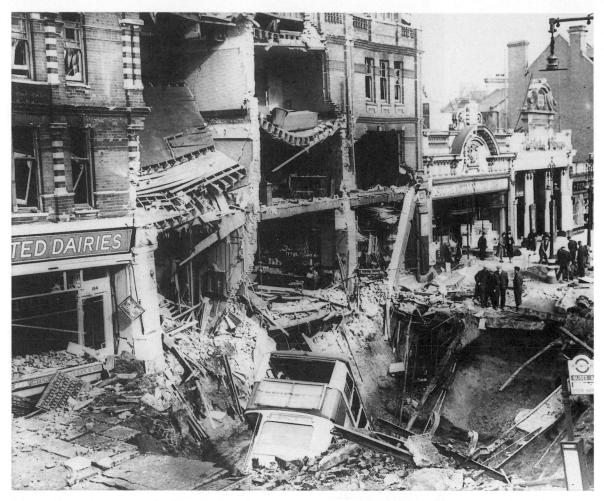

Fig. 10.8. Bus in a bomb crater - London 1940. At the time the censor would not release this picture for reproduction.

Photography became much more functional instead. On both sides it played an important role in photoreconnaissance, giving armed forces upto-date maps and military intelligence. Aerial cameras, lenses and large format rollfilms were specially developed for this purpose. All RAF Bomber and Coastal Command aircraft were fitted with cameras for day and night photography – by 1944 some 200,000 aerial photography prints were being produced from British service darkrooms each week.

The Farm Security Administration changed to become part of the US Office of War Information. *Life* magazine ran a school of photography for army and air force personnel. Edward Steichen became commander of the US Naval Aviation photography unit, while in Britain Cecil Beaton and other distinguished professionals spent periods as documentary photographers for the Ministry of Information. French *Vogue* closed for the duration.

At home advertising photography had shifted to propaganda. Pictures by officially accredited photographers showing British civilians enduring the blitz were widely distributed to the then uncommitted nations. The work was strictly censored for security, then sent through news agencies for use in (slimmed-down) papers and magazines at home, and for propaganda purposes abroad. Travelling photographic exhibitions were also made up to tour war factories, emphasizing to workers their importance in the War effort and how products were helping to beat the enemy. All pictures released this way were designed as morale-boosters, so pictures

of the fallen were not acceptable. Similarly spectacular shots of bomb damage (Fig. 10.8) were rarely published at the time. Military defeats and withdrawals were documented through expressions of determination to make good. Judged by today's viewpoint the work was simplistic, non-confrontational, and highly patriotic. Germany produced pictures in a similar way, publishing them in the Nazi multilingual magazine Signal (Fig. 10.10).

Post-war industrial boom

For some years after 1945 photographic supplies remained hard to obtain. Professionals struggled along, kept going on government surplus (roll) paper and film. Ektachrome reached Britain in the late 40s but the market for colour reproduction was still small. Very few labs existed and professionals had to carry out the (14 step) E-2 process themselves.

Photographers previously working in advertising, or for the information services during the war, or who were just all-rounders, now turned their attention to a booming new market – industrial photography. Industries had changed to a peacetime footing and now needed to compete again for international markets. Photography was seen as important both for promotion and internal company communications. Good prestige pictures of products, facilities and processes were wanted, and industrial organizations had the money to hire the best professional practitioners.

In Britain Walter Nurnberg, Maurice Broomfield and others applied their own dramatic approach (after all factories in reality were ugly and cluttered places). Nurnberg particularly brought a 'New Objectivity' feeling for the basic visual qualities of man-made objects – an approach also apparent in some pre-war British industrial architecture photography (Fig. 10.2). Nurnberg used the viewpoint freedom offered by a Rolleiflex rollfilm camera and deployed Hollywood-style lighting to make industrial workers look like film stars (Fig. 10.11). Factories were specially lit with spotlights placed

Fig. 10.9. (below) Allied soldiers with cheerful, determined expressions appeared frequently on British picture magazine covers during World War II.

Fig. 10.10. (below right) At the same time Germany produced Signal magazine, distributed in several languages. It was full of morale-boosting pictures of their troops.

Fig. 10.11. The dramatic approach to industrial photography – a 1956 cover by Walter Nurnberg.

ENGINEERING

to merge unwanted background detail into blackness. For his industrial clients Nurnberg's pictures sold the concept of quality and care, but for himself – he exhibited widely – they expressed industrial labour in terms of heroic dignity.

Numerous industrial firms set up their own photographic units too, 'Industrial staff photography' became a promising career. Some units within large international corporations achieved enormous prestige, such as the London-based Shell Photographic Unit which until the 1960s sent its photographers all over the world to take pictures for a crop of in-house company publications and PR.

However, as Britain started to become less industrialized, the 1970s brought a shift from traditional manufacture towards electronics. The

change of work and changing social attitudes lessened demand for the imagery associated with heavy industry. Fewer jobs meant closures of photographic units and a switch to freelance commercial photography instead. As for the visual appeal of the new technologies – microchips, fibre-optics, lasers – photography now needed to communicate precision skills and 'clean' laboratory-type environments. Use of coloured light and special effects optics came into vogue. Workers shown dwarfed by heavy industrial plant were seen as primitive and outdated. Industrial photography as a career or freelance specialization dwindled, especially since more could be earned working in the youthful 1960s Pop world of editorial and fashion photography.

Youth culture

As for the general public, once post-war rationing finally faded away everyone became consumers in the 1950s. Advertising began to be directed more towards the young, who had not up to now had much on which to spend their money. Starting in America, fashion and advertising photography generally took on a more fast-living style, with greater use of better reproduced colour. Models were now more personalized, and easier air-travel encouraged use of a wide range of real locations all over the world.

At Harpers Bazaar art editor Alex Brodovitch encouraged a new generation of fashion, portrait and advertising photographers such as Irving Penn, Richard Avedon and Arnold Newman. These people helped to

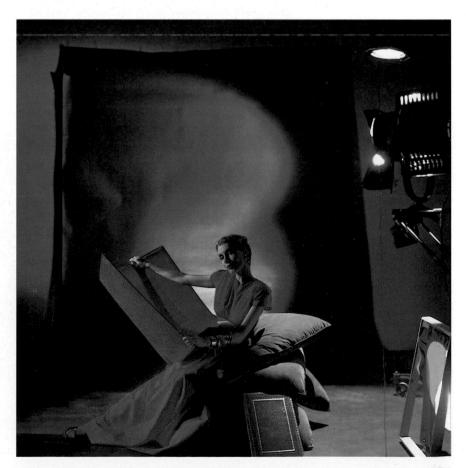

Fig. 10.12. Set up for a Cecil Beaton fashion shot in Vogue's London studio, 1950. Beaton made every effort to adapt his style to the times. Compare with Fig. 10.7.

Courtesy Sotheby's London.

Fig. 10.13. The graphic approach of a 1951 Vogue cover by Irving Penn. Lighting and setting are simple and austere.

Fig. 10.14. Composer Igor Stravinsky by Arnold Newman, for Harper's Bazaar 1946. Brilliant use of the open top piano suggests a musical setting and creates a shape balancing and directing the viewer's attention to the man. © Arnold Newman.

change the style of photography in the quality magazines to something simple and austere. Instead of elegant room settings backgrounds were now often plain white paper. Back-lighting and harsh stagey spotlights died away. Lighting was diffused (often reflected off white walls) to give an 'overcast daylight' appearance. The approach was straight, with retouching avoided. Results had immense directness. Notice (Figs. 10.13 and 10.14) how line and tone contrast was used to give strong graphic shapes.

The fashion magazines became so innovative they gained considerable power and status, dictating the newest look. Budgets for shoots expanded. But although at first eclipsed by the Americans, the leading role in the early 1960s cult of youth was passing to London. Here young photographers (several like David Bailey trained at the highly successful John French advertising studio) were about to become big names in their own right. Spearheaded by new London-based talent such as Mary Quant and Ozzie Clark fashions, the Beatles in music, the emergence of Richard Hamilton and other pop artists, and a young David Frost knocking 'the establishment' on TV, opportunities were being opened everywhere for new ideas, especially if linked to the youth market.

The 'Swinging Sixties' was an exciting, trendy period in which professional photography caught the public's imagination along with discos, boutiques, sex, and newspaper colour supplements. Antonioni's 1966 movie 'Blow Up' (modelled largely on David Bailey and shot in John Cowan's London studio) epitomized the life style which made people admire photographers as the new Hot Somebodies.

This mood for change coincided with technical developments such as studio electronic flash (with modelling lamps), flash meters; much better lenses for small format cameras and Polaroid backs. First class labs quickly appeared to take over the labours of colour film processing for the new young professionals. In the publication world medium and small format transparencies were now acceptable for reproduction thanks to electronic

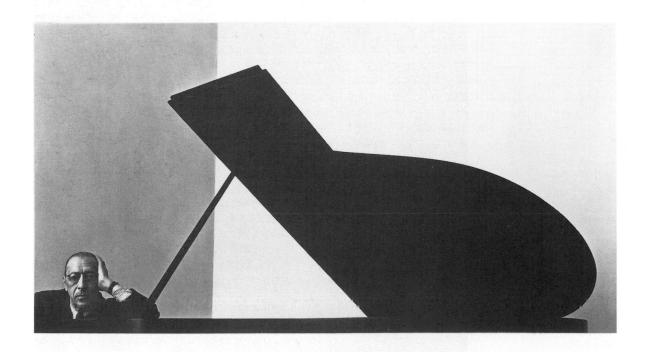

Fig. 10.15. Sam Haskins, a leading advertising photographer working in London, helped epitomize professional photography's lively new freedom of approach. This image is a composite of two separate shots and comes from his narrative picture book 'Cowboy Kate and Other Stories', 1964.

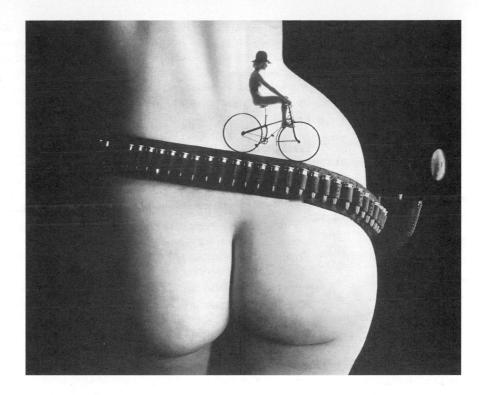

scanners and webb offset printing presses. Photography had become the preferred, up-to-the-minute way of illustrating posters, magazines, record sleeves and advertising of every kind.

By the mid-sixties London had grown to become fashion capital of the world. The rag trade saw how young photographers and art directors could make exactly the right contribution for marketing fashion to this new trendy. permissive society. They turned elegance into sexiness, discovered and made their models into individual stars. Photographers were clearly in with the beautiful people. The previous public image of the professional as a genteel, velveteen-jacketed old buffer working a mahogany camera in some down-town portrait studio had been swept away. Instead he (rarely she) was now seen as more likely to be an ex-working class, highly paid swinger, surrounded by Hasselblads and flash packs, in a studio blaring out music, and full of mini-skirted models. Photographers still in their twenties earned more in a year than the British Prime Minister. Equally though, photographs became less precious – like pop records they were regarded as more 'throw-away'. Many of the older brigade of established fashion and advertising photographers guietly disappeared, retired or returned to less hot-house competitive areas of professional photography. A few of the best (Norman Parkinson who had started with British Vogue in 1948 for example) survived because they could continuously come up with fresh ideas whatever the fashion 'look' of the day.

During the later 70s the cult of the young gradually faded as tougher economics cut back the fat. Several professional photographers who had done well for a decade dropped away like yesterday's pop stars. Some followed the money on into making TV commercials, or directing movies. Photographers became less bravado, more 'employed' by the fashion magazines which were now much less feudal and powerful.

Nevertheless photography – both visually and technically – had been

permanently expanded in all sorts of directions. You could also now go into any library and find not only technical information on photography but a rich variety of well reproduced collections of pictures by individuals. By this means it was possible to make a serious study of style, seek out the work of particular workers world-wide, compare a wide range of approaches. You could teach yourself about the music as well as how the instruments worked.

Influences on society

Professional photography has always been affected by outside social and economic changes, but increasingly it has influenced them too. Like cinema it has taught people to become much more visually sophisticated, less easily taken in by the surface appearance of photographic images. Consequently approaches employed by advertising have had to grow more subtle and entertaining as well as eye-grabbing, in order to work their messages. Professional photography itself has matured from simple illustration into visual communication.

Advertising and fashion photography as a whole seems to remain largely frivolous but closely reflects the mood and social attitudes of its time (the role of women for example). In other areas – documentary, scientific, medical – professional photography has spread to contribute an evergrowing flow of information for both experts and the general public to evaluate. The first pictures on the moon (1968) or from later remote sensing devices revealed unimagined new environments. But equally photographs of our own planet seen as a 'global village' from space, or of terrestrial atomic tests (See Figs. 10.16 and 10.17) led to concerned discussion of important environmental issues.

In the mid-50s New York's Museum of Modern Art put on a landmark photography show *The Family of Man* curated by Edward Steichen, director of MOMA's photography section. It used the work of many professional documentary photographers – from *Life* magazine, from the Magnum agency, plus leading individuals such as Andre Kertesz and Ansel Adams

Fig. 10.16. The mushroom cloud of water and radioactive material produced by the test detenation of an atomic bomb at Bikini Atoll in the Pacific Marshall Islands, on July 25th 1946.

Fig. 10.17. Earthrise, as seen by a NASA Apollo mission to the moon, 1968. For the first time man had moved far enough into space to see and record Earth as a sphere of clouds, land and sea. People began to realize just how unique - and vulnerable - our planetary environment really is.

– to present 'the world's people to the people of the world'. The exhibition was a highly successful humanistic exercise. Following on not so long after the world war and creation of organizations such as the United Nations it showed in a positive manner how different communities shared common aspirations. The Family of Man became the world's most attended exhibition and spent the next decade travelling from country to country. Its huge visual impact and emotional power, plus the publicity it received fostered a new public awareness and respect for what was seen as truthful documentary photography.

Even as TV in the mid-60s became a serious threat to the photojournalist and the picture magazine (Chapter 7) young photographers such as Don McCullin were determined to awake public conscience about wrongs in our changing society. Pictures began to pose questions instead of answering simplistic ones in a bland and sometimes patronizing way. This proved none too popular with the advertisers who sometimes found their frivolous products on the same pages as heart-wrenching pictures of famine and deprivation. Fig. 10.18 is one example of a professional press picture which caused millions of people to question events in Vietnam. In fact all the

Fig. 10.18. Vietnam police chief executes Viet Cong prisoner in the street, February 1968. When this press picture was published around the world it shocked the nations backing the Vietnamese in the war.

Fig. 10.19. Parkview, on the Stoke to Birmingham Road. Janine Wiedel 1978. Pictures like this now prodded people's consciences about pollution and health, whereas twenty years before it would have been received simplistically as a visual joke.

protest movements since the 1960s – ban the bomb, colour prejudice, anti-Vietnam, women's rights, pollution of the environment – have learnt to select and use effective photography to help persuade people to their cause.

Summary - professional photography

- The emigration of talent during the 1930s had a prolonged influence on professional photography in Britain and America. It ducted new approaches and styles of work. Growth of popular movies was influential too.
- Fashion photography, born out of society magazines with their fondness for romantic pictorialism (de Meyer) became more related to New Objectivity realism in the late 1920s. Cecil Beaton retained romance in his work for London Vogue but made brilliant, flamboyant use of surrealism too.
- American advertisers were first to adopt (expensive) colour reproduction in the 30s, but this only became general in Britain some ten years after World War II.
- Portraiture at high street level moved slowly negatives were still retouched and studio lighting often based on the Hollywood approach. Top portraitists differed greatly in style – Karsh's dramatically lit emphasis on 'greatness'; Newman's use of environment and sense of design; Avedon's often stark directness.
- Wartime shortages and call-up limited professional development.
 Pictures were censored, used for morale boosting and propaganda on both sides. Air Forces particularly made vast use of photography for reconnaissance purposes.
- Professional photography for industry boomed in the 50s and 60s.
 A dramatic New Objectivity approach (e.g. Nurnberg) was used in prestige and public relations images. Large organizations such as Shell Oil set up their own photographic units.
- A younger generation of magazine fashion and portrait photographers, encouraged by Brodovitch (USA) or stemming from John French (London), responded to a new cult-of-youth trend which rapidly centred on London. Together with pop music and pop art, photography was at the centre of 60's life style. Studio flash, colour labs, colour supplements appeared.
- Although the swinging sixties faded later with some photographers moving on to TV commercials and film, the public concept of professional photography as a young and lively activity remained. More books showing the work of photographers appeared.
- Wide-spread use of skilled professional photography in every field, from fashion to scientific, to photo-journalistic, etc., helped make the public more sophisticated in interrogating meanings out of images. Photographs often posed questions which powerfully evoked concern on current social and environmental issues.

Project

P10.1 Research and find modern examples of photographs used in each of the following ways (1) To publicize industry in a dramatic way. (2) To evoke some form of social protest. (3) To advertise a product, showing it directly. (4) To advertise something by association – soft selling it without actually showing the product. (5) To record information difficult or impossible to obtain any other way.

Concern for meaning

For all the youthful appeal of fast-moving professional photography during the 1960s, a more thought-based and lasting development in personal work was happening too, particularly in America. The root of most of this change was reaction to modernism. Like pictorialism in its day, 'acceptable' modernist subject matter, style and technique had become set-in and established. The next generation of photographers were not interested in stagnating, working within fixed traditions and feeding off the past. They were much more concerned to reflect changing, emerging ideas, perhaps trying revolutionary ways of working. It wasn't just a change to more contemporary subject matter or new techniques either – more a new and deeper way of thinking about photographs.

For one thing there was now a much greater presence of photography everywhere. Technically it was more accessible – latest 35 mm SLR equipment meant that everyone could shoot pictures, and to the enormous growth of family snapshots was added all the photography in advertising, editorial illustration, and scientific documentation. It could be said that you were far more likely to see a photograph of something than the thing itself. Photography along with TV now practically defined how life was experienced, be it the fantasy world depicted by advertising images skilfully calculated to encourage consumption, or the news media's not so 'objective' use of pictures to shape our knowledge of global society.

The question of *meaning* in images began to grow into a study during the 1960s. It involved discussing the use of symbols, the effect of wordsplus-pictures, how assumptions are made (sometimes unconsciously) and how different kinds of reality can be constructed and reacted to by the viewers of photographs. This greater conceptual (idea/thought) element encouraged deeper ways of reading photographs and the greater use of meaning for creative purposes. It further encouraged pictures which ask questions as much as offering information.

Of course, by placing greater emphasis on the thought process behind an image than the image itself sometimes leads to visually boring results. But sometimes too what first seems banal has a subtle and interesting content provided the viewer has the perception, interest (and time) to decode it. The analysing or 'deconstructing' of photographic representation formed part of what by the early 1980s became labelled as post-modernist photography. It led to artists generally recognizing how all-embracing and important in an avant garde way photography had become.

This chapter discusses why, when photography had already earned for itself an important modernist role in the commercial and artistic world, the ground should start to shift under everyone's feet . . .

Reactions to modernism

The 1960s, with their flowering of youth culture and enthusiasm for photography, was also a period when photography was taught more widely – notably in the US. The earlier GI Bill by which veterans could attend college cheaply had triggered groat growth in the student population, and new courses set up in many American art schools started to include photography. These courses were in greater swing by the 60s with more

Fig. 11.1. Gun I, New York, 1955, William Klein. © W. Klein, courtesy Howard Greenberg Gallery, NYC.

Fig. 11.2. Windowsill daydreaming, 1958, Minor White. The Minor White Archive, Princetown University © 1982.

young people attending and bringing a healthy questioning of where photography stood. Growing up with heal poels, hippies and experimental artists, the idea of critical debate generally was seen as an important element of contemporary life. Students wanted some kind of 'critical theory'

alongside practical work in photography courses in order to encompass problems of meaning within images. For older photographers this sounded rather academic but it linked up with US youth 'needing to do its own thing' (a practical possibility with a one-person activity like photography).

At the same time seeds of more general counter-culture were beginning to germinate. The ideals of Earth as a global village (promoted by man's landing on the moon) and Steichen's one-world humanist but simplistic 'Family of Man' exhibition began to be questioned. People were getting disillusioned by wars in Korea and then Vietnam, draft-dodging, race riots. The more progressive documentary photographers grew concerned to publish a more personally conceived truth – unsanitized by editors keen to keep politicians and advertisers unruffled

One means of doing this was to get your own book of photographs published. For example, William Klein, a tough Bronx-born 28 year old returning to New York after 6 years in Paris saw his home town with a fresh vision. Disregarding 1950's rules of good documentary photography – harmoniously composed moments of passing life epitomized by Cartier-Bresson's work – Klein went for a brash, aggressive approach. His technique (or lack of) featured blur, 'mis'focus, grain and perspective distortion. American publishers dismissed his 'biased' set of pictures as portraying New York as a slum, so Klein's book 'New York' 1956 was initially published in Paris.

A similarly difficult birth applied to Robert Frank's 'The Americans' also published abroad, two years later. These new books of expressionist documentary photographs were harsh and critical (unlike the 'poor-but-dignified' FSA pictures of the 30s). Cherished activities and national institutions were shown with irony, turned into metaphors for violence, shallowness and consumerism. The American public, brought up on *Life* magazine, found these fly-blown portrayals of their country deeply disturbing. Art photographer disciples of straight photography were shocked too by their combination of 'inferior technique' and 'ugly imagery'. Other warts-and-all books such as derisive portraits by Diane Arbus taken in the late 60s were also unspoken revelations of US culture and life-style.

Another, although different radical influence on young photographers was Minor White, editor of *Aperture* (America's main art photography journal during the 1960s). As discussed on page 144, White was concerned with symbolically interpreting subjects beyond their mere surface representation. What had begun with Stieglitz's 'Equivalents' became linked up with Oriental religions, Zen philosophy and the self expression preached by early 60s Hippie movements. Wynn Bullock and Paul Caponigro were among other US photographers who worked in a similar way photographing rock formations, peeling paint, plants, etc., as semi-abstract images (although following Adam's use of pure photographic technical qualities and straight use of the camera). Like Minor White they were all influential photography course teachers.

Since appreciation of such work relied a great deal on having viewers willing and able to find inner meaning by free association there was no great public attention. But Minor White's mystic way of using line and shape as symbols relating to abstract thought and shades of feeling (Fig 11.2), encouraged serious photographers' exploration of meaning. Individualism was clearly possible, and the 60s was a time for self-expression.

Duane Michals was one photographer then moving away from simply observing and reporting, to explore imaginary events through his own

'narrative' sequences of images. See Fig. 11.3. These appeared to be documentary, but in fact all the scenarios were fictitious, (exploding the idea that photography is objective). Michals' series each presented a time-based scene with a beginning, middle and end – typically they were also somewhat surreal with a dreamlike kind of private reality. His way of exploiting photography's apparent truth to present fictitious scenes, like movies, was to be developed further in the 1980s by pseudo-documentary photographers such as Cindy Sherman (Fig. 11.9) and Eileen Cowin.

Changing course content

American colleges played an important role in the 60s by providing teachers of photography with sufficient security to enable them to explore and develop personal work. With few galleries selling art photography at that time the only other source of income was to take on commercial assignments.

In Britain photography had been accepted as a subject to be taught in colleges during the 1950s, but to begin with this took place in only one or two *technical* colleges – better funded than art colleges and so able to afford the equipment and staff. Even so the traditional way into photography, by apprenticeship in a commercial studio, remained the training route for most young people. For Britain and most other European countries this meant that meaningful art education was missing from photography programmes. At first the courses were taught by commercial photographers, and so students were sent out as young professionals with mainly technical skills. Exams were set nationally by organizations such as the Institute of British Photographers. (Photography in America was instead integrated into university courses in communications and in fine art.)

From the mid-1960s however the science-versus-art nature of photography was better appreciated and when art education schemes were updated photographic courses expanded into art colleges instead. Here photography, painting and printmaking were more likely to interact. British art centres gradually upgraded courses from Diploma to Degree level and in the process introduced more thought-provoking elements into the curriculum, such as critical theory. It was taught by staff educated in art history but often unskilled in photographic practice.

This new academic approach to photography tuned in to French philosophy, sociology and Marxist political theory. Books by philosophers such as the French linguist Roland Barthes, and also German critic Walter Benjamin began to become influential. Barthes applied the methods of <code>semiology</code> – the study of signs and <code>symbols</code> – to examine how photographic images are read. Put simply, a photograph carries messages to several levels of meaning. At first level it represents what was in front of the camera. But at the next and deeper level it triggers the viewer's associations with life experiences, such as the significance of shapes, colour or tone, gestures, expressions. Something with many low key tones for example may suggest menace, mystery, speak of death . . .

Every photograph therefore goes beyond straight representation, contains 'signifiers' which are open to interpretation according to your own personal collection of past experiences, prejudices, even your political views. So the viewer has as big a part to play as the photographer. The use of metaphor for example can raise the photograph above the level of simple description and begin to make people think about wider issues. (Consider Figs. 11.1, 11.4 or 12.8).

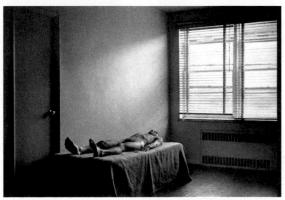

Fig. 11.3. The spirit leaves the body, 1968, Duane Michals. Courtesy Sidney Janis Gallery, NY.

My wife's Acceptable tory. Dur relationship is setisfactory.

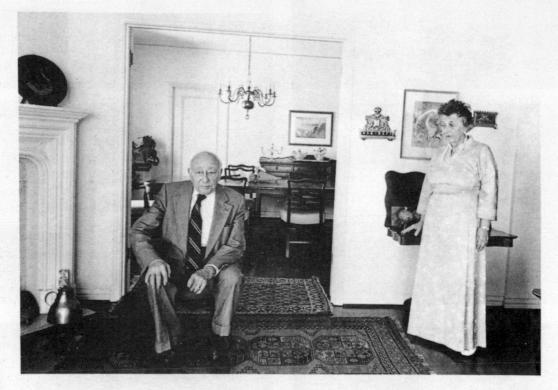

Edgar looks splendid here. His power and attenth of character come through. He is a new private person who is not demonstrative of this affection; that has never made me unhappy. I accept him as he is.
We are totally devoted to each other.

Pegins Goldstine

Pergim:

Pray you be as lucky in marriage!

Some of this theory sounds like stating the obvious (it is often employed in advertising for example) but it brings European teaching back more in line with Minor White's approach in reading photographs. In White's view the significance of a photograph can't be comprehended by an immediate response – it contains metaphors, symbols and similes which although showing the external world also refer to the internal worlds of both photographer and viewer.

Flow of information

One of the changes brought about by the boom in photography courses was a marked increase in publishing. Good quality reproduction of photographs in books and magazines already existed, but cost and the small market had kept these publications to tiny numbers. Growing demand in the 1970s was met with an increasing list of monographs on the work of individual photographers. Soon critics and curators began writing on topics ranging from the comparison of different styles and approaches to the crusading of their own photographic theories. Museums and some contemporary art galleries expanded the number and kinds of photographic exhibitions they showed and generally added a seal of approval in the eyes of the public. Through exhibitions and books photographers could learn what a wide range of other workers were doing. Actions and reactions speeded up.

Writers already concerned with communication, sociology and fine art began to realize that by examining the nature of photography – its uses and meanings as art, as well as its practitioners – they could find plenty to discuss. Everything seemed to benefit and grow from everything else. The new university level courses badly needed debatable texts, and the

students were there to buy them.

Influential books by Susan Sontag ('On Photography' 1973) and by John Berger ('Ways of Seeing' 1972) explored for example how photographs are read in relation to accompanying text. Captions have the power to make a neutral, relatively mute photograph 'speak'. Photographers such as Jim Goldberg, Fig. 11.4, and Duane Michals too turned the power of accompanying words into cohesive pieces where combined picture and text enormously strengthen meaning. Fig. 11.8 is another example. This of course is fine when the photographer is in total charge of the final work, but captions by others can be slipped on or off photographs like a glove. A photograph intended to deliver one reaction to an event can often be made to communicate the opposite through a constructed headline or caption. Imagine Fig. 7.11 for example with the caption 'Sunday's a day off, and the family races down to the beach to get out the motorboat for another fishing trip'.

Sometimes too the impact and meaning of a well-intentioned picture with appropriate caption is weakened by the photograph's attractive compositional structure. Look at the pattern and shape in the atom bomb explosion Fig. 10.16, or the perspective lines of Hine's factory interior Fig. 7.9. Some viewers would argue that such 'prettiness' defuses the horror

and concern that these pictures otherwise convey.

'New topographics', colour photography

Image-making based on structure and form was given a new ironic twist in the late 70s by a small group of American photographers. Dubbed 'New Topographers' in recognition of their links with 19th century survey

Fig.11.4.(Opposite) Untitled, 1981, Jim Goldberg. One of a series where the people he portrayed were later invited to write their own reflections on the contents of the picture.

Fig. 11.5. Untitled, 1973, William Eggleston: Lunn Gallery/Graphics International Ltd, Washington DC.

photographers, page 88, they began making pictures which recalled the medium's original brief – to record and describe. Rejecting style, form, or presence as much as possible they aimed to blandly represent content 'from which all references to memory could be deduced'.

Whereas their forebears had charted the US wilderness, *New* Topographers re-presented land as controlled and restrained by man. Photographers such as Stephen Shore (Fig. 11.6) and Lewis Baltz presented urban streets, factory buildings, land developments. But in contrast to Ansel Adams they selected viewpoints and lighting which diminished any sense of grandeur. Recording uneventful information devoid of emotional content (and using colour as an informational element) resulted in 'squeaky-clean', factual photographs. Eventually this became a kind of minimalist style in itself, and really proved no more factual than images expressing a social or political point of view. (See also Fig. 12.10).

Other topographic photographers, influenced by the growth of Pop culture, began to shoot the trappings of American life – advertising and street signs, automobiles, cheap eating places – as their subject matter. Colour clearly had an important role to play here. (Because colour photography first appeared in advertisements it was regarded by some serious artists as commercial, glossy and trivial, therefore 'tainted', and certainly difficult to use well.) William Eggleston was one of the first to meaningfully use strong colour to help ram home the banality of urban surroundings and tatty deserted streets, often at night, Joel Meyerowitz, another influential photographer turned to colour when neg/pos materials improved sufficiently in the 70s to allow gallery quality results. In his landscape work nuances of colour relate different elements in his pictures.

Fig. 11.6. El Paso Street, El Paso, Texas, 1975, Stephen Shore. Courtesy Pace Wildenstein MacGill, N.Y.

Fig. 11.7. Cape Cod, 1977, Joel Meyerowitz.

sometimes with quietness and calm, and sometimes with a degree of surrealism (Fig. 11.7).

Growth of critical theory deepened discussion of representation – how photographs present women, ethnic minorities, ecological and viewers' social issues. Coming from a position where the pubic had always regarded photography's role as a provider of fact there was much enlightening to be done. One important consequence of the widening of photography courses was the increase of women students too. This introduced new ideas and preoccupations, linked for example with the finding and establishing of personal identity, and close examination of female portrayal. Cindy Sherman's work in particular questioned the way photography has long subordinated women through the 'male gaze'. Throughout the 1980s she photographed herself as various stereotyped Hollywood 'types' starting with a series called 'untitled film stills'. Each one - often showing her in stilted submissiveness – was like using a mask, offering many depictions of the wearer but never the real self. See Fig. 11.9. Work such as this has been instrumental in highlighting the meaning of feminine or masculine identity roles.

New York photographer Barbara Kruger championed feminist theory through a poster type approach. She combines an ambiguous political or hard-sell type printed slogan with a graphic female image (Fig. 11.8). But the powerful, authoritative 'voice' in the work seems to be given over to the woman represented – a voice Kruger sees as being a dispossessed victim, normally muted by the overwhelming power of the commercial advertisement's message. Experience as a graphic designer for women's magazines promoting beauty, sexual appeal, etc., led her to produce work which knowingly examines this role of the female body as a marketing vehicle. Her overlaid text uses 'We' or 'I' or 'My' to set an uncertain relationship between photographer and viewer, 'My Face is Your Fortune', or 'We are your circumstantial evidence' for example. Once they recognize the code these words also register differently with male and female viewers. although continually charging society with male exploitation of the female body through commerce and 'the gaze'. Kruger aims to show that advertisements, posters and commercials are not as innocent as they seem all contain a gender-charged political element. In Britain Jo Spence too was a leading influence during the 80s tackling issues of class, gender and health through her (self-portrait) practical photography and critical theory.

Martin Parr's 1980s colour documentary essays on the British (Fig. 11.10) represent a rejection of the *Picture Post/Life* approach. His candid pictures often subvert their subject matter, portraying social situations in stark, unattractive ways (but unlike Klein or Frank often adding an element of humour). Parr's pictures are displayed without further information – achieving meaning by the way they play on the prejudices of you the viewer.

Influences of critical theory

Starting in the 1960s and increasingly in the 70s and 80s cultural theory affected all fields of the arts, not only photography. Many older individuals, groups and some college faculties responded with alarm. They saw this development as an over-intellectual approach which had little to do with human emotion, either in the conception of photographic images or their reception by an audience. These critics regarded it as simply reflective of the cynicism, rejections and disenchantment of the new generation – much stemming from 1970s American post-Vietnam war pessimism and self doubt. ('Anti-Photography' just as the Dadaist movement was Anti-Art

Fig. 11.8. 'Untitled' (We have received orders not to move), 1982, Barbara Kruger. Courtesy Mary Boon Gallery, N.Y.

following World War I.)

It seemed that photography's particular qualities, the use of good design, light used to accentuate form, etc., were disregarded as hindrances to all-important 'Messages'. These were frequently politically motivated or at least derisory of traditionally acceptable social attitudes and of the Establishment. Surely there is a danger that work which is so issue-based destroys the joys of imagery as such? Theory never produces good art; critics don't make good photographers, they protested. On top of this it was argued that too much of the work was directed at an elitist, arts/humanities audience. Unless you are familiar with the language you can't comprehend the meaning.

Supporters of critical theory and conceptual approaches on the other hand argued that this has enriched and influenced photographic practice without damaging it or taking anything away from its fundamental possibilities. Theory gives photographers useful insights into their work, helps the understanding of both historical and contemporary influences. Instead of being over-concerned with the techniques and stultifying aesthetic of photography it takes in other views of the world which sharpen awareness and sensibility. After all the artist's job is not merely to decorate, but ask questions of themselves, their medium and present society. Photography no longer exists as it did in the past because it has grown into a far broader language.

People who look at photographs today tend to be better educated, informed and media-literate. Everyone has his or her experiences against which an image can be interpreted. It is known that a photograph is no longer reliable as a an accurate representation of a subject, but instead of seeing this in a negative sense it has opened up an enormous range of challenging ways to use photography. 'Deconstructing' representation and also being 'inter-active' with the viewer in what meanings he or she is able to get out of a picture has greatly influenced the work of 1980s and 90s post-modernist art photographers, see Chapter 12. At the same time most of the ordinary public lagged behind, finding it difficult to understand conceptual aspects of 'art world theory' and preferring photography which was simply decorative or documentary.

Fig. 11.9. 'Untitled film still'. 1981, Cindy Sherman. One of her many self portraits exploring the modern equivalent of the mask (presenting many appearances of the wearer but never the self.)

Summary - concern for meaning

 Reactions to modernism and the universal use of published photography during the 1960s encouraged American photographers particularly to think more about the range of meanings possible in

Fig. 11.10. Serpentine, England, Martin Parr/ Magnum Photos.

their work. A more conceptual approach was appearing. It included what could or should be read into images; the way symbols are used; assumptions made, prejudices aired.

 Photographic critical theory grew as part of 60s general critical debate within US youth society. Major public exhibitions like 'Family of Man' now seemed simplistic, contrasted with younger photographers Klein or Frank's gritty but actuality look at US society.

 Another influence, photographic teacher and Aperture editor Minor White, produced work concerned with metaphor – interpreting subjects beyond surface representation. Like Stieglitz's equivalents it was open to the viewer to find meaning. Technique though was 'straight' using all the fine qualities of black and white photography as advocated by Adams and other modernists.

 Photographers exploring new areas of meaning in the 1960s included Duane Michals (narrative sequences) and Diane Arbus.

 College teaching in art colleges helped American avant garde photographers develop new conceptual approaches. In Britain courses were more commercial/technical until the late 60s. Critical theory, added when British photography was upgraded to Degree level, first centred on philosophical works by Barthes, Benjamin and others. Semiology – the study of signs and signifiers – featured in courses.

 1970s growth in publishing collections of photographers' personal work, plus critical texts (Sontag, Berger, etc.) increased the scope of conceptual studies. This element of courses started to become selfgenerative.

Well-presented exciting exhibitions of photography (one-person shows and themes) began to appear in art centres and museums. More scholarships and awards were provided for photographers. In Britain photographic societies and clubs were no longer the main way to get your work known.

 The ways photographs and accompanying words work together, and how traditional picture composition strengthens or weakens meaning came under scrutiny. US 'New Topographers' such as Stephen Shore rejected style in blandly recording urban landscapes. Neg/pos colour, used creatively by Eggleston and by Meyerowitz became another aid to meaning.

Interest grew in photography's representation of minority groups.
More women students brought new issues to bear, such as personal
identity. During the 1980s Cindy Sherman's stereotyped 'film stills'
and Barbara Kruger's sloganed posters questioned feminine roles as
presented by the media.

In Britain Jo Spence used self-portraits for a range of social issues.
 Martin Parr's candid documentary work probed the British class system – photographs which on the gallery wall or in books conveyed their own meaning according to the prejudices of the viewer.

Projects

- **P11.1** Seek out examples of work by photographers primarily concerned with metaphor: For example Wyn Bullock; Harry Callahan; Mari Mahr; Olivia Parker; Aaron Siskind; Fredrick Sommer; Jerry Uelsmann; Minor White.
- **P11.2** Compare Duane Michals' use of allegory with that of J. M. Cameron 100 years earlier. How do their approach, intended meaning and execution differ?

12 Photography in a post-modernist age

During the 1980s photography as a creative medium grew increasingly accepted and fully at home with other forms of fine art - particularly printmaking and painting. In fact it started to become difficult to see where one activity ended and the other began, since painters added photographic images to canvases and photographers abraded and handworked prints on photographic paper. (Compare Fig. 12.1 with Fig. 12.14 for example). Similarly the very terms 'artist' and 'photographer' began to merge when they both worked with equal freedom for

galleries or print-shops.

Partly this came about because, from the late 70s beginning in America, the art-buying public started to regard photographs as collectable. Also camera-based images were looked upon by the practising art world as currently very appropriate for exploring a great range of conceptual and visual ideas covered by the artspeak term post-modernism. Styles varied greatly. Some artist/photographers chose to direct or construct in some way every situation in front of the camera; others used photographs torn from magazines. Some again made widespread use of colour, or giant prints, or mixtures of silver halide emulsion and ink screen printing, or combinations of words and images which rely on oneanother, see page 171.

All this mixed media activity and the many more possibilities for implementing ideas drew innovative, imaginative individuals into photography. Most came with an understanding of fine art which when applied to photography gave it added breadth and much needed maturity. This chapter looks at a selection of work from the 1970s and 80s, discussing what the photographers were individually trying to do and how this was achieved. It also illustrates how art photography began to spread out and

be used in wide-ranging, original ways.

Post-modernism

To understand why 'post-modernist' photography is so-called it is necessary to go back briefly to the 1920s and Paul Strand's modernist views (Chapter 9). He maintained that photography should be used honestly, respecting its materials and processes, using its unique qualities to communicate subject forms, textures, shapes 'straight'. Purity of medium was important. Photography should be used for what it does best, offering superb tone range, sharpness of detail, etc. It was the photographer's individual recognition of the visual qualities of ordinary things backed by mastery of technique which would keep photography pure, and able to stand on its own feet. Such an attitude made it quite separate from other mediums like painting (a necessary warning then, remembering photography had just come through a long period of art-conscious pictorialism).

This separateness and isolation of photography from fine art and its critical concerns still remained present in the 1950s. Painters meanwhile directed their energies to Abstract Expressionism (anti-naturalism, and expressed in exaggerated style, with simple outlines and broad colours) a movement picked up in some of the trendy professional photography of

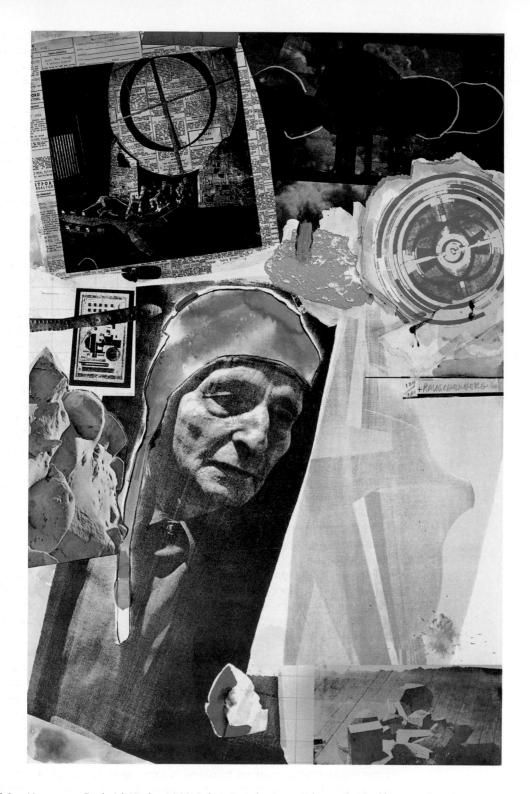

Fig. 12.1. Homage to Frederick Kiesler, 1966, Robert Rauschenberg. Lithograph. The Museum of Modern Art, New York. Rauschenberg had a profound influence on currents in fine art, constructing work in an undisguised way from his own photographs, clips from magazines and other contemporary fragments. It was recognised as highly anti-art establishment, stretching the constraints of painting, photography and printmaking.

the 60s too. Expressionism also went along with Minor White and his fellow mystics' concern to interpret the inner meaning of subjects in an individual way beyond surface representation – although never relaxing their grip on 'pure' photographic techniques. Photographers and artists

remained separate species.

Things began to change in the early 1960s when some artists in Britain and America turned to using the all-pervasive commercial images around them as representing current society. Pop Art was to inspire use of photography and other products of everyday life as art forms, often altered to increase their impact but still instantly recognizable. Photographs played a double role here (1) as the actual subject of a painting or drawing, since they represented the most common-place and throw-away kind of images linked with consumerism and the way people experience much of the world. Also (2) developing out of this, photography was recognized as a versatile, 'unprecious' medium which artists and designers could use creatively and as freely as silk-screen printing, use of plastic paints, air-brushing and so on.

Two American leaders of the Pop Art movement were Robert Rauschenberg and Andy Warhol. Both had a healthy disregard for what a work of art should be. Rauschenberg had a surrealist interest in collaging actual snapshots, news pictures and advertising photographs onto canvases. By the mid-60s he was using his own or 'found' photographs transferred via silk-screen or lithography into ink on paper, canvas or metal. Image fragments were allowed to overlap and clearly show their component nature in a constructed montage. See Fig. 12.1. By this means one canvas could communicate the discordant mass of photographic realities with which people are daily bombarded, while the actual contents of each fragment could make puns and other

kinds of references to a main theme.

An important feature of Rauschenberg, along with Richard Hamilton and other young artists working in Britain, was their tremendous sense of anarchy. Their work overturned the art establishment (yet again) by demonstrating that blatantly descriptive common images, intact, could be used in abstract ways. Their risky creativity, unfettered use of mixed media, and generally over-the-top approach had a strong influence on the attitude of art students everywhere. It became possible to think of people like Rauschenberg as not *painting* so much as *reproducing*, by printing already existing images. It reflected the fact that image reproduction was what the world at large mostly knew. Ideas of this kind were also subversive, undermined all the gallery/museum traditions about Art being original, authentic and a work of genius (the 'masterpiece syndrome').

During the 1970s treatment of photographs as meaningful signs – a language more than a picture – added to the way they were perceived within the art world. See Chapter 11. With all this activity stemming from Pop and Conceptual art, and the critical attention now paid to photography, it was being drawn into the art world on increasingly equal terms with painting, printmaking, even sculpture. By the 80s fine art photography (or photography practised by fine artists – the two had become one) had grown to become a key element in what was now described as Post-modernism. Consequently the range of usage that the

medium allowed and encouraged developed enormously.

These 'isms' of art are really art-historian jargon - convenient pigeon holes for trends and counter-trends. After all, most creative people are individualists, and either don't fit neatly into groups or have long productive lives which take them through several movement phases. However, post-modernist art is accepted as being against the modernist's views that photographs are a less exalted visual material than painting or sculpture. It also has no faith in originality of image or the artist as a genius figure. Instead he or she is someone who stages and mediates - the viewer is expected to be inter-active. Post-modernist photographic artists make pictures that admit to being artificial because they no longer believe that photography offers a window on reality and truth. Some workers make statements, create meanings, through scenes specially constructed for the camera. Or they combine their own and other people's work, mix it with other media, often montage elements all without disguising what they have done. Look at Fig. 12.5 for example. Some are concerned with 'deconstructing' formal elements of photography. visually commenting on its single-viewpoint perspective, for example in an 'inside-out' kind of way. See Figs. 12.4 and 12.9. Others exploit styles such as pictorialism and even documentary, but through parody or tableau make it clear that these are artificially adopted. Post-modernist art legitimately makes use of second-hand images too because it's considered that all we are and know are images - the world is seen as a 'hall of mirrors' which the viewer is expected to meaningfully interpret and relate to.

Surrealism

Within and alongside post-modernism, dreamlike constructions continued to absorb many photographers even though surrealism had long been abandoned in painting. Unlike the 1930s however (page 140) surrealist images now showed greater depth and sophistication, facing the viewer with more challenging meanings. Jerry Uelsmann's black and white images produced in the late 1960s and 70s for example present a strange private world for others to interpret as they wish. Elements – often natural settings, close-ups of rocks or plant formations – he photographed separately, then combined in the darkroom by printing several negatives in turn onto one sheet of paper. The juxtapositioning and mixtures of scale this allows gives mysterious results, see Fig. 12.2. Convincing looking environments therefore play on photography's deceptive realism, with Uelsmann questioning and provoking the viewer rather than providing answers.

Sandy Skoglund, another American photographer, uses photography in an apparently realistic way but her surreal environments are fictional worlds which tell stories the viewer has to make up. See Fig. 12.3. Typically pictures feature imagined, somewhat threatening experiences of everyday life. Mundane suburban homes or office interiors (repainted overall) are shown disconcertingly populated by dozens of fish, or leaves, or squirrels or other creatures. Their highly saturated, childlike and contrasty colour creates a bizarre tableau, played off against ordinary people shown present behaving in an unconcerned way.

Works like this – life-size installations made only to be photographed and then dismantled – mix sculpture and photography to achieve a conceptual idea. It might be argued that the installation could itself be gallery exhibited like a stage set, leaving photography out altogether. But

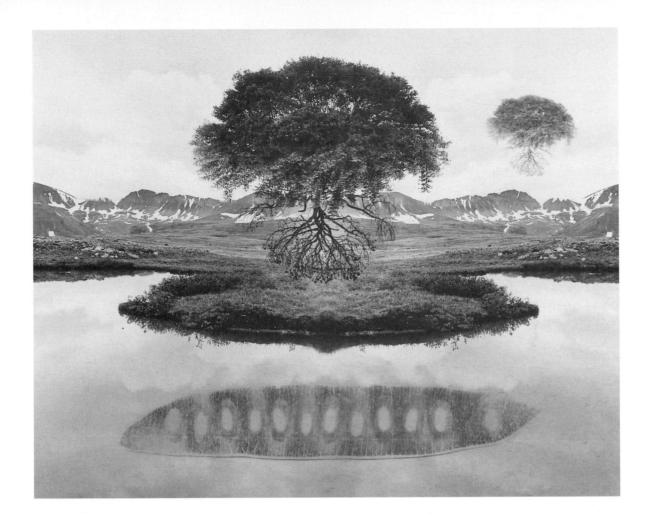

Fig. 12.2. By Jerry N. Uelsmann, 1969.

unlike sculpture the whole piece is constructed to be seen from one viewpoint and in a single-point perspective – the camera's eye. Making the final artwork a photograph also allows Skoglund control over size (usually large) and colour (intense).

Scottish photographer and ex-sculptor Calum Colvin also depends on the construction of sets as intermediates which photography turns into framable art. But here the camera and three-dimensional set are even more intimately linked. If you examine his work closely – the self-portrait Fig. 12.4 for instance – the actual objects in a still-life scene are overlaid with a painted image. Technically this is achieved by drawing on the ground glass screen of a large format view camera. Then by putting a bright light behind the camera and screen the combination becomes a projector, enlarging the drawing over various objects within the darkened set where they can be traced and then painted over. So it is only when photographed from this same camera position that the two and three-dimensional elements work together.

Colvin's imaged interiors are full of illusions and include a mixture of references to art, masculinity and Scottish history (some tongue-in-cheek). Prints are huge in size so that viewers feel they can 'enter' an installation, examine all its detail. His way of incorporating other imagery – pictures,

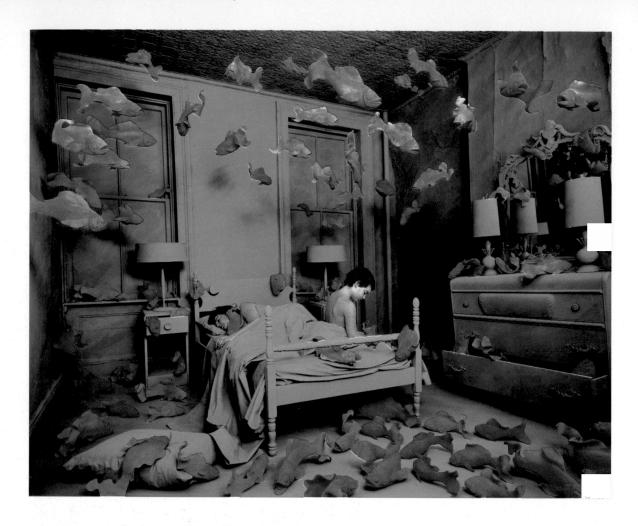

Fig. 12.3. Revenge of the goldfish, 1981, Sandy Skoglund.

model figures, texts, etc. — is not by Rauschenberg's method of adding printed reproductions but through direct photography of such items as two or three-dimensional objects. The sculptor/photographer's approach, rather than the printmaker/photographer's approach. However it can be argued that this is still essentially photography — as every creative element is channelled towards how it will appear to the viewer of a final print.

Not that the stuff of dreams always led artist-photographers into complex set building, decked with consumer debris. Surrealism can be explored by curiously juxtapositioning just two simple elements, insignificant in themselves, to create an enigma for the mind and leaving the interpretive role to the viewer. Mari Mahr, a photographer of Hungarian origin, created during the 1980s several series of personal, semi-narrative sequences by a deceptively simple procedure. In front of an enlarged black and white print of a landscape, or part of a building exterior, she set up a simple object – spectacles, a toy, a torn music score – and then photographed the combination. See Fig. 12.5. This of course allows her enormous freedom to alter scale between the two elements, just as Uelsmann achieves through double-printing.

Often Mahr's sequences are based on her memories of journeys and visits... music heard here, a small event which occurred there... travellers' tales. They are like a set of verses in a poem, with the only text clue an

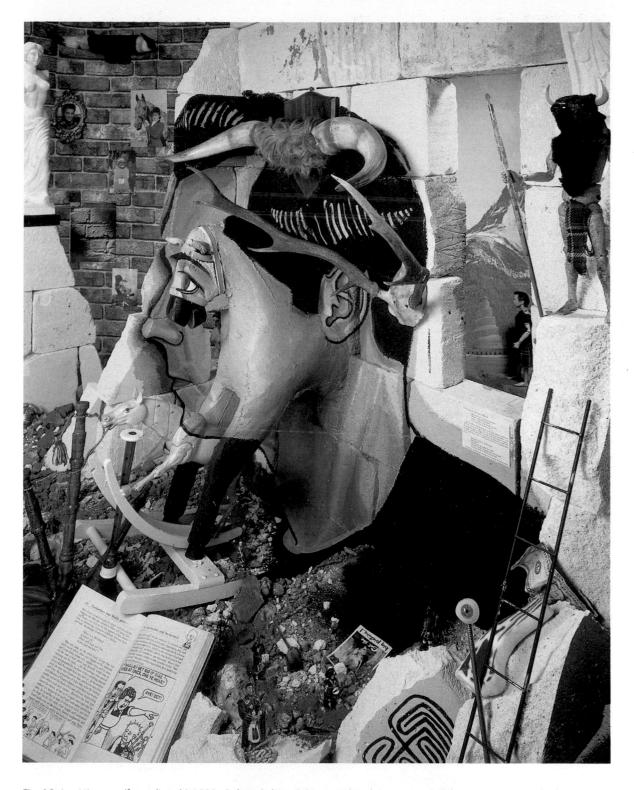

Fig. 12.4. Minotaur (from diptych) 1989, Calum Colvin. O bjects within the set are painted over to present a further image when photographed from this one viewpoint.

Fig. 12.5 From the series A Few Days in Geneva, 1985. Mari Mahr.

overall title such as 'A Few Days in Geneva'. Although personal to Mari Mahr, her somewhat disturbing yet familiar Alice-in-Wonderland world can evoke for viewers past memories and imagined story lines.

Space and picture construction

Some artists concern themselves with the way the camera's one-point perspective allows us to explore visual illusions, make people rethink how

Fig. 12.6 From A Few Days in Geneva, 1985. Mari Mahr.

space and distance affect the appearance of their surroundings. Lee Friedlander for example has produced much work concerned with visual properties of space. These pictures are in a way documentary but play on effects such as false attachment (one thing being behind another), perspective, reflections and tight geometric cropping within the frame. Mundane streets and landscapes are shown to have a surreal strangeness. In a way he is deconstructing photography by showing how the camera's single viewpoint determines what is 'reality'.

Ken Josephson's pictures (Fig. 12.8 for example) try to relate the appearance of a photograph of his subject to how it actually is, even though of course this is also presented as a photograph. He questions the nature of photography by including a photo-print held within his photograph of a scene. The two demonstrate through their differences that photography has no objective truth – the photo is only one person's interpretation, seen at another point in time.

Representation of landscape by the optics of the camera is a preoccupation of John Pfahl. In his series 'Altered Landscapes' the natural scene in front of the camera is manipulated by adding constructions – sometimes subtle, often witty – which give the illusion of 'mapping out' perspective (Figure 12.9). They again play on differences between the real three-dimensional world and how this may appear in a two-dimensional photograph.

Pfahl's interactions with landscapes typically take the form of string, rope or foil positioned on or amongst trees, ground detail, etc. These are very critically placed so that, as imaged by his large format camera, they become convincingly integrated with the other natural shapes and lines which give the picture its construction. Once set up the colour photography is completely 'straight'. In fact Pfahl's high standard of technique purposely maximizes colour accuracy and decorative appeal (also cocking a snook at the Ansel Adams straight photography brigade).

Unlike Adams the result is not a picture to re-create an emotional experience. Pfahl's picture is the experience. His painstaking work plays

Figure 12.7. Idaho, 1972, Lee Friedlander. Simple photography making use of reflection and division of the picture area. Questions reality, and also implies physical and spiritual emptiness.

off differences between expectation and conceptual understanding. Photographic picture composition is deconstructed, shown to be as much optical illusion as any 'window on the world' or 'mirror of reality' as it used to be described. Like Josephson and Friedlander he comments on photography from inside photography.

Mosaics and other multiples

During the early 80s another and more internationally known artist – David Hockney – also explored the camera's way of 'drawing' perspective. Using a Polaroid camera (and later neg/pos colour film) he built up small prints into a tile-like mosaic forming one composite image. One hundred or more might be needed for each large-scale photomontage.

Mostly Hockney's subjects were his literary or art friends in Britain and the US shown within a patchwork environment. Constructing photographic images in this way Hockney moved on from the stillness of earlier, painted portraits. People in some of his mosaics (Fig. 12.12) appear animated, as if existing in a short loop of film, created by multiple prints in the parts of the work the figures occupy. Surroundings are more like static scenery, given stability by match-together print join-ups but rarely revealing more than a suggestion of room structure. Elements within the room Hockney finds interesting and relevant are shown in place; other areas are left out altogether. The finished piece is presented like a half-completed jigsaw. It's interesting to compare Hockney's undisguised quick-fire, almost sketch like prints against the composites painstakingly pasted together by Peach

Fig. 12.8. Drottningholme, Sweden, 1967, Kenneth Josephson. Museum of Art, Rhode island School of Design.

Fig. 12.9. Triangle, Bermuda, 1975, John Pfahl.

Robinson to create the allegories and other lofty themes of High Art 125 years earlier. See page 29.

Numerous American photographers were using the multiple frame in the early 80s. Some found them appropriate for progressions and narrative sequences like Duane Michals, 12 years before. Regular rectangular grid structures are often chosen by artists for their repetitive, inflexible nature. Andy Warhol worked on grid-based paintings and silk-screen throughout the 60s. By featuring repetitive photographs, they made the point that mass produced photographic images dominated the visual world.

Images intended to be compared are often best displayed as pairs (diptych-like) or in grid blocks. German conceptual artists Bernhard and Hilla Becher have spent many years formally photographing industrial structures such as water-towers in different countries. Presenting them in uniform grid blocks of nine or so prints sharpens up the viewer's attention to similarities of construction, and (especially) individual variations. Totally opposite, the American Joyce Neimanas uses 150 or so SX-70 Polaroid prints at a time to assemble dense collages. They totally cover their support sheet, squares of colour or detail erratically overlapped and arranged to form an image which does not reproduce the original scene before the camera.

Constructing the sensational

The morbid and erotic tableaux of US photographer Joel-Peter Witkin

Figure 12.10. Watertowers, 1980. Bernd and Hilla Becher. Courtesy Sonnabend Gall, NY. Participants in the original 1975 New Topographics exhibition, which featured passive, non-interpretive methods of description, the Bechers have photographed many series of isolated man-made objects like these under uniform lighting and fixed composition. Results are stripped of dramatic effect - un unit modernist approach to landscape photography.

Fig. 12.11. 'Jackie 1964'.
This is a silkscreen print
composition by Andy Warhol.
It is based on stark, repetitive
press photographs of
Jacqueline Kennedy. © ARS,
New York and DACS, London.

created great controversy as well as influencing many fellow artists throughout the 1980s and 90s. Like the painter Francis Bacon his use of repellent subject matter (parts of corpses, foetuses, deformed people, and the paraphernalia of sexual activity) reference horror, suffering, fears we closet in isolation... the existence of Hell. See Fig. 12.13. Typically Witkin stages his models in studio set-ups against a roughly slung backdrop, and using soft daylight 19th century type lighting. He often damages his negatives with chemicals or by brutally scoring or scratching, adding to the pervading violence.

Witkin's work has a chamber-of-horrors quality some surrealist artists also used in the 20s. He also often re-stages earlier works of art (again like Bacon) in a corrupted and parodying form. Fig. 12.13 for example relates to Masaccio's 'Expulsion of Adam and Eve'. The images are full of minor references – to classic art history, to the occult, eroticism, religion – using the past as a framework for addressing disturbing issues of the present.

It is important not to dismiss such work as mere voyeurism or products

Fig. 12.12. Christopher Isherwood talking to Bob Holman, Santa Monica, March 14 1983. © David Hockney.

of a disordered mind. Witkin draws his material from nightmarish, indefinable aspects of humanity. They dwell on the violence and horror aspects of modern life, a complex subject which some artists take on as a challenge. His deceptively accomplished images use the photographic process with great control to suit grotesque themes, and without regard for photography's visual conventions. Witkins work is also proof that photographs, like other forms of art, may be constructed at every stage by the artist.

David Hiscock, the British fine art and advertising photographer, also chemically 'distresses' his negatives as necessary for expressive ends. Other techniques include etching, painting, baking, and the incorporation of materials as varied as tracing paper, stone, wood or crumpled copper sheet on or around the finished piece. To call these special effects is to degrade his work – they form a palette to be used to enrich and strengthen meaning.

Hiscock's photography as official artist at the 1992 Olympic Games concentrated on the sheer physical effort of individuals during long arduous training as much as the event itself. Fig. 12.14 shows his interpretation of a swimmer's dynamic power, and the sense of being both above and below the water. Photography and subject are unmanipulated at the time of shooting – his approach might be called post-camera construction. Hiscock's openness and the use of whatever mixture of media will best help him communicate the visual meaning in a piece matches Rauschenberg's attitude thirty years before.

Influences of art as photography, and photography as art

Fine art photography of the most recent past is always the most controversial to discuss because, after all, it is the most in doubt. A great deal of inept and derivative work appears and disappears each year. On the other hand where an artist does something new people only seem to see the discontinuities and madness of it – then as time passes they end up seeing the opposite. Remember how Impressionists' paintings met great hostility; Davison's naturalistic photography was banned from The Photographic Society; Cubism was greeted with total confusion; and Duchamp's Modernist pieces caused riots in Chicago (page 126).

One feature of post-modernist art is what its opponents describe as obsessive self-referring examining its own parts. This critical analysis has

Fig. 12.13. Expulsion from Paradise of Adam and Eve, 1980, Joel-Peter Witkin. Courtesy Pace Wildenstein MacGill, NY, and Fraenkel Gallery, SF.

Fig. 12.14. Olympic swimmer Duncan Goodhew, 1992, David Hiscock.

meant that photography has been heavily discussed, its elements deconstructed and held in question. As a result some photographers complain that an artist's *practical* ability in the use of tools and materials no longer seems to matter much, only his or her *intellect*. They argue that the 'isms' of Art, of which post-modernism became the current buzz-word in the 80s, form an art-speak language which too often mystifies and alienates the general public. It has become acceptable to cross-reference or totally appropriate (hijack) one person's image in another's work, because post-modernism no longer believes in terms like original masterpiece, or even original author. Art is seen as a reflector of society. This also leads some artists to make work primarily to impress other artists, not meet what critics describe as its important job of feeding and developing the visual perceptions of people and so improve society.

Taking a more positive view, young photographers who were trained as artists now carry a strong sense of enquiry. People educated exclusively as photographers (particularly in Britain) until the recent past were orientated to see the world through photographic equipment and mastery of processes that provide the highest technical excellence. The art-trained person doesn't get inhibited by the same purity of process. Straight photography is just one option. Also, by having a flexible and open-minded attitude they are more able to successfully blend photographic images with materials and techniques of other processes, including 21st century computer-based digital imaging – whenever this is visually most meaningful and appropriate.

Professor Van Deren Coke argues that as the possibilities for straightforward photography seem to have become exhausted, it has been those photographers who know about the history of art who shape the future. At a commercial level too, many innovations and ideas born out of free-ranging fine art photography are eagerly adapted and used in

professional photography for advertising and editorial purposes.

Not surprisingly it is becoming difficult for anyone to say what the words 'photographer' and 'artist' now really mean. What is the difference for example between someone calling themselves an artist who uses a camera and presents work in photographic form, and the photographer who constructs scenes, directs subjects and maybe uses some form of ink printing system to get final results? Post-modernism practitioners are also concerned that, along with other art media, photographs should spark off ideas rallier than become collectable investments. It is ironic that in spite of these ideals the gallery art market has taken post-modernism in its stride and in no time at all started selling such works as valuable contemporary art objects.

Summary – photography in a post-modernist age

The late 1970s and 80s brought much greater acceptance of photography as a flexible, fine art medium for exploring conceptual and visual ideas. Although newer, it was seen as of equal standing to painting, printmaking and sculpture in the post-modernist art world. More art-trained people were drawn into using photography. broadening it, helping to make it more adventurous and mature.

In simple terms post-modernist photography is a reaction to 'straight' modernist work - with its purity of process and separateness from other art forms. Pop Art introduced use of everyday consumer images (therefore typically photographic) into artworks. Rauschenberg, Hamilton, Warhol, led the incorporation of photographs silk-screened onto canvas, etc. By recycling existing images as Art, antiquated

establishment values were undermined.

Post-modernism has little faith in the originality of images – and with photography now no longer seen as delivering a 'window on reality' it fits well into this approach. To make statements scenes might as well be constructed for the camera, (Sandy Skoglund) or arrived at through mixtures of images which may include appropriation of other peoples' photographs. Previous styles and formal elements of photographs, such as optical perspective, are de-constructed (John Pfahl). Final works may present montages and mixed media openly, without disguising how they are artificially constructed. After all, almost everything we are and know are images . . .

Surrealism remained alive in this image-obsessed world, but approached by photographers in ways more conceptual and with greater ambiguity than during the 1930s. Jerry Uelsmann's combination black and white printing from original straight negatives; Skoglund's fictional colour-added interiors; Calum Colvin's still-life concoctions full of symbolic bric-a-brac and optical illusions made possible by the camera's single eye. Combinations of a photographic print image and simple object, (Mari Mahr) can seem to have a strange aptness, without necessarily spelling out what and how it speaks to the imagination.

Some photographer-artists are absorbed in how photography deludes the viewer in portraying three-dimensional space. Lee Friedlander's 60s pictures work through false attachment, reflections, and cropping; his subjects are typically mundane. Ken Josephson used a photographic print shown within its subject scene to relate the truths

Fig. 12.15. Architectural site 10, December 22, 1986, Barbara Kasten.© Nat. Museum of American Art, Washington. Kasten creates abstract images through temporary constructions featuring mirror shapes plus, here, architecture illuminated with coloured light. Like Calum Colvin however the resulting (straight) photograph – in the form of a giant Ilfochrome print – is the final artwork, rather than the installation itself.

of photographic appearance to actuality. John Pfahl manipulated landscapes themselves by adding linear constructions within his subject elements, playing with the nature of picture geometry as seen by the camera.

 David Hockney's constructed colour print mosaics explore time differences and selective framing during shooting, break down the physical actions of photography. The viewer remains very conscious that these 'tiles', are snatches of memory.

 Multiple frames presented as formal grids are ways of expressing the omni-presence of the photographic image; also to highlight subtle differences in otherwise similar subjects (Bernhard and Hilla Becher's industrial structures) or to express a narrative.

Influential yet repellent black and white tableaux photography by Joel-Peter Witkin address aspects of violence and horror. Early artworks are referenced or re-staged in macabre, surreal set-ups. Models wearing masks, defaced and stained negatives, add to nightmarish effect. Photography here is very much an artefact constructed by the artist.

 Treatments to hand-work negatives after photography, and the open use of ink printing and painterly processes, can add immeasurably to the expressive meaning of a final image. But unless handled perceptively (which can at times mean boldly) by artists of the calibre of David Hiscock such techniques risk being dubbed mere special effects.

Post-modernism's obsession for self-examination and self referencing lead to accusations that practical ability in photography is now less important than intellect. Critical theory 'art-speak' mystifies large sections of the public, as may the cross-referencing or appropriating of other peoples' work. For full appreciation you need to know the language, understand the codes. Post-modernist artists were accused of making work primarily in reaction to, and in order to impress other artists. Society's needs are overlooked.

• Photographers trained as artists rather than technicians were seen to have a wider sense of enquiry, be less inhibited by purity of process. They tended to be more flexible, willing to mix media and adapt procedures for all-important visual ends, often with a conceptual content. Fine art photography also provides a powerhouse of ideas adapted and used later within professional advertising and editorial photography.

 Photography had lost its credibility factor in the public eye – photographs could no longer be claimed to deal with factual information ('photographic truth'). But the great gain was that photography had at last moved out of this enclosure; it was now able to explore the avant garde with a freedom matching that of any other medium.

Projects

P12.1 Find images by a painter or photographer which consciously reference or appropriate another artwork. For example look at:

Jeff Weiss: American Gothic 1985

The Stern Twins: Accession 1985 (and Phillipe de Champaigne: Deposition 1602)

Anne Rowland: Untitled, Allie Mae Burroughs, 1986 (and Walker Evans: Tenant Farmers Wife 1936)

Terry Dennett: Remodelling Photo-history 1982 (and Harry Callahan: Eleanor, Port Huron 1954)

Francis Bacon: Study after Velasquez 1952 (and Velasquez: Pope Innocent X, 1650)

Bill Brandt 1950s figurative studies on the beach, and Henry Moore sculptures. Rejlander: Two Ways of Life 1858 (and Couture: The Decadence of the Romans, 1847).

P12.2 Two pictures produced half a century apart may show superficial similarities – such as the kind of process used, physical organization of subject matter, items incorporated within the frame etc. Yet the motives and meanings behind them (appropriate to their day) may now be seen to be quite different. With this in mind compare:

Demarchy, Fig. 8.7 with Hiscock Fig. 12.14 (Hand manipulation) Stieglitz, Fig. 8.9 with Rauschenberg Fig 12.1 (Inclusion of other images) Lake Price, Fig. 8.4 with Skoglund, Fig 12.3 (Constructed tableau)

Final word

Looking back over the history of photography, with its odd mixture of skills in handling machinery and expressing visual ideas what are your strongest impressions? It is surely sad that for so long hangups over whether photography is technical or artistic confused and held back its role in society. But then for years the process was very complicated to use. It is sad too that for so long photographers felt themselves in the shadow of painting and aped it slavishly in their pictures rather than freely exploring ideas of their own. The critics among their own ranks seem to have been preoccupied with the technical qualities of photographic images and compliance with the rules of composition, whereas art critics harped on its lowly status and need to follow accepted painting of the time. No wonder reactions of this kind drove it into an aesthetic corner. Today a broader view is taken because so many photographs are seen and they cover an infinitely more varied range of functions and visual approaches.

Clearly too, photography means different things to different people. Even the 'isms' which have been discussed fit only loosely because of the different ways individuals apply and interpret these terms (Emerson's 'naturalism' for example was not quite the same as other people's idea of the word). Every movement seen as adventurous and modern in its day becomes tomorrow's crusty 'establishment', needing to be overthrown. But the new approach doesn't actually mean the death of the old either; it's usually a reaction to it. Photographers seem to be mostly influenced by (1) the photography of their contemporaries; (2) art movements and social issues of the time; and (3) current photographic theories and creeds. All these circulate through exhibitions, reproduced work and written texts. Long-lived active photographers go through several stylistic changes in their work – reflecting obsessions at different periods. (Look at books containing comprehensive collections of the

work of Bill Brandt, or Andre Kertesz).

Of the people who have been discussed here who in your view was right and who was misguided? The work of photographers of the past is often reinterpreted in the light of what followed them, work of which of course they are unaware. Remember that photography, like any other art form reflects the tastes, fashions and the collective feelings of society, things which are gradually changing all the time. For example, people have grown enthusiastic for romantic, then impressionistic, then abstract, then expressionistic painting. All were revolutionary and influential in their time. Equally pictorial photography (much despised after about 1918 but still practised) may be due for a comeback.

Try to assess what kinds of photographs you currently find interesting and successful. Select from books, say, twenty photographs which you feel work well. Decide, or better still discuss with someone else, features or meanings these chosen pictures may have in common. Perhaps you

prefer something obscure and challenging, or a clear, full statement? Is the actual subject of greatest importance . . . or the picture's formal design . . . or the meanings and questions it contains? Look too at photographs you liked or disliked when you first started studying photography, and decide whether these views still hold. The way you assess a photograph is affected by your experience of reading pictures – sometimes like learning to crack a code – as well as events in the world at large.

Back in the 1840s the camera seemed a magical device which would allow anyone to make accurate, excellent pictures. But it is really no more nor less of a machine than, say, a word processor which cannot itself produce good written ideas. To take photographs today anyone just needs to line up the subject in the camera's viewfinder system, perhaps adjust settings if there are any, and press the button. But whilst making photographs is getting so easy, the art of photography remains difficult. The challenge is to produce at least some work meaningful to other people.

On the next few pages a List of Events recaps aspects of the history of photography and puts them into the context of other happenings at that time. Notice from the time-scale relationships how movements in fine art often influenced the approaches of photographers, typically a few years later. Again, the introduction of new processes or equipment (e.g. in 1851, 1876 and 1924) widened the range of subjects which could then be tackled. and often simplified the necessary technical skills. Such cause-and-effect is not unique to photography. In 1841 artists' oil paints were sold for the first time pre-mixed and in tubes. Painters no longer needed a knowledge of chemistry and the physical means of grinding their own pigments. This new technology had far-reaching effects - like dry plates for photography, paint in tubes enabled painters to work on their canvas anywhere outdoors, and contributed greatly to the development of Impressionism. History also tends to repeat itself. With the ending of the 20th century the introduction of electronic imaging has caused some photographers acute anxiety and insecurity over photography's future. So much is proclaimed about the wonders of digital equipment that pessimists have adapted Paul Delaroche's famous words to say 'from today photography is dead'.

Finally, don't forget that the history of photography is a continuing story in which you have a part. The photographs around you now, including the ones you take and preserve yourself, are storing up history too. They will reflect the ways of life, interests, attitudes and concerns of people today

to others maybe at the far end of the 21st century.

EVENTS BY DATE

tain) ins frial use nce) many)			
rain) Ins	Current Affairs	Internal combustion engine invented. Daimler (Germany) Eighth and final Impressionist exhibition (France) First Impressionist exhibition London 'How The Other Half Lives' published (US) Growth of 'Art Nouveau' (W. Morris, Britain) Ellis Island immigrant receiving station opens (US) Ellis Island immigrant receiving station opens (US) First model T Ford car (US) First model T Ford car (US) Daily Mirror using all half-tones pub. (Britain) Russian Revolution San Francisco earthquake. First Matisse show in US, at 291 Gallery Modern music. Stravinsky's 'Rite of Spring' Duchamp's 'Nude Descending a Staircase' Woolworth building - America's tallest at 792 ft World War I (1914-1918) Dada Movement began (Zurich) until about 1922 D. W. Griffiths makes Hollywood movie 'Intolerance' Bauhaus design school founded (Germany)	Regular 'wireless' programs broadcast (US) Surrealist paintings from about this date
iio (Britain) per introduced plates manufactured (Britain) oduced halftone blocks on of bromide paper begins sxtremely popular process developed (US) ication for transparent rollfilm set down H & D emulsion vie equipment (US) cess developed for pictorial use oment demonstrated (France) X-rays, radiography (Germany) trollfilm camera (US) box camera (US) s designed (Germany) introduced in Britain introduced in Britain introduced (France) R plates camera (Britain) fery film base replaces e nitrate (US) trainted (Germany) Press camera (US) developed developed mitinued1917	Photographers and Movements	Thomson's pictures of London street life published Muybridge's experiments, photographing galloping horses (US) Marey locomotion photo-experiments 1882–96 (France) Photo-club founded, Paris Muybridge's locomotion pics (11 vols) published (US) Riis photos of NY slums published (US) Riis photos of NY slums published (US) Riis photos of NY slums published (US) Riis ghotos of NY slums published (US) Riis photos of NY slums published (US) Riis ghotos of NY slums published (US) Stieglitz returns from Germany, to live in US Vienna carnera club founded The Linked Ring formed (Britain) Stieglitz edits 'Camera Notes' (US) New American Photography exhibition at RPS Photo Secession founded, first issue 'Camera Work' (US) Photo Secession founded, first issue 'Camera Work' (US) Armory exhibition, dissolution, The Linked Ring Armory exhibition of modern art, New York Growth of modernist photography ideas begins Strand's photographs' (Britain) Final issue Camera Work. 291 Gallery closes	Man Ray, Moholy Nagy, photogram experiments Renger-Patzsch begins realism photography of everyday objects E. Steichen appointed chief photographer Vogue
Technical processive in the control of the control	Technical processes, equipment	Past electric light studio (Britain) Platinum printing paper introduced First ortho sens. dry plates manufactured (E First commercially produced halftone block Large scale production of bromide paper bb Detective' cameras extremely popular Fathone engraving process developed (US) Eastman patent application for transparent Hurter and Driffield set down H & D emuls speeds (Britain) Ecison perfecting movie equipment (US) Gun bichromate process developed for pic Lurriere movie equipment demonstrated (F Roenigen discovers X-rays, radiography (G Rochagen discovers X-rays, radiography (G Rochagen discovers Y-rays, radiography (G Rochagen discovers developed Ritain Rochagen discovers developed Ritain Thi-cocur Carbro process developed (Britai	1921 1922 1923

	Technical processes, equipment	Photographers and Movements	Current Affairs
1924 1925	Leitz manufacture first Leica camera (Germany) Emanox camera. fl.8, lens manufactured	Weston, in N. Mexico, begins 'straight' approach	
1927	(Sound movies now universal		Picture palaces' built everywhere to show movies
1928	Capstaff formulates D-76 developer First Rolleiflex TLR rollfilm camera (Germany)	Salomon begins political candids (Germany) Renger-Patzsch 'World is Beautiful' published	Picture magazine Berliner Illustrierte Zeitung pub.
1929	Flashbulbs introduced (Germany) First colour print service (professionals only)	(Germany) Film und Foto exhibition (Germany)	Stock-market crash, start of world-wide depression
1931 1932	First photo-electric meter (US) 8 mm amateur movie film and equipment (US) First Technicolor film shot using three-strip camera	Group f64 formed	Roosevelt's New Deal social reform programme (US)
1933	(US) First panchromatic rollfilms (US)	Heartfield, photomontagist, flees Germany	Bauhaus closed. Nazis come to power (Germany)
1935	Dutaycolor rollfilm infroduced (France) Kodachrome 35 mm films infroduced (US)	FSA photo project launched (US) Photo League of NY still photographers formed	First issue Life magazine
1937	Dutaycolor roll and sheet film available UK First 35 mm SLR camera - Exakta (Germany)	Weston receives first Guggenheim Award	New Bauhaus opens, Chicago
1938 1939	First camera with built-in meter, for rollfilm (US) Edgerton evolves first electronic flash (US) German lenses and cameras, and Agfa materials,	given to a photographer McBean surrealist theatre portraits (Britain)	First issue Picture Post (Britain) and Match Paris Second World War (1939–45) Steinbeck's 'Grapes of Wrath' published
1940	cut off by war		Photo sect. of Museum of Mocern Art opens (US)
1942	Agfa neg/pos colour film and paper (Germany) Kodacolor rollfilm colour neg and printing	Irving Penn begins photography while art directing for New York Vogue	
1945	,		
1947	photographer (US) Instant pic (B&W) film and cameras, Polaroid (US)	Magnum photo co-operative formed by Cartier Bresson etc.	Cinema-going reaches its peak, soon rapidly declines
1948	First model, Hasselblad rollfilm SLR Contax S, first pentaprism finder 35 mm		
1950 1951 1952	SLR (Germany)	Photo league ceases (US) 'The Decisive Moment' by H. Cartier Bresson pub.	George Eastman's House opens as museum (US) First Xerox copying machin (US) Popular growth of (B&W) TV begins First pocket size transistor radios (Japan)
		First issue Aperture magazine, New York	End of Korean War

		r notographers and Movements	Current Atlants
1955 1957	Hasselblad 500C model First Japanese precision 35 mm SLR (Nikon F)	Family of Man exhibition opens New York	The Berlin Wall is built 'Pop Art' first coined I act issue <i>Picture Post</i> . America passes first Civil Richts Bill
1958		R. Rauschenberg and others pioneer US Pop Art	
1959	_	Death of Edward Weston Robert Frank's book 'The Americans' pub. (US)	
1962 1963		David Bailey's first British Vogue contract, at age 23	Sunday Times pub. first Brit. newspaper colour supplement Colour TV becomes general President Kennedy assassinated
1964	Expanded range of new optics - 'fish eye' lenses etc.		First successful beatles record US involvement in war in Vietnam Lace richts in maint 11S, ritios
1966		Antonioni's film 'Blow Up' Death of Marcel Dichamp	Dr. Martin Lumps Martin Lumps assassinated Six million et done amol in 11S higher adversation
1969	Offset litho gives improved printed page repro. of colour	Witkin Gallery, exclusively photography, opens in New York	First photographs taken on moon, using Hasselblads First photographs taken on moon, using Hasselblads First charge-coupled device (CCD) invented (US)
1970			250 000 anii-wa denionados mach in washington Peminists parade - 50th year of women's voting rights The Female Eunuch' by G. Greer published (UK)
1971		Opening of the Photographers' Gallery, London	
1972	Polaroid SX-70 one-step colour print system introduced (US) Kodak launch 110 format cameras and films		Life magazine ceases publication
1973 1974	C-41 processing replaces C-22 for color	Death of Edward Steichen International Centre of Photography opens in New York	Cease-fire in Vietnam Resignation of Pres. Nixon, following Watergate scandal
1975		New Topographics exhibition, George Eastman House New York	
1976	First SLR with TTL flash metering – Olympus OM-2	Death of Man Ray, Minor White Side (Allow) Names ellowing	Mainth of Buttoh nous shoot man and an atom B 9. W
1982	Prototype 'still video' camera (Mavica) demonstrated by Sony	Death of Bill Brandt, Cecil Beaton	Projoing of Diffusi flow shoot findle colour than D ∞ W
1983		Opening of National Museum of Photography, Film and Television, Bradford	
1984		Death of Ansel Adams 150 years of photography celebrated	

Glossary

Abstract image An image in which the depiction of real objects in nature has been discarded for a pattern or structure of lines, shapes, colours etc. The subject may be real but so stylized, blurred or broken down into basic forms that it appears unrecognizable.

Air-brushing Painting or colourling by hand using a paint-spray.

Albumen A clear faintly-yellow organic material found in plants and animals. White of egg is albumen in its purest form.

Albumen prints Prints made on thin paper coated with an eggwhite-and-salt solution and sensitized with silver nitrate. The image was often gold chloride toned, giving a purplish-brown colour. Prints are recognizable from their glossy surface and yellowish whites. In general use in 1885–1890s.

Ambrotype An (underexposed) wet-collodion glass negative, image whitened and presented against a black background – which gave it a positive appearance. Popular for cheap portraiture in the 1850s and 1860s.

Aperture The circular hole controlling the amount of light which passes through a photographic lens, therefore affecting image brightness. Aperture sizes are calibrated in f numbers.

Autochrome process Early colour transparency process using mixtures of red, blue and green dyed starch grains stuck to a glass plate (black carbon filling spaces in-between) and coated with a layer of panchromatic emulsion. Exposed through the back of the plate the grains acted as a mosaic of tiny filters. Needed black and white reversal processing. See page 62. In use 1907–1930s.

Autofocus (AF) Focusing adjustment system by which the lens automatically forms a sharp image of a chosen part of the subject.

Avant-garde Art which differs from what is considered normal at the time, in an original experimental (even outlandish) way. The term is French for vanguard.

Bitumen of Judea A type of whitish asphalt found in Syria, Trinidad etc. Can be dissolved to form a varnish which gradually hardens when exposed to light.

Bromide prints Photographic paper coated with silver bromide in gelatin. Introduced in 1873.

Bromoil Printing process by which suitable bromide paper is exposed to a negative (by contact or enlargement), processed, then bleached to remove the black silver image. Oil pigment is then applied with a brush and 'takes up' in image areas only. Result can be given a hand-finished appearance. Invented 1907.

Calotype From the Greek for 'beautiful picture'. Talbot's paper negative process, patented in 1841.

Carbon print Process using tissue coated with gelatine, bichromate, and either carbon black or a pigment. After contact printing exposed areas contain hardened gelatine. The tissue was then attached to gelatine-coated white receiving paper, and the tissue and unhardened image areas soaked off. Popular for giving

rich black images (when carbon used) 1864–1930s.

Carbro process Printing process using a combination of carbon tissue and a bromide print, the two being held in face contact in the presence of ferrocyanide to give a hardened gelatine image. By use of three tissues pigmented in yellow, magenta and cyan, a tricolor carbro print could be assembled from three black and white separation negatives. In use for professional colour print making 1930s. See pages 62 and 68.

Collage From the French word 'Coller' (to glue). Like assemblage, refers to works that are pasted together.

Collodion Guncotton (cottonwool dissolved in nitric acids) in a solution of ether and alcohol. A clear sticky solution discovered in 1847 and used for dressing wounds e.g. in Crimean war. Later (1851) formed the basis of the wet-collodion photographic process.

Collodion positive See Ambrotype.

Contact prints Prints made by direct contact with the negative. To produce large prints you need an equally large negative.

Daguerreotype Process invented by Louis Daguerre and introduced in 1839. The direct positive image was produced on a small silvered plate. See page 4.

Depth of field Distance between nearest and furthest parts of a scene which appear on the photograph in sharp focus. Greatest when using short focal-length lenses and small diameter aperture settings.

Development Chemical treatment by which an exposed but invisible (latent) photographic image is made visible, either as black silver or coloured dyes.

Diffusion Scattering of light. Image diffusion by means of a lens attachment gives photographs with spread or 'smudged' highlights. Light diffusion (e.g. light through cloud, tracing paper in front of lamps) gives soft shadowless subject illumination.

Digital imaging Image-forming by a digital, electronic device; in photography as opposed to a chemically based system.

Diorama Theatrical entertainment using large translucent paintings lit from the front and/or behind, moved and changed to give realistic and dramatic scenic effects. Very popular in the 18th and 19th centuries.

Dye transfer process Slow, expensive method of making excellent colour prints from separation negatives. Three enlargements made on special matrix film, are dyed yellow, cyan and magenta, and pressed in sequence onto paper. Introduced in 1946.

Emulsion (photographic) Light-sensitive salts in gelatin, as coated on photographic plates, film or paper. **'Equivalents'** Term coined by Alfred Stieglitz for his photographs attempting to express inner meaning or metaphor. See page 120.

f-number Effectively the diameter of the lens aperture divided into the lens focal length. The *higher* the *f*-number the *smaller* the aperture.

False attachment Part of one object seen behind another so that lines, or shapes or tones seem to join

up. Also used to make images in which foreground and background objects appear to occupy the same plane.

Ferrotype Another name for Tintype.

Filter (light) Transparent glass, acetate or gelatin sheet, usually coloured. Mostly used over lens (or lights) to alter the way coloured objects are rendered in a photograph.

Fisheye lens Extreme wide-angle lens, often able to include over 100° viewing angle of a scene. However, gives a bowed appearance to most straight lines, plus distorted perspective.

Fixing In processing, the chemical stage after development, to make remaining (undeveloped) silver halides insensitive to light and soluble.

Flashbulb Glass bulb containing metal wire or foil, ignited by electrical fuse. Burns out in a brilliant light flash, without smoke. Unaffected by damp. Introduced 1929, mainly for press photography.

Flashpowder Finely ground magnesium powder ignited by a taper or spark. Could give an extremely bright flash, but also smell, ash and smoke. Unreliable in windy, damp conditions.

Focal length In simple terms, the distance between lens and image when focused for a distant subject. Normally a camera has a lens with focal length about equal to the diagonal of the picture size it gives.

Focal plane shutter Blinds just in front of the film surface, which open briefly to make the exposure. Being part of the camera body this shutter can be used with any lens.

Focusing Altering the lens-to-film distance (or lens-to-subject distance) until a clearly focused image is formed on the focusing screen or film.

Gelatin prints See Bromide prints.

Gum bichromate process Similar to carbon printing. Paper coated with gum arabic, potassium bichromate and the artist's choice of water-colour pigment is contact printed from a negative. Warm water washes out pigment in image highlight areas unhardened by light. Considerable control is possible, e.g. by manipulation of the wet print with a brush. See Fig. 8.7. Introduced 1894 but eventually replaced by bromoil which could be used for enlargements too.

Gum process Shortened name for Gum bichromate process.

Hand camera Camera designed to be used held in the hand.

Heliography Means 'sun drawing', the 1820's lightsensitive process devised by Nicéphore Niépce, using bitumen coated polished pewter.

High key A picture made up of predominantly light tones or colours.

Highlights The lightest parts of the final (positive) photographic image.

Hypo Chemical known in the 19th century as hyposulphite of soda (now named sodium thiosulphate). Used for photographic fixing, as first suggested by Sir John Herschel in 1839.

Instant pictures General term for camera materials, (e.g. Polaroid), giving finished prints a minute or so after making the exposure.

Kodachrome First multi-coated screen-free colour transparency film, commercially produced by Eastman Kodak (35 mm) 1936.

Laterally reversed Reversed left-to-right, as when you see yourself reflected in a mirror.

Low key A picture mostly consisting of heavy dark tones or sombre colours.

Miniature A very small painted portrait, generally oval in shape and produced on ivory or card, using transparent water colours. Most popular in the 18th century until the invention of photography.

Miniature cameras Term used in the 1920–1960s to describe all cameras designed for small rollfilm and (particularly) 35 mm film.

Montage A picture made up from several separate images, arranged so that they join, overlap or blend with one another.

Negative An image in which subject highlights appear dark and dark shadows appear light. In a colour negative subject colours are reproduced in complementary hues.

Oil process See Bromoil.

One-shot colour camera Camera containing semi-reflective mirrors, which gave three separate images, identical in size and viewpoint, from a single exposure. Used during the 1930s and 1940s to give separation negatives (through red, green and blue filters) for making early colour prints. See page 63.

Orthochromatic Photographic material sensitive to blue and green light but not red. (i.e. Red subjects are reproduced as a very dark tone on the final print).

Panchromatic Black-and-white emulsion sensitive to all colours of the visual spectrum – red as well as green and blue – therefore reproducing them in correct tones of light and dark.

Photography 'Drawing' or 'writing' by means of light. (From the Greek *photos* meaning light, and *graphos* meaning writing). Term suggested by Sir John Herschel to William Fox Talbot in 1839.

Photogravure A process for printing mechanically in ink. A final size negative image is formed on special tissue, then transferred to a prepared copper plate or cylinder. After etching and inking this plate is printed on a press. Gives rich half-tones without an apparent screen pattern.

Photomechanical printing General term covering those processes which result in a hard-wearing surface which can be repeatedly inked and brought into contact with paper to give a large quantity of reproductions of photographs etc.

Pinchbeck A metal alloy used to imitate gold. Often used for the decorated mounts and frames of 19th century photographs.

Plate camera Camera designed to use light-sensitive materials in the form of glass plates. From the late 1930s onwards usually adapted to accept sheet film instead.

Platinum paper Ready-manufactured material for contact printing which, after development, clearing in hydrochloric acid and washing, gave an image of platinum fused into the fibres of the paper. Prints had extremely rich blacks unobtainable by other processes, and the image was very permanent. Invented in 1873, but went out of production about 1917 owing to its high cost.

Plates Originally this term referred to the light-sensitized, silvered copper plates used for the Daguerreotype camera. From the 1850s however, when collodion allowed the use of glass, it continued to be used for sensitized glass sheets of various set sizes.

Platinotype print A print made on platinum paper. **Positive** An image in which subject highlights appear light and shadows appear dark.

Realism General term for pictures which depict things as they appear naturally, without much apparent distortion or stylization.

Reflex camera Any camera using a mirror between the lens and a (usually horizontal) focusing screen. Allows the image to be seen and composed right way up.

Repeating back A mechanical device holding a row of three plates at the back of an ordinary stand camera. By sliding the back sideways three separation negatives could be exposed in quick succession. Gave results similar to the more expensive one-shot colour camera, but limited to still-life subjects. See page 66.

Resolution (of films) The ability of an emulsion to record fine detail – particularly important when negatives are greatly enlarged in printing.

Resolution (of lenses) The ability of a lens to form an image containing fine detail. Depends upon correction of lens faults (aberrations), glass surface coating to reduce flare, accurate focusing, lens condition, etc.

Retouching Handwork on a negative or print, generally with brush or pencil to disguise unwanted marks, wrinkles in faces, etc. May also be achieved electronically.

Reversal process Processing sequence by which the film exposed in the camera is made to form a positive (instead of negative) image. Usually consists of about 6 to 8 stages.

Screen printing Also known as photo-silkscreen. Uses a fine mesh of fabric type material onto which is stuck a high contrast negative developed to form a stencil. Printers ink is then pushed through the unblocked holes with a flat rubber blade to print the image onto paper/canvas/metal.

SLR Single-lens reflex camera. Has a hinged mirror to reflect the image to a focusing screen for viewfinding. When the shutter release is pressed the mirror moves to allow the lens to project the image through an opened shutter directly onto the film.

Sensitometry The scientific study of the light sensitivity of photographic materials.

Separation negatives Normally three black-and-white negatives taken identically in all respects except that each is exposed through a strong filter of a different colour – either red, green or blue. See page 63.

Sheet-film Single sheets of film (replacing earlier glass plates) loaded into filmholders in the darkroom and used in large format cameras.

Shutter Device to control the time the image is allowed to act on the film.

Silver halides Silver chloride, silver bromide and silver iodide are silver halides – compounds of silver used for most photographic materials. First used by Daguerre and Talbot, they are still unrivalled for light sensitivity and image resolution.

Snapshots A term originally used in rifle shooting, but from about 1890 coined for photographs taken with a hand camera involving little or no delay in aiming. Generally describes results given by simple cameras used by beginners.

Soft-focus image An image in which sharp detail is overlaid with a slightly diffuse image, 'spreading' light parts of the picture. Produced by a special soft-focus lens or attachment.

Solarization (Strictly called pseudo-solarization or Sabattier effect). Image manipulation by exposing

photographic film or paper to light part-way through development. Gives a part positive, part negative result.

Speed (of films) Numbers denoting the relative sensitivity of films. Various speed ratings systems have been used, the first being H & D. Today's most common system uses ISO speed numbers.

Speed (of shutter) Timing of the shutter open period e.g. 1/25 sec, 1/250 sec, etc.

Stand camera A camera designed for use on a tripod or stand only.

Stereoscopic photographs Three-dimensional pictures produced by taking two photographs from viewpoints about 65 mm (2° in) apart, then viewing these in a device which allows each eye to see one picture only. Most popular in the 1860s. See page 31.

Stops Aperture settings, see *f*-numbers.

Straight photography An approach to photography in which the process itself is used in a direct way. Most creative decisions are taken in the choice of subject, lighting, viewpoint etc. The image itself is manipulated as little as possible.

TLR Twin-lens reflex camera. Designed with two lenses of identical focal length. One lens, fitted with a shutter, forms an image direct onto film; the other forms an image via a reflex system on a focusing screen at the top of the camera. Both focus together.

Talbotype Alternative name for calotype. Talbot's friends preferred to use this word in view of the way Daguerre's name featured in daguerreotype.

Telephoto lens A compact long-focus lens, able to give a large image of a distant subject – as when looking through a telescope.

Through-the-lens (TTL) metering Sensing system able to measure image light after passing through the camera lens; may make instant exposure settings.

Time exposure General term referring to exposures longer than about one second.

Tintype A low-cost reversal process very similar to the ambrotype but produced on collodion-coated black or brown enamelled tinplate sheets. Particularly popular in America as from about 1860. Used until recent times by 'while-you-wait' street photographers.

Toning Changing the image of a black-and-white photograph from the normal black silver to a chemical of a different colour.

Tripod Three legged folding and adjustable height camera support.

Unbacked plates Early dry plates which lacked a dark dye coating on their rear surface to prevent image light reflection from 'flaring' bright highlights.

Viewfinder Sighting device to ensure that the camera is aimed in the right direction and includes only the wanted parts of the scene.

Viewpoint The position of the camera relative to the subject.

Washing The stage of chemical processing which removes unwanted chemicals and by-products from the negative or print.

Wash-off relief Early form of dye transfer process, used for making assembly colour prints from separation negatives. Invented 1926.

Waxed paper process Variation of the calotype process using waxed paper to give more transparent negatives.

Brief biographies

Ansel Adams (1902-1984) American. Professional concert pianist turned professional photographer 1930. In 1932 a founder member of Group f64. From 1941 photographed characteristic landscapes of various US regions as photomuralist for the Department of the Interior. 1950s and 60s taught and published books on visual and technical aspects of 'straight' photography. Page 135.

Robert Adamson (1821–1848) Scottish. Learned the calotype process and in 1843 opened a professional portrait studio in Edinburgh. Approached by painter D. O. Hill for reference portraits for a major painting commission, the two went into partnership. They produced over 1500 calotypes of people, architecture, and Newhaven fishing scenes, until

Adamson's death. Page 18.

Frederick Scott-Archer (1813-1857) English. Sculptor and professional photographer. Inventor of the revolutionary collodion wet-plate process 1851, which he did not patent. Author of a manual of collodion photography. Died in extreme poverty. Page 22.

Eugene Atget (1856–1927) French. Ex-actor who turned to photography in 1898, documenting the people and architecture of Paris - mostly in areas soon due for demolition and redevelopment. Produced straight reference photographs for authors and painters such as Utrillo, Braque, Picasso and Marcel Duchamp. Recognized after his death as a 'straight' photographer of great sensitivity. Left about 10 000 photographs, the best of which have now been extensively published.

David Bailey (1938–) British. Interest in photography began during National Service in the RAF. Became assistant to John French, 1959. Work published in Daily Express etc. Contracted to London's Vogue magazine 1960. Made his name through spectacular fashion photography, with model Jean Shrimpton, and 'swinging London' portraiture. Books include Goodbye Baby & Amen (1969). Has directed films and commercials.

Richard Beard (1802–1885) English. Ex-coal merchant and business opportunist who bought the British rights to the daguerreotype process and Wolcott mirror camera. Set up first photographic portrait studio in Britain (1841) and later several others in London and the provinces. Made his fortune from studio profits and sub-licence fees. Eventually became bankrupt through continually suing other British photographers infringing the patents. Page 11.

Cecil Beaton (1904–1980) English. Amateur photographer turned professional portrait and fashion photographer for Vogue 1928. Until 1953 worked as a top photographer for this magazine in London, Paris and New York, specializing in flamboyant settings. During World War II became for a time a documentary photographer in Britain and the Middle East. Important stage and costume designer. Author of many picture books on ballet, travel, portraits. Page 150.

Mathew Brady (1823–1896) American. Owner of several East Coast daguerrectupe portrait studios in the late 1840s. and a photographer of important contemporary personalities. Strong believer in the importance of historical records. At outbreak of US Civil War (1861) sent out teams of photographers to cover most Important actions. Produced well over 6000 collodion negatives of the war, which were eventually bought by the US government. Page 87.

Bill Brandt (1905–1983) Born Germany, naturalized

British. Learnt photography in Paris from Man Ray, 1929. In 1931 settled in London as a freelance reportage photographer. Worked for British and American magazines (mostly Picture Post) covering Northern towns during the depression, the British way of life, portraits, landscapes. Published six books of photographs including Perspectives of Nudes (1961). Page 102.

Harry Callahan (1912-) American. Student of Ansel Adams 1941, then industrial photography technician until he met Moholy-Nagy and began teaching at Illinois Institute of Technology, 1946. Associate, then professor, Rhode Island School of Design, 1964. Frequent international exhibitor – his subjects mostly semi-abstract nudes, austere natural forms, and multiple image experimental photography. Page 139.

Julia Margaret Cameron (1815–1879) English (born Calcutta). Began amateur collodion photography after her husband retired in 1863. Self-taught. Photographed many distinguished Victorian friends and intellectuals visiting her neighbour the poet Tennyson. Published pre-Raphaelite style illustrations to Tennyson's works, but today most famous for her original and striking male portraits 1864–1875. Frequent exhibitor in London shows. Ceased serious photography when the family moved to Ceylon. Page 37.

Robert Capa (1914-1954) Hungarian, naturalized American. Born Andre Friedman. Photojournalist who became the best known combat war photographer during the late 1930s and 1940s. Made his reputation covering the Spanish Civil War (1936), World War II, Israel and Indochina - where he was killed. His work was published mostly in Life magazine, also several books of war photographs. Co-founder of Magnum agency in 1947.

Lewis Carroll (1832-1897) English. The Reverend Charles Dodgson, Oxford don and author of Alice in Wonderland. Enthusiastic amateur photographer 1856-1880, mostly child portraits of pretty girls; also Victorian celebrities. He had a naturalistic approach to portraiture well ahead of his time.

Henri Cartier-Bresson (1908-) French. Painting student turned reportage photographer. Travelled extensively recording various countries in the 1930s using the new Leica camera. For three years worked as assistant to film director Jean Renoir. After World War II (1945) returned to the still photography of actuality human interest subjects – using his gift for exploiting the decisive moment. Exhibited and published extensively in picture magazines throughout the world. Produced eight books of photographs. Founder member of Magnum agency 1947. Gave up photography for painting in the early 80s. Page 100.

Antoine Claudet (1797–1867) French. London-based sheet glass importer who learnt the daguerreotype process and purchased (for £200) a personal licence from Daguerre to practice in England. Set up a rival studio to Beard in London, 1841, and also became sole agent for Daguerre's cameras. He had considerable skill as a photographic scientist and was an enthusiast for stereoscopic photography. Claudet's professional photography was widely shown and he often acted as an exhibition judge during the 1850s. Page 11.

Alvin Lauydon Coburn (1882-1966) American. Founder member of Photo-Secession, but worked mostly from London where he was elected a member of The Linked Ring. Believed in liberating photography from 'having to express reality'. Many one-man shows 1906–1913, mostly portraits of celebrities and city landscapes. Extremely versatile and experimental in his styles and techniques; links with abstract, cubist painting. Very influential exhibitor, particularly during 1920s and 1930s. Became a British subject 1932. Page 121.

Jean Corot (1796–1875) French. Painter and etcher. Founder of Barbizon School of Intimate Mood Landscape Painting. Interested in photography and for a time drew directly on collodion-coated glass instead of metal to produce reproductions by photographic printing. Famous for his paintings of landscapes having diffused detail and muted greygreen colours and tones.

Louis Daguerre (1787–1851) French. Realist painter, stage designer, showman. Manager and joint inventor of elahorate Parisian diorama show (destroyed by fire 1839). After unfruitful 1829 partnership with Niépce he worked out his own daguerreotype process – the world's first practical method of photography, announced 1839. Awarded special pension in return for making his invention freely available (but already patented in England). Greatly honoured in France. Wrote a manual of the daguerreotype process. Pages 4 and 10.

George Davison (1856–1930) English. Amateur photographer and an early secretary (1886) of the London Camera Club. Considered a pioneer of modern pictorial photography at this time. Leading figure in the secession of RPS members who left in 1892 to form The Linked Ring. In 1900 appointed managing director of Kodak Limited (England), but asked to resign eight years later owing to his anarchist political activities. Page 113.

Edgar Degas (1834–1917) French. Painter and sculptor known in the 1870s for his deceptively informal compositions and unusual viewpoints, openly influenced by hand camera photography. Concentrated on contemporary subject matter – often dancers and ballet trainees. Organized and exhibited in most of the Impressionist exhibitions, 1874–1886.

Philip Delamotte (1820–1889) English. London artist and designer who began calotype photography in the late 1840s. Using the collodion process he documented the reerection of the Crystal Palace in 160 photographs, 1854. became professor of drawing at Kings College 1856. Organized the Manchester Art Treasures Exhibition 1857, and illustrated many books with photographs or drawings.

Robert Demachy (1859–1937) French. Banker, amateur painter and photographer. Leading member of French Photographic Society and Photo-Club of Paris, late 1880s. Produced impressionist style romantic portraits and landscapes with figures from 1907. A believer in the manipulated pictorial print. Regularly exhibited and honoured by Royal Photographic Society, London. 1905 Member of The Linked Ring. Ceased photography in 1914. Page 114.

Andre Disderi (1819–1890) French. Of humble origin, first became a professional photographer in Brest, then (1852) set up a large portrait studio in Paris. In 1854 patented cartede-visite photographs, which soon became immensely fashionable. Photographer to Napoleon III, Queen Victoria, Czar of Russia, etc. Became Europe's richest photographer by 1861, but wasted away his fortune and ended his career as a Monaco beach photographer in the late 1880s. Page 35.

Marcel Duchamp (1887–1968) French. Painter and one of the original Dadaists. Early works (about 1911) include Cubo-Futurist '*Nude Descending a Staircase*', influenced by motion analysis photography. Later shocked the establishment by his exhibitions (1914 and 1917) of ready-made objects – bottles, urinals, etc. – and apparently random constructions in wire and foil. Produced few paintings after 1930 and instead devoted his activities to chess.

George Eastman (1854–1932) American. Bank clerk and amateur photographer. In 1878 began making gelatin emulsion plates for his own use. Invented an emulsion coating

machine and set up commercial production of plates in Rochester, NY as the Eastman Dry Plate Co. 1880. In 1888 marketed the enormously successful No. 1 Kodak, the first simple camera backed by a D & P service. Kodak products progressed from strength to strength – transparent rollfilm, folding cameras, paper, movie films, colour materials. After retirement Eastman died by his own hand, leaving much of his vast fortune to the University of Rochester. Page 47.

Peter Emerson (1856–1936) English. Doctor of medicine and extremely influential amateur pictorial photographer. Abandoned his medical career for photography 1886. Published Naturalistic Photography promoting photography as an independent art (1889), then withdrew these opinions (1890). Produced several picture books of East Anglian landscapes 1886–1895. Much honoured by Royal Photographic Society In Ilie 1890s. Ceased exhibiting and judging, and gradually became forgotten after the turn of the century. Page 111.

Frederick Evans (1852–1943) English. London bookseller and amateur photographer – mostly making portraits of literary friends. In 1898 devoted his full time to professional photography, including architectural studies of English cathedrals, French chateaux, etc., for the magazine Country Life. In 1901 became a member of The Linked Ring. First British photographer reproduced in Camera Work, 1903. Gave up photography when platinum paper was discontinued after World War I. Page 114.

Walker Evans (1903–1975) American. Documentary photographer, at first specializing in indigenous architecture, mostly for book illustration. With other members of FSA he documented poverty-stricken US farmers 1935–1937. Illustrated *Now Let Us Praise Famous Men*, 1941. Several picture books of his objective style work published. Worked for *Time* and became associate editor *Fortune* magazine. Page 95.

Roger Fenton (1819–1869) English. Aristocratic background. Studied art and photography in Paris in the 1840s, then law – qualifying as a barrister. Paintings exhibited at the Royal Academy. In 1854 changed his profession from law to photography. Founded and was first secretary of the Photographic Society of London (later RPS) in 1853. Became famous for documenting the Crimean War and for his photographs of English architecture, landscapes, still lifes, royal portraits. Regularly photographed sculpture, documents, etc., for the British Museum. Gave up photography 1862 and returned to his legal career. Pages 24 and 54.

Robert Frank (1924–) American. Apprentice at studios in Basle and Zurich 1940–42, then freelanced in Switzerland until 1944. Moved to New York 1947 and worked under Alexey Brodovitch for *Harpers Bazaa*r, also for *Fortune*, *Life* and *Look* magazines. First exhibition MOMA 1948. Guggenheim fellowship sponsored a two-year tour of America, culminating in his book *The Americans* published 1958 (France) 1959 (USA). At a time when photo-journalism still dominated photography its stark, grim reality marked a new approach, influencing many other photographers. Exhibited again at MOMA 1962, but increasingly turned to the making of films.

Francis Frith (1822–1898) English. Wholesale grocer who in 1850 became partner in a printing firm which mass produced photographic (albumen paper) prints. From 1855 he was fully occupied as a collodion photographer taking views of Britain and abroad. Travelled extensively in the Middle East 1856–1860. His firm marketed a range of several hundred thousand scenic views by 1890. Published his own books with pasted-in prints. Page 24.

Bert Hardy (1913–1994) English. Self-taught photographer, while working as teenage messenger boy for a D & P laboratory. Ten years later became freelance press

photographer for a Fleet Street press agency – one of the first using 35 mm equipment. Joined *Picture Post* 1940, and served with the Army Photographic Unit, returning to become the magazine's chief photographer until its closure 1957. Thereafter turned mostly to advertising photography.

John Heartfield (1891–1968) German. Born Helmut Herzfelde but changed to a British name in 1916 as a political gesture. Painter and montagist of photographs, leader of Berlin Dadaism 1920s. A communist who used photomontages – reproduced as magazine covers, posters, etc. – to combat capitalism and militarism during the 1930s. Also chose this technique to design many book covers, Expelled from Germany in 1934, returning there 1950. Page 141.

David Octavius Hill (1802–1870) Scottish. Somewhat uninspired portrait and landscape painter. A founder, regular exhibitor of the Scottish Royal Academy for forty years. Commissioned to paint 474 recognizable faces of ministers for a commemorative work in 1843, Hill set up a fruitful partnership with photographer and chemist Robert Adamson. Returned to painting after Adamson's early death in 1848. Page 18

Lewis Hine (1874–1940) American. Sociologist and school teacher 1901–1907. Took up photography in 1905 to help publicly expose the lives of poor immigrants, Pittsburgh coal miners, etc. Became staff photographer to the National Child Labor Committee 1911, and produced photographs showing shocking exploitation of youngsters. American Red Cross photographer in World War I. Later (early 1930s) documented more positive workers' achievements – including the erection of the Empire State Building. Page 93.

Kurt Hutton (1893–1960) German. Born Jurt Hubschmann, and originally studied law but interrupted by World War I, learnt photography instead and set up in a Berlin portrait/advertising studio 1923. Turned to candid photoreportage for the new German illustrated magazines 1930. In 1934 emigrated to Britain (anglicizing his name) eventually becoming staff photographer for *Picture Post* 1938–1955.

Yusuf Karsh (1908–) Canadian. Born America. Set up as a studio portrait photographer in Ottawa in 1932, becoming the most famous and commercially successful photographer of leading world figures – particularly during the 40s–50s. His theatrical lighting and flawless technique influenced many portrait studios world-wide. Books of work include *Faces of Destiny* (1947) and *Portraits of Greatness* (1959).

Andre Kertesz (1894–1985) Hungarian. Documentary photographer in his own country 1912–25 before moving to Paris. Work published in *Berliner Illustrierte*, *Vu*, *The Times*. Immigrated to America 1936, freelancing for *Harpers*, *Look*, *Vogue* etc., on a variety of assignments including fashion and advertising. Contracted to *Vogue* 1949–62. Produced a wide range of photography, reflecting art movements of the time but with an individual approach. Many of his pictures were an instinctive reaction to his everyday environment – somewhat surreal, with a strong graphic element. Kertesz's work influenced many other photographers through books published 1964–81 (e.g. *Andre Kertesz: Sixty Years of Photography*).

Dorothea Lange (1895–1965) American. Studied photography under Clarence White and opened a portrait studio in San Francisco, 1919. Member of Group f64, 1934. Concerned for the depression unemployed, she acted as photographer in a research project on migrant labour, then produced her most famous work as a leading FSA photographer 1935. During World War II documented the internment of Japanese Americans. Later she travelled producing numerous photoessays on American and toroign local communities, published in *Life* and similar magazines. Page 94.

Richard Maddox (1816–1902) English. Doctor of medicine and amateur photographer. Invented the first

successful silver halide gelatin emulsion in 1871. Improved later by others, his discovery led directly to the manufacture of dry plates and films during the 1880s. Maddox, like Scott Archer twenty years earlier, never patented his discovery.

Angus McBean (1905–1990) Welsh. Shop assistant and amateur photographer who turned professional in 1934, working in a London society photographer's studio. Opened portrait studio in 1935 and quickly established himself as London's leading theatrical photographer – a position he held until the 1960s. Following World War II McBean delighted in adapting surreal ideas to create unusual studio portraits of actors and actresses. Page 142.

Rene Magritte (1898–1967) Belgian. Surrealist painter trained in Brussels but briefly in contact with French surrealists when living in Paris 1927–1930. His paintings have a dreamlike clarity, evoking impossible events but featuring everyday subjects. They often use pale muted colouring. Working from Brussels he turned out a large volume of variable quality work between the 1920s and the early 60s. Page 142.

Mari Mahr (1941–) Born in Chile of Hungarian parents. Studied photography and journalism in Budapest and worked as a Press photographer in Hungary 1960–72. Moved to London, studied for BA Photographic Arts at the University of Westminster and changed to a far more personal type of work. As a photographic artist first exhibited at the Photographers' Gallery London 1977, later exhibitions Germany, Holland, Italy, USA, Greece, New Zealand, Japan. Page 184.

Felix Man (1839–1919) German. Born Hans Baumann, Studied art and drew illustrations of sports events for a Berlin magazine. Having used photography for reference material he became a professional photojournalist in 1928. Achieved international fame for his photo-interviews with important Europeans. Emigrated to Britain 1934 and changed his professional name. Helped to found *Weekly Illustrated*, worked for *Picture Post*, *Life*, etc.

Etienne Marey (1830–1904) French. Physiologist who inspired by Muybridge's experiments, devised photographic equipment and techniques to record human movements. Apparatus included disc shutter cameras which gave a whole sequence of images on one photographic plate. Much of Marey's work, like Muybridge's, could be viewed in suitable equipment which 'replayed' the original movements. Page 50. Paul Martin (1864–1944) French, living in England. A newspaper illustration wood-engraver and successful amateur pictorial photographer. He also delighted in recording everyday life with a concealed 'parcel' camera. Gave up wood-engraving with the coming of half-tone blocks and in 1899 became a freelance photographer. Known today mostly for his (spare time) candid photographs of ordinary London street scenes, the seaside, etc., (1895-1914), now of great historical interest. Page 91.

Baron de Meyer (1868–1949) French. Elegant fashionable man-about-town who married a relative of Edward VII and was created a German Baron in 1899. In following years photographed the fashionable rich of European society, Diaghilev's ballet company, etc., as an amateur. Was elected to The Linked Ring and had pictures featured in *Camera Work*. Because of his German connections the Baron left Britain for America in 1914, where he turned professional and worked on contract from Condé Nast. His glittering, elegant portraits and fashion plates decorated *Vogue* 1914–1922, then *Harper's Bazaar* 1923–1935. Page 148.

Duane Michals (1932–) American. BA (Art) Denver 1953. Photographie-Illustrator who turned to photography in 1958. Combines personal work with commercial editorial photography. The former has been widely exhibited and published in book form, e.g. *The Photographic Illusion*. First exhibited at MOMA 1970, also galleries in France, England,

Germany, Japan, and throughout the US. Page 167.

Laszlo Moholy-Nagy (1895–1946) Hungarian. Studied law, interrupted by World War I. Began painting and drawing 1918. Moved to Berlin as an abstract painter, increasingly influenced by German expressionists. Joined the Bauhaus 1923, experimenting in photography and movies, and becoming head of the first-year course. Collaborated on stage design, light and colour experiments; produced various books on design education. Resigned 1928 and became stage/film designer in Berlin; then (1935) a photographer and designer in London. In 1937 moved to America as director of the New Bauhaus, Chicago. Page 128.

Edweard Muybridge (1830–1904) British eccentric, born Edward Muggeridge Emigrated to America 1852. Became official scenic photographer to the government, also to railway and steamer companies. From 1872 he was commissioned by a rich owner to record the exact motion of galloping horses. During 1884–1885 he produced a systematic analysis of animal and human locomotion of great significance to artists, published 1887. Designed 'replay' equipment which contributed to early movies. Retired to England in 1900. Page 49.

Felix Nadar (1820–1910) French. Born Gaspard Tournachon. Began his career in Paris (1842) writing comic articles and drawing illustrations aided by photography. Became a professional photographer 1853, first in partnership and then (1860) set up in large elegant portrait studio as 'Nadar'. Adventurous spirit – active in the political revolution of 1848; took the first photographs from a balloon 1858; created an aerial postal service during the siege of Paris; and made some of the first photographs taken by electric light 1861. Supported the (much ridiculed) impressionist painters. Page 27.

Arnold Newman (1918–) American. Took up photography 1939 and opened a New York portrait studio 1946. However, specializes in showing eminent people in their own environment, often using dynamic but simple composition devices. Uses 4 x 5 in or larger stand cameras but still achieves a candid looking result. Work published frequently in *Life* and similar international magazines, particularly during the 1960s.

Nicéphore Niépce (1765–1833) French. Nobleman, landowner and amateur scientist. Interested in photo-etching and lithography. Experimented from 1816 on methods of photography using silver chloride, then bitumen on metal. Made successful copies of drawings by contact printing 1822 and later the world's first photograph from nature 1826. Entered into partnership with Daguerre in 1829 to devise a more practical camera system, but died four years later.

Tim O'Sullivan (1840–1882) American. Learnt collodion photography while working at Brady's portrait studio in New York, then Brady's Washington establishment. During the Civil War covered many Federal Army battlefronts, afterwards (1867) became a government photographer recording scenic views on pioneering survey expeditions to the West. In 1881 appointed Treasury Department chief photographer, Washington. Page 89.

Irving Penn (1917–) American. Trained in art school as a designer, but began to take his own photographs while working as art director for Vogue in early 1940s. Following World War II became America's foremost fashion, portrait and advertising photographer. Penn photographs are austere and simple, using the minimum of setting. He published two outstanding books of portraits in the 1960s and early 1970s.

William Lake Price (1810–1896) English. Successful watercolour artist of the 1830s and 1840s who became a collodion photographer in 1854. He pioneered artificial constructed compositions based on literary and historical subjects, and also photographed the Royal family. Both types of work were much exhibited and admired. Wrote a *Manual*

of Photographic Manipulation in 1858. Gave up photography 1862. Page 110.

Robert Rauschenberg (1925–96) American mixed media artist. Studied at Kansas School of design and Bauhaus-influenced Black Mountain College 1946–49. Leading avant-garde artist exploiting the manifestations and contradictions of commonplace culture. First exhibited New York 1951 as a painter and, famously, in 1955 exhibited works or 'combines' being hybrids of painting, sculpture, photographs, furniture. In the early 60s Rauschenberg used photography extensively in silk-screened paintings, and also as ready-mades and transfers direct from printed ephemera. Enormously influential as an innovator, mixing, combining and recombining images – principally photographic. Exhibited regularly, on a world-wide scale Page 181.

Man Ray (1890–1976) American. Born Emmanuel Rudnitsky. Worked as a draughtsman and studied painting in New York – a frequent visitor to Stieglitz's 291 gallery. Paintings exhibited in 1912 and 1915. One of America's first abstract artists, working with New York Dadaist group including Duchamp (1917). In 1920 began photography before moving to Paris, 1921. Invented abstract 'Rayographs' (photograms) 1922. Earned his living as a professional fashion/portrait photographer, continuing his experimental abstract work. Made several surrealist movies 1923–1929. Returned to America in 1936 and 1940 as painter/photographer, later (1951) returning to Paris and concentrating on painting. Page 128.

Oscar Rejlander (1813–1875) Swedish, resident in Britain. Portrait painter who used collodion photography as an aid. In 1855 became a professional portrait photographer, also providing figure study reference photographs for other artists. Exhibited art photographs in the style of popular allegoric paintings, using combination printing techniques. Also (1872) produced studies of facial expressions for Charles Darwin's *The Expression of the Emotions in Man and Animals*. Died in poverty. Page 108.

Albert Renger-Patzsch (1897–1966) German. Exchemistry student appointed (1922) head of the photo unit of an art book publisher. Began close-ups of natural and manmade objects. In 1925 opened his own photographic studio. Produced picture books of portraits, landscapes and everyday objects, pioneering the New Objectivity style. Taught photography briefly prior to World War II, later specialized in architecture, landscape and industrial photography. Page 137. **Jacob Riis** (1849–1914) Danish, emigrated to America 1870. A carpenter who became police court reporter on New

1870. A carpenter who became police court reporter on *New York Tribune*. Shocked by the social conditions which led to crime, he began documenting New York slums (often using flashlight). Wrote and illustrated books crusading for reforms, with considerable success. Page 91.

Henry Peach Robinson (1830–1901) English. Bookshop assistant and amateur painter, who first learnt photography through the daguerreotype process. Operated a portrait studio in the midlands of England 1857–1862. From 1858 exhibited art photographs built around sentimental themes. An outspoken and influential member of the Royal Photographic Society. Moved into a studio partnership in southern England 1868–1888. Published many books and articles on photographic picture making. Founder member of The Linked Ring. Page 27.

Arthur Rothstein (1915–1985) American. Began reportage photography in 1934 and established his reputation working on the Farm Security Administration photographic project 1935–1936. Later a photographer for the US Army and the United Nations. Became technical director of photography for *Look* magazine. Wrote several books on photojournalism, colour photography, etc. Page 95.

Erich Salomon (1886–1944) German. Doctor of Law. Worked for the publicity department of a leading magazine

publishing house, becoming a freelance photoreporter 1928. Quickly became well-known for his existing light photography of social, political and musical events, mostly using the unobtrusive Ermanox camera. Throughout the 1930s his pictures sold to the new German picture magazines and to newspapers abroad. Being Jewish, Salomon and his family were persecuted, then murdered by the Nazis during World War II. Page 100.

Cindy Sherman (1954–) American. Studied BA photographic arts, State University College, Buffalo. First exhibition (B&W images *Untitled Film Stills*) 1979, followed by shows at Metro Pictures gallery, New York, and in Germany, Holland and England. Achieved international prominence during the 1980s–90s for images questioning self-identity and the 'author' in art by portraying herself as a variety of cultural types. Page 174.

Edward Steichen (1879–1973) Born Luxembourg but resident America. Lithographic apprentice, art student and amateur photographer. Elected a member of The Linked Ring 1901. Contributed pictorial photographs (and paintings) to major exhibitions from 1899. Founder member of Photo-Secession (1902) and its Gallery, 1905. During 1906-1914 settled in France, painting and sending work by modern European artists for showing in New York. He became Lt. Colonel in charge of aerial photography, US Expeditionary Forces, World War I. Gave up painting after the war, he set up an advertising photography studio in New York and worked as Condé Nast chief fashion/portrait photographer 1923-1937. Retired in 1938, but became Captain in charge US Naval Aviation Photographic Unit during World War II. Director, Department of Photography, Museum of Modern Art 1947-1962. Page 118.

Alfred Stieglitz (1864-1946) American. Student of engineering, then of photo chemistry Berlin 1882-1890. Won Amateur Photographer competition award 1887. 1890–1895 partner in New York photo-engraving business. An active amateur photographer, using a hand camera for pictorial studies of city. Member of the Linked Ring 1894. Editor of American Amateur Photographer 1893–1896, then Camera Notes 1897-1902. Organized breakaway exhibition of a group he named The Photo-Secession, 1902. Founded and edited Camera Work 1903-1917, opened and ran the 291 Gallery 1905–1917. (From 1908 hanging work of modern European artists as well as photography.) Numerous oneman shows and international honours 1932-1940. Ran gallery 'An American Place' New York 1929–1946. Page 116. Paul Strand (1890–1976) American. Learnt photography from Lewis Hine. Given a one-man show at 291 Gallery in

1916. Made his first semi-abstract photographs and closeups of man-made forms 1917. A US hospital technician during World War I. Movie cameraman 1919. Still photography of landscapes, portraits in New Mexico 1930. Spent 1933–1942 mostly making documentary films, reverting to still photography in 1943. From 1950 lived in France producing photo-books, profiling various European and African countries. Page 131.

Frank Meadow Sutcliffe (1859–1940) English. Set up a photographic portrait studio in Whitby, Yorkshire, 1875. Produced and exhibited many local landscapes, seascapes, fishing and country scenes around the town, becoming well-known for his naturalistic approach to pictorial photography. A founder member of the Linked Ring 1892. On retirement became curator of Whitby Museum.

William Fox Talbot (1800–1877) English. Landowner, scientist, Member of Parliament, inventor of negative/positive photography. Produced the first permanent photographic negative on paper 1835. In improved form this was patented as the calotype process, 1841. Published the first book illustrated with (pasted in) photographs 1844. Pioneered flash

and photomechanical engraving in primitive forms. Talbot was also a visually talented photographer. Page 6.

John Thomson (1837–1921) Scottish. Explorer and early photographer. Travelled extensively in the Far East 1852–1874 and published books (with pasted-in photographs) of his scenic views in various countries. Taught photography at the Royal Geographical Society (1870). Made a famous series of posed but authentic documentary collodion photographs of London's street life, 1876. Also ran his own professional portrait studio.

Andy Warhol (1928–1987) American. Graduate of fine arts from Institute of Technology, Pittsburgh 1949. Employed on *Glamour* magazine as an illustrator, then as New York commercial artist 1950–57. Worked independently as a Pop artist from 1957 using images from advertising and icons of popular culture, as photographically reproduced in the media. Began using silk-screen techniques for paintings from 1962. Adopted repetition/serial approaches to presentation. Edited *Inter/View* magazine 1960s–70s. Ran The Factory, his own artists' space. From 1963 onwards Warhol directed over 50 avant-garde films. Page 189.

Tom Wedgwood (1771–1805) English. Son of Josiah Wedgwood, the famous potter. Pioneer attempts about 1801 to photograph on paper or leather soaked in silver nitrate solution. He produced primitive silhouette photograms, but results were unfixed and so impermanent. Page 3.

Edward Weston (1886–1958) American. Student, Illinois College of Photography, 1908. In 1911 opened a portrait studio and (1914–1917) received many awards and honours for his diffused pictorial-style work. Spent 1923–1926 working in Mexico City portrait studio – decided to redirect his exhibition work towards objective straight photography of natural forms. First made use of an 8 x 10 in view camera. 1928 opened a San Francisco portrait studio with son Brett. Founder member of Group f64 1932. A Guggenheim Award allowed him to give up commercial portraiture so that he could travel and photograph extensively in the Western US 1937–1938. Southern and Eastern states trip 1939. Major exhibitions New York (1946) and Paris (1950). Ceased taking photographs 1947 when stricken with Parkinson's disease. Page 133.

Minor White (1908–1976) American. University graduate in botany 1933. Poet. Learnt photography through recording microscope slides. 1938 WPA Project photographer. Director of an Art Center 1940, where he began teaching photography. After World War II studied art history, worked under Beaumont Newhall (Director of Photography Department, Museum of Modern Art), taught at the School of Fine Arts, California. Made frequent visits to work with Weston during the late 1940s. Produced 'sequences' - portfolio sets of original photographs, mostly landscapes and close-ups of natural forms. Editor and publisher of Aperture magazine from 1952. Taught at Rochester Institute of Technology 1955-1964 and Massachusetts Institute of Technology 1965-1973. Produced books containing collections of his own mystic/ metaphoric style of work, including 'equivalents'. A believer in visual analysis and meditation (zen) as a central core of photography. Pages 144 and 167.

Joel-Peter Witkin (1939–) American. Cooper Union BFA 1974. University of New Mexico MFA 1981. Four times recipient of a National Endowment for the Arts, Photography 1974–86. From the early 70s Witkin has produced an increasingly complex and challenging imagery, based on tableaux combining the erolic and the morbid. Exhibitions, Britain, France, Holland, Australia, and throughout America. Page 189.

Picture credits

Photographs were reproduced by kind permission of the following:

Chapter 1: 1.1, 1.4, Science and Society Picture Library, Science Museum; 1.3, 1.7, 1.8, 1.9, The Royal Photographic Society, Bath; 1.5, Gernsheim Collection, Harry Ransom Humanities Research Center, The University of Texas, Austin. Chapter 2: 2.2, 2.5, 2.8, 2.9, 2.10 Science and Society Picture Library, Science Museum; 2.11, 2.13 The Royal Photographic Society, Balli, 2.12, 2.14 Courtery George Eastman House; 215, 2.16 By Courtesy of the Board of Trustees of the Victoria and Albert Musuem.

Chapter 3: 3.2, 3.6, 3.7, 3.8, 3.10, 3.11, 3.19, 3.25, 3.29, 3.30, 3.31 The Royal Photographic Society, Bath; 3.3, 3.26, 3.28 Science and Society Picture Library, Science Museum; 3.9 By permission of the British Library; 3.16, 3.23, 3.24 Courtesy George Eastman House; 3.32 Notman Photographic Archives, McGill University, Canada.

Chapter 4: 4.1, 4.4, 4.5b, 4.5c, 4.5d, 4.8, 4.15, 4.16, 4.17, 4.18, 4.19, 4.20, 4.21, 4.22 The Royal Photographic Society, Bath; 4.2, 4.3, 4.5a, 4.6, 4.11 Science and Society Picture Library, Science Museum; 4.7, 4.14 Courtesy George Eastman House; 4.13a, 4.13b Sidney F. Ray; 4.23 M.L Perony; 4.24 The William B. Jaffe and Evelyn A.J Hall Collection. Photograph © 1997 The Musuem of Modern Art, New York; 2.25 Jockey Club Estates Limited; 4.26 Marguerite Nelson.

Chapter 5: 5.1, 5.2, 5.3, 5.5, 5.7, 5.8, 5.10a&b, 5.13, 5.14, 5.15, 5.10 The Doyal Photographic Society, Rath: 5 fia h & c Sidney F. Ray; 5.9 Visual Publications Ltd; 5.16, 5.17, 5.18 Science and Society Picture Library, Science Museum.

Chapter 6: 6.1, 6.2, 6.4, 6.6, 6.8, 6.16, 6.19 The Royal Photographic Society, Bath; 6.10, 6.12, 6.17 Science and Society Picture Library, Science Museum.

Chapter 7: 7.1, 7.7, 7.11, 7.12, 7.14 The Royal Photographic Society, Bath; 7.2 Royal Geographical Society London; 7.5 From Ralph Andrews "Picture Gallery Pioneers"; 7.6 Dr. Barnardos; 7.8 The Jacob A. Riis Collection, Museum of the City of New York; 7.13, 7.16, 7.21 By permission of The British Library; 7.17, 7.18 © Peter Hunter from The John Hillelson Agency; 7.19 Henri Cartier-Bresson/Magnum Photos; 7.20 Bill Brandt © Bill Brandt Archive.

Chapter 8: 8.1 Board of Trustees of the National Museums and Galleries on Merseyside (Walker Art Gallery, Liverpool); 8.2, 8.3, 8.4, 8.5, 8.6, 8.7, 8.8 The Royal Photographic Society, Bath; 8.10, 8.11 photograph © 1996, The Art Institute of Chicago. All Rights Reserved.

Chapter 9: 9.1, 9.2, 9.4, 9.9, 9.10 The Royal Photographic Society, Bath; 9.3 The British Council; 9.5 Mrs Juliet Man Ray, 9.6 Miss Hattula Moholy-Nagy; 9.7 Science and Society Picture Library, Science Museum 9.8 Professor Harold Egerton MIT; 9.11, 9.12 © 1981 Center for Creative Photography, Arizona Board of Regents; 9.13 The Ansel Adams Publishing Rights Trust/Corbis; 9.14, 9.15, 9.17 Galerie Wilde, Cologne, West Germany; 9.18 Bill Brandt © Bill Brandt Archive; 9.19 Frau Gertrud Heartfield, Berlin; 9.20 Musuem Boymansvan Beunignen Rotterdam Holland; 9.21 Theatre Collection, Harvard University USA, 9.22 The Minor White Archive, The Art Museum, Princeton University © 1970 by The Trustees of Princeton University. All Rights

Chapter 10: 10.1 USSR Reconstructs; 10.2 The Royal Photographic Society, Bath; 10.3 The Museum of Modern Art, New York. Gift of Richard Avedon. Copy print © 1997 The Museum of Modern Art, New York; 10.4, 10.6a and b The National Portrait Gallery; 10.5, 10.13 Courtesy of The Conde Nast Publications Inc; 10.7, 10.12 Cecil Beaton photograph courtesy of Sotheby's London; 10.8 PA News; 10.9 IPC Magazines; 10.10 The Trustees of the Imperial War Musuem, London; 10.11 Walter Nurnberg; 10.14 © Arnold Newman; 10.15 © Sam Haskins; 10.16 Science and Society Picture Library, Science Museum; 10.17 NASA; 10.18 Associated Press; 10.19 Janine Wiedel.

Chapter 11: 11.1 © William Klein, Courtesy Howard Greenberg Gallery, NYC; 11.2 The Minor White Archive, The Art Museum, Princeton University © 1982 by The Trustees of Princeton University. All Rights Reserved; 11.3 Courtesy Sidney Janis Gallery, New York; 11.5 William Egglestone, courtesy of Art and Commerce Anthology Inc; 11.6 © Stephen Shore, courtesy PaceWildensteinMacGill, New York; 11.8 Mary Boone Gallery, New York; 11.9 Metro Pics; 11.10 Martin Parr/Magnum Photos.

Chapter 12: 12.1 The Museum of Modern Art, New York. John B. Turner Fund. Photograph © 1997 The Museum of Modern Art, New York; 12.2 Jerry N. Uelsmann; 12.3 Sandy Skoglund/SuperStock; © Calum Colvin; 12.5, 12.6 © Mari Mahr; 12.7 Courtesy Fraenkel Gallery, San Francisco; 12.8 Museum of Art, Rhode Island School of Design. Gift of Mr. And Mrs. Gilman Angier. Photography by Cathy Carver; 12.9 Jannt Borden Gallen; New York, NY; 12.10 Sonnabend, New York; 12.11 © ARS, NY and DACS, London 1997; 12.12 © David Hockney; 12.13 Copyright Joel Peter-Witkin, Courtesy Pace Wildenstein MacGill, New York and Fraenkel Gallery, San Francisco; 12.14 David Hiscock; 12.15 © National Museum of American Art, Washington DC, USA.

Copyright holders of the following pictures were unable to be traced. The publishers would welcome any information that would allow this to happen: 11.4 Photographer Jim Goldberg; 11.7 Photographer Joel Meyerowitz.

Abstractionism, 126	Collodion process, 22–3, 42
Actinometer, 81	Colour photography developments, 60–2, 67
Actuality photographs, 56	Colour printing, 62
Adams, Ansel, 135-6, 160, 208	Colour separation process, 61–5
Adamson, Robert, 18, 208	Colvin, Calum, 183
Advertising uses, 148–51	Combination printing, 25, 27
Agfacolor, 66	Communication developments, 171
Ambrotype process, 30	Corot, Jean, 209
Aperture (magazine), 144, 167	Cowin, Eileen, 168
Arbus, Diane, 167	Critical theory approach, 174–7
Archer, Frederick Scott, 22	Cubism movement, 126
Atget, Eugene, 208	Cunningham, Imogen, 135
Autochromes, 62–3	Garmingham, mogen, 100
Automatic exposure systems, 81–2	Dadaism movement, 127-8, 130, 140
Avedon, Richard, 152, 157	Daguerre, Louis, 4–5, 209
7.7.	Daguerrean Galleries (portrait studios), 12–14
Bailey, David, 158, 208	Daguerreotype process, 5–6, 10–12
Baltz, Lewis, 172	Davison, George, 113, 193, 209
Barnack, Oscar, 73	
Barnardo, Dr. 90	de Meyer, Baron, 148, 210
Bauhaus (art school), 128–30, 139	Degas, Edgar, 209
	Delamotte, Philip, 24, 86, 108, 209
Beard, Richard, 208 Reaten Casil 150, 154, 208	Demachy, Robert, 114, 209
Beaton, Cecil, 150, 154, 208	Disc cameras, 80
Becher, Bernhard and Hilla, 189	Disderi, Adolphe, 35, 209
Berliner Illustrierte Zeitung (magazine), 99, 103	Distortion and manipulation, 104–5
Blossfeldt, Karl, 136, 138	Dodgson, Rev. Charles, 37, 208
Brady, Mathew, 87, 89, 208	Driffield, V.C., 52, 112
Brandt, Bill, 102–3, 139, 208	Dry plate process, 44–5
British Army Film and Photography Unit, 103	du Hauron, Ducas, 61, 62
Brodovitch, Alex, 157	Duchamp, Marcel, 127, 128, 193, 209
Bromide paper, 45	Dyke, Willard Van, 135
Broomfield, Maurice, 155	
Bullock, Wynn, 167	Eastman Dry Plate Company, 47
	Eastman, George, 47–8, 209
Cabinet photographs, 36	Eastman Kodak Company, 48
Calendar of events, 201–4	Edison, Thomas, 50
Callahan, Harry, 139, 208	Eggleston, William, 172
Calotype process, 6–7, 14–15	Ektachrome, 155
Camera obscura, 1–2	Emerson, Dr Peter Henry, 111–12, 116, 209
Cameras:	Environmental issues effects, 160
amateur, 80	Equivalents, 142
compact, 80	Ermanox camera, 74
detective, 49	Ernst, Max, 141
disc, 80	Evans, Frederick, 114-16, 209
disposable, 82	Evans, Walker, 95, 209
dry plate, 45	Exposure measurement, 81–2
early forms, 1-2, 71-2	Expressionism, 179, 181
Ermanox, 74	,,
Hasselblad, 78	Farm Security Administration, 94-5, 97, 154
Kine Exacta, 76	Fenton, Roger, 24, 25, 87, 209
Kodak, 47–8	Ferrotype process see Tintype process
Leica, 74	Films:
monorail, 79	35 mm, 80
precision designs, 73–4	colour negative, 66
professional, 78–9	first roll, 47–8
Rolleiflex, 74, 78	multi-layer colour, 65–7
rollfilm, 47–8, 72–3	panchromatic, 50
SLR, 75–7	rollfilm, 72
technical improvements, 82	sensitivity, 50–2
Cameron, Julia Margaret, 37–9, 110, 208	Fine Art photography, 193–5
Capa, Robert, 102, 103, 208	Flashbulbs, 53
Caponigro, Paul, 167	Flashpowder, 53
Carroll, Lewis see Dodgson, Rev. Charles	Frank, Robert, 167, 209
Carte-de-visite prints, 34–6, 40	Friedlander, Lee, 187
Cartier-Bresson, Henri, 100–2, 208	Frith, Francis, 24, 36, 209
Cassette film, 80	Futurism, 127
Claudet, Antoino, 11, 208	racardin, 127
Clerk-Maxwell, James, 60	Gallery, 291, 116
Coburn, Alvin Langdon, 117, 122, 126, 208	Gelatin emulsions, 44–5
Coke Prof Van Deren 1945	GLOSSARY 205_7

Group f64, 135

Half-tone photographs, 54-5 Hamilton, Richard, 181 Hardy, Bert, 209 Harpers Bazaar (magazine), 157-8 Hasselblad camera, 78 Heartfield, John, 141-2, 210 Heliography, 4 Herschel, Sir John, 21 Hill, David Octavius, 18, 210 Hine, Lewis, 93-4, 132, 210 Hiscock, David, 192 Hockney, David, 188 Hurter, F., 52, 112 Hutton, Kurt, 210

Illustrated (magazine), 100, 103 Impressionism movement, 120, 122 Industrial photography, 155-7 Institute of British Photographers, 168

Jackson, William, 89-90 Josephson, Ken, 187

Karsh, Yousef, 152, 210 Kertesz, André, 139, 160, 210 Kine Exacta camera, 76 Klein, William, 167 Kodachrome, 66, 67 Kodacolor, 66 Kodak disc cameras, 80 Kodak (trademark), 47 Kruger, Barbara, 174 Land, Dr Edwin, 67 Lange, Dorothea, 95, 145, 210 Leica cameras, 74 Lens, improved designs, 72, 73 Lens design, 53 Lewis, Wyndham, 126 Life (magazine), 100, 103, 154, 160 Light meters, 81 Light sources, 53 Light-sensitive materials, 2-4 Linked Ring, The, 113, 117, 119, 120, 122 London Stereoscope and Photographic Co., The, 36, 87 Lorant, Stephen, 103 Lumière brothers, 62

McBean, Angus, 142-3, 210 McCullin, Don, 161 Maddox, Richard Leach, 44, 210 Magic lantern lectures, 41 Magnum (agency), 102, 160 Magritte, Rene, 210 Mahr, Mari, 184, 186, 210 Man, Felix, 210 Manipulation and distortion, 104-105 Marey, Prof. Etienne, 50, 210 Martin, Paul, 91, 210 Meaning, in use of photography, 164, 167-8 Metaphor, photographic, 144 Meyerowitz, Joel, 172 Michals, Duane, 167-8, 189, 210 Modernism, 125-8, 134, 138-45 Moholy-Nagy, Laszlo, 128-30, 141, 211 Monorail cameras, 79 Movement/action pictures, 49-50 Multi-layer colour films, 65-7 Muybridge, Edweard, 49-50, 57, 211

Nadar, Felix, 27, 28, 30, 211 Naturalistic photography, 109 New Objectivity movement, 136-8, 139, 155 New Topographers, 171-2 Newman, Arnold, 152, 157, 211 Newspaper photography see Photojournalism Niépce, Nicéphore, 3-4, 211 Nurnberg, Walter, 155

Orthochromatic plates, 50 O'Sullivan, Tim, 89, 211

Painting:

influence of photography, 57-8 influence on photography, 120, 122 Panchromatic plates and films, 50, 61

Parkinson, Norman, 159 Parr, Martin, 174

Pencil of Nature (book), 15-16

Penn, Irving, 157, 211

Pentax, 77 Petzval, Josef, 6 Pfahl, John, 187-8 Photo-Secessionism, 117, 120

Photograms, 128

Photographic block development, 53-5 Photographic Society of London, 25, 112 Photography:

Calendar of events, 201–4

effect of new materials and equipment (1880s), 55-9

importance of discovery, 9-11, 19-20 Photojournalism, 97-100, 103-4

Pictorial photography/pictorialism, 107-11

Picture magazines, 103-4 Picture Post (magazine), 100, 103 Polaroid material, 67 Pop Art movement, 181

Portraiture, 27, 151-2

Post-modernist developments, 179-82, 193-5

Price, William Lake, 211 Professional equipment, 78-9 Propaganda photography, 154-5

Rauschenberg, Robert, 181, 211

Ray, Man, 128, 211 Rayographs see Photograms Realism experiments, 130-3, 136

Rejlander, Oscar Gustav, 25, 27, 108, 110, 211

Renger-Patzsch, Albert, 136, 137-8, 211 Riis, Jacob, 91-3, 211

Robinson, Henry Peach, 27, 110-11, 188-9, 211 Rolleiflex camera, 74, 78

Rollfilm, 47-8, 72-3 Rothstein, Arthur, 95, 211 Royal Photographic Society, 25

Salomon, Erich, 100, 211 Schulze, Prof. J., 2 Scott-Archer, Frederick, 30, 208 Screen mosaic materials, 63 Semiology application, 168 Separation negatives, 62, 63, 64 Seymour, David, 102, 103 Shell Photographic Unit, 156 Sherman, Cindy, 168, 174, 212 Shore, Stephen, 172 Signal (magazine), 155 Skoglund, Sandy, 182, 183 SLR (single lens reflex) cameras, 75-7

Social effects, 39-42, 160-61

Spence, Jo, 174

Steichen, Edward, 117, 118-19, 150, 154, 160, 167, 212 Stereoscopic photographs, 31-4

Stieglitz, Alfred, 116-18, 132, 144, 212 Straight photography, 129, 130

Strand, Paul, 131–3, 212 Stryker, Roy, 95, 97 Sun Pictures in Scotland (book), 16 Surrealism movement, 140, 182–4 Sutcliffe, Frank Meadow, 113, 212

Talbot, Henry Fox, 6–7, 14–18, 212 Technicolor, 65 35 mm films, 80 Thomson, John, 90–1, 212 Tintype process, 31 Toumachon, Felix see Nadar, Felix Training course changes, 168

Uelsmann, Jerry, 182

Vogel, Prof. Herman, 50, 61 Vogue (magazine), 148, 150, 154 Voigtlander camera, 11 Vorticism, 126 Warhol, Andy, 181, 189, 212
Wartime photography, 153–5
Wedgwood, Thomas, 3, 212
Weston, Edward, 133–5, 144, 212
Wet plate process, 21, 22–3, 23
White, Minor, 144, 167, 171, 181, 212
Witkin, Joel-Peter, 189, 191–2, 212
Wolcott camera, American, 10, 11
Woodburytype, 54
Works of art, photographic records, 41

Youth culture photography, 157-60

Zeiss Ikon, 77 Zeotrope, 50 Zone System, 136